THE ART SPIRIT

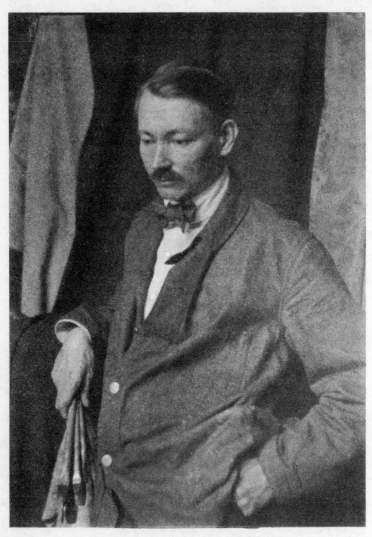

Robert Henri (1865–1929)

THE ART SPIRIT

Robert Henri

<hr/>

Notes, Articles, Fragments of Letters and Talks to Students, Bearing on the Concept and Technique of Picture Making, the Study of Art Generally, and on Appreciation. Compiled by Margery Ryerson. Introduction by Forbes Watson.

ICON EDITIONS

1817

Harper & Row, Publishers, New York
Grand Rapids, Philadelphia, St. Louis, San Francisco
London, Singapore, Sydney, Tokyo, Toronto

FIRST ICON paperback edition published 1984.

Library of Congress Cataloging in Publication Data

Henri, Robert, 1865-1929.
 The art spirit.

 (Icon editions)
 Reprint. Originally published: Philadelphia: Lippincott, 1923.
 1. Art—Addresses, essays, lectures. I. Ryerson, Margery. II. Title.
N7445.2.H46 1984 700 83-48970
ISBN 0-06-430138-9 (pbk.)

 91 92 93 94 95 MPC 10

ROBERT HENRI

Introduction by Forbes Watson

NO other American painter drew unto himself such a large, ardently personal group of followers as Robert Henri, whose death, July 12th, 1929, brought to an end a life of uncontaminated devotion to art.

Henri was an inspired teacher with an extraordinary gift for verbal communication, with the personality and prophetic fire that transformed pupils into idolators.

Not only so but he ardently believed in the close relationship of Art to Life—believed that Art is a matter in which not only professionals and students, but *everyone* is vitally concerned; and his contention is supported by the immense benefit that has accrued to France through its devotion to art and its production.

The list of men now eminent who developed under Henri's precepts is a long one. He sought, above all things, to cultivate spontaneity. He always attempted to bring out the native gift. He gave his followers complete respect for an American outlook. He showed them the Frenchmen but he did not encourage them to imitate the Frenchmen. Without jingo Henri taught them artistic self-respect. It was not a crime to look at American material with American eyes.

Yet, for all the impulsion which he gave toward

what might be called a native school, Henri was the
first artist to spread in any broad way the news of
the great French painters who made the nineteenth
century such a glorious epoch. It is hard for us to
realize that only a short generation ago changes in
French art were not registered in New York with
anything like the present rate of speed. New York
had not then become the great financial centre of
the world. French paintings were not then bought
at such dazzling prices or in anything like the same
quantity as now, nor had the collecting of Parisian
art, popular as it was more than ten years ago, be-
come the social mania in America that it is today.

Curiously, although William Chase and other
prominent American painters and painting teachers,
who belonged to the period immediately preceding
Henri's reign, might have brought back from Europe
for their future pupils the fresh news of Manet,
Degas and the others, it remained for Henri, the
great protagonist of a new American school, to be
the first prophet to bring to students in any great
numbers, both a sense of the importance of the last
half of the nineteenth century in French painting
and a knowledge of the revived interest in such old
masters as Frans Hals, Goya and El Greco.

To be sure Chase talked to his students about El
Greco before Henri started teaching, and other
painters of Chase's generation knew these things.
But Henri was a far more dynamic teacher than
Chase. It required his extraordinary personal mag-
netism, his fervor, his passion for the verbal com-
munication of his ideas to place before a vast suc-
cession of eager youth the new world of vision and
to make general, knowledge which before had been
too special to be effective. No one who has not felt
the magnetic power of Henri, when he had before
him an audience of ambitious students hungry for

the master's moving words, can appreciate the emo-
tional devotion to art which he could inspire as
could no other teacher. One had to know those
students to realize how it could have been possible
at that late date for a young painter to combine
genuine painting eagerness with a sublime igno-
rance of the whole world of art that had its being
outside of the Henri class. This ignorance in many
of his students Henri set himself to overcome by
opening their eyes to the fundamental meaning of
art. But he did not hold up to them the art of the
past or the great contemporary art of France as an
ideal to imitate.

One can hardly believe now, were the facts not
so easy to establish, that many of the young men
and women who studied under him, although so
passionately interested in painting, first heard the
names of Daumier, Manet, Degas, Goya and a host
of others from the lips of Robert Henri. One won-
ders how some of them ever came to painting at all
after exhibiting such surprising ability to dodge
knowledge. Henri was not on the lookout for
cultivation. Native talent, in whatever crude dis-
guise it might appear, was what he sought. Let the
untrained student be as naïve, as profoundly illiter-
ate, as filled with æsthetic misconceptions as possi-
ble, Henri disregarded the outward dress and
pointed lack of polish. He looked to the man's
potentialities, which he attempted to develop with-
out regard to himself in time and energy. He
demanded from his students a first hand emotion
received not from art but from life.

When Henri's classes were at fever heat, im-
pressionism was already being taught in the Penn-
sylvania Academy. Twachtman, who died in 1902,
had inculcated impressionist theories of light in his
students at The Art Students League. But Twacht-

man was an unwilling, comparatively inarticulate teacher, capable of communicating only to the few some sense of his rare and subtle spirit. Henri, on the other hand was, as I have said, an inspired teacher, with an extraordinary gift for verbal communication.

Henri never showed the slightest interest in the more scientific side of impressionism. The blond beauties of sunlit landscapes had no special appeal for him. What he did take from the impressionists and what, after all, was perhaps the most valuable contribution made by the group, the only contribution which they all made in common, was the idea of looking at contemporary life and contemporary scenes with a fresh, unprejudiced, unacademic eye.

His students followed Henri without complaint even when they suffered thereby great material hardships. They did not make the slightest compromise with the ideals which Henri held before them. I can still remember sitting on a bench in Union Square listening to some Henri students in a heated discussion of what Henri had said that evening to his Night School students. The discussion was so ardent that no one hearing it could have believed that these young men, who had worked all day at manual labor, and painted for hours at the Henri School, were about to sleep on a bench in a park because they could not afford to hire a room for the night.

It is difficult for us to realize today how infinitely more arduous exhibition conditions were then for the young painter. Art had not then become news to anything like the degree it has since become news. Dealers were not then chasing each other over the face of the earth to discover the unknown genius. The great official exhibitions were controlled by the

prize-winning repeaters. Men who today cannot give their pictures away prospered greatly and were powerful influences on our public and on some of our private collections. As long as these tame specialists controlled the situation the young independent American artist had no opportunity to sell or even to show his work. Henri was hated by the officials because from the first they realized that his attack on them was disinterested. He was not fighting for a theory of painting or for his own individual advancement. He merely demanded from the reactionaries in power a fair and free opportunity for the young independent American artist.

The first American Independent Exhibition which Henri and his friends and pupils inaugurated, the ancestor of the present Independent Society, contained paintings of real power, some of which are now the proudest possessions of collectors and museums, but which then could find no public exhibiting space outside the walls of the Independent.

No one will ever be able to estimate how much Henri contributed to the free and open conditions of today. All over the United States ex-Henri students are to be found. The men and women who were taught by Henri to respect freedom of expression never have forgotten or can forget this invaluable lesson.

To Henri the man and the teacher, the debt that America owes is inestimable. He came at a time when the officials were still in power, and had their heavy paws firmly on the neck of youth and originality. Henri fought for freedom and he gave to his students the courage to conquer officialdom.

The Art Spirit embodies the entire system of Henri's teaching. To make it more complete he

went over his notes and correspondence for twenty-three years. His book is indeed so individual and characteristic that those who knew him can recognize the very tones and manner of utterance that he employed. The book is not only teaching, it is inspiration.

Foreword by the Author

MANY students have asked for this book, and that is the reason the fragments which are its composition have been brought together. No effort has been made toward the form of a regular book. In fact the opinions are presented more as paintings are hung on the wall, to be looked at at will and taken as rough sketches for what they are worth. If they have a suggestive value and stimulate to independent thought they will attain the object of their presentation. There are many repeats throughout the work, many times the same subject is taken up and viewed from a different angle or seen in relation to other matters. At the end there is a complete index which will make up for the absence of chapters and sections and the general scarcity of headings. There is no idea that anyone should agree with any of the comments or that anyone should follow the advice given. If they irritate to activity in a quite different direction it will be just as well. The subject is beauty—or happiness, and man's approach to it is various.

R. H.

June, 1923

¶ *There are moments in our lives,
there are moments in a day, when
we seem to see beyond the usual.
Such are the moments of our great-
est happiness. Such are the moments
of our greatest wisdom. If one could
but recall his vision by some sort of
sign. It was in this hope that the
arts were invented. Sign-posts on
the way to what may be. Sign-posts
toward greater knowledge.*

ROBERT HENRI

¶ART when really understood is the province of every human being.

It is simply a question of doing things, anything, well. It is not an outside, extra thing.

When the artist is alive in any person, whatever his kind of work may be, he becomes an inventive, searching, daring, self-expressing creature. He becomes interesting to other people. He disturbs, upsets, enlightens, and he opens ways for a better understanding. Where those who are not artists are trying to close the book, he opens it, shows there are still more pages possible.

The world would stagnate without him, and the world would be beautiful with him; for he is interesting to himself and he is interesting to others. He does not have to be a painter or sculptor to be an artist. He can work in any medium. He simply has to find the gain in the work itself, not outside it.

Museums of art will not make a country an art country. But where there is the art spirit there will be precious works to fill museums. Better still, there will be the happiness that is in the making. Art tends towards balance, order, judgment of relative values, the laws of growth, the economy of living—very good things for anyone to be interested in.

¶THE work of the art student is no light matter. Few have the courage and stamina to see it through. You have to make up your mind to be alone in many ways. We like sympathy and we like to be in company. It is easier than going it alone. But alone one gets acquainted with himself, grows

up and on, not stopping with the crowd. It costs to do this. If you succeed somewhat you may have to pay for it as well as enjoy it all your life.

✗ Cherish your own emotions and never undervalue them.

We are not here to do what has already been done.

I have little interest in teaching you what I know. I wish to stimulate you to tell me what *you* know. In my office toward you I am simply trying to improve my own environment.

Know what the old masters did. Know how they composed their pictures, but do not fall into the conventions they established. These conventions were right for them, and they are wonderful. They made their language. You make yours. They can help you. All the past can help you.

¶AN ART student must be a master from the beginning; that is, he must be master of such as he has. By being now master of such as he has there is promise that he will be master in the future.

A work of art which inspires us comes from no quibbling or uncertain man. It is the manifest of a very positive nature in great enjoyment, and at the very moment the work was done.

It is not enough to have thought great things *before* doing the work. The brush stroke at the moment of contact carries inevitably the exact state of being of the artist at that exact moment into the work, and there it is, to be seen and read by those

who can read such signs, and to be read later by the artist himself, with perhaps some surprise, as a revelation of himself.

For an artist to be interesting to us he must have been interesting to himself. He must have been capable of intense feeling, and capable of profound contemplation.

He who has contemplated has met with himself, is in a state to see into the realities beyond the surfaces of his subject. Nature reveals to him, and, seeing and feeling intensely, he paints, and whether he wills it or not each brush stroke is an exact record of such as he was at the exact moment the stroke was made.

¶THE sketch hunter has delightful days of drifting about among people, in and out of the city, going anywhere, everywhere, stopping as long as he likes—no need to reach any point, moving in any direction following the call of interests. He moves through life as he finds it, not passing negligently the things he loves, but stopping to know them, and to note them down in the shorthand of his sketchbook, a box of oils with a few small panels, the fit of his pocket, or on his drawing pad. Like any hunter he hits or misses. He is looking for what he loves, he tries to capture it. It's found anywhere, everywhere. Those who are not hunters do not see these things. The hunter is learning to see and to understand—to enjoy.

There are memories of days of this sort, of wonderful driftings in and out of the crowd, of seeing and thinking. Where are the sketches that were made? Some of them are in dusty piles, some turned out to be so good they got frames, some

became motives for big pictures, which were either better or worse than the sketches, but they, or rather the states of being and understandings we had at the time of doing them all, are sifting through and leaving their impress on our whole work and life.

¶DON'T worry about the rejections. Everybody that's good has gone through it. Don't let it matter if your works are not "accepted" at once. The better or more personal you are the less likely they are of acceptance. Just remember that the object of painting pictures is not simply to get them in exhibitions. It is all very fine to have your pictures hung, but you are painting for yourself, not for the jury. I had many years of rejections.

Do some great work, Son! Don't try to paint *good landscapes*. Try to paint canvases that will show how interesting landscape looks to you—your pleasure in the thing. Wit.

There are lots of people who can make sweet colors, nice tones, nice shapes of landscape, all done in nice broad and intelligent-looking brushwork.

Courbet showed in every work what a man he was, what a head and heart he had.

Every *student* should put down in some form or other his findings. All any man can hope to do is to add his fragment to the whole. No man can be final, but he can record his progress, and whatever he records is so much done in the thrashing out of the whole thing. What he leaves is so much for others to use as stones to step on or stones to avoid.

The *student* is not an isolated force. He belongs to a great brotherhood, bears great kinship to his

kind. He takes and he gives. He benefits by taking and he benefits by giving.

¶THROUGH art mysterious bonds of understanding and of knowledge are established among men. They are the bonds of a great Brotherhood. Those who are of the Brotherhood know each other, and time and space cannot separate them.

The Brotherhood is powerful. It has many members. They are of all places and of all times. The members do not die. One is member to the degree that he can be member, no more, no less. And that part of him that is of the Brotherhood does not die.

The work of the Brotherhood does not deal with surface events. Institutions on the world surface can rise and become powerful and they can destroy each other. Statesmen can put patch upon patch to make things continue to stand still. No matter what may happen on the surface the Brotherhood goes steadily on. It is the evolution of man. Let the surface destroy itself, the Brotherhood will start it again. For in all cases, no matter how strong the surface institutions become, no matter what laws may be laid down, what patches may be made, all change that is real is due to the Brotherhood.

¶IF THE artist is alive in you, you may meet Greco nearer than many people, also Plato, Shakespeare, the Greeks.

In certain books—some way in the first few paragraphs you know that you have met a brother.

You pass people on the street, some are for you, some are not.

Here is a sketch by Leonardo da Vinci. I enter this sketch and I see him at work and in trouble and I meet him there.

Letter to the Class, Art Students League, 1915:

¶AN INTEREST in the subject; something you want to say definitely about the subject; this is the first condition of a portrait. The processes of painting spring from this interest, this definite thing to be said. Completion does not depend on material representation. The work is done when that special thing has been said. The artist starts with an opinion, he organizes the materials, from which and with which he draws, to the expression of that opinion. Every material he employs has become significant of his emotion. The things have no longer their dead meaning but have become living parts of a coördination. A prejudice has existed for the things useful for the expression of this special idea, only things essential to this idea have been used. Nature is there before you. A particular line has been taken through nature. A special and particular vision is making itself clear. The lace on the lady's sleeve is no longer lace, it is part of her, and in the picture stands as a symbol of her refinement and her delicacy. The color in her cheek is no longer a spot of red, but is the culminating note of an order which runs through every part of the canvas signifying her sensitiveness and her health.

To start with a deep impression, the best, the most interesting, the deepest you can have of the model; to preserve this vision throughout the work; to see nothing else; to admit of no digression from

it; choosing only from the model the signs of it; will lead to an organic work. Every element in the picture will be constructive, constructive of an idea, expressive of an emotion. Every factor in the painting will have beauty because in its place in the organization it is doing its living part. It will be living line, living form, living color. Because of its adjustment, it is given its greatest power of expansion. It is only through a sense of the right relation of things that freedom can be obtained.

As different as ideas and emotions are, there can be no set rule laid down for the making of pictures, but for students found working in a certain line suggestions may be made. There is a certain common sense in procedure which may be basic for all, and there are processes safe to suggest, if only to be used as points of departure, to those who have not already developed a satisfying use of their materials.

It is on this ground that I offer you the following: With your model posing as he does in the same position every day of a week you have choice of differing modes of study, and it is up to you to decide well which will be the most profitable, which will carry you further. Some will work the entire week on the same canvas and others will find it an advantage to make an entirely new start every day, preserving as far as possible the canvases of the early days to compare with the work in hand, and making these comparisons, sitting in judgment on them and coming to decision as to what to do next. Some will find it advisable to start a canvas number one on the first day, and a canvas number two on the second, and alternating these two canvases for the rest of the week, they will in a sort of duel teach each other much. I myself have found it useful to work on two canvases, alternating them

with every rest of the model. One does not sleep
in this kind of work, there is an excitement in it
that can improve the sometimes dying energies in a
classroom in the later days of the week. Every
mode has its virtues and its vices, but the student
who is a student and attending to his own case will
in the mode just described crowd into a week a lot
of experience in *commencing* a work, and he will
come to a very great knowledge of his understand-
ing and his possible visions of the subject. The
value of repeated studies of *beginnings* of a paint-
ing cannot be over-estimated. Those who cannot
begin do not finish.

And for all who continue to work on the same
canvas let me suggest that your struggle throughout
the week should be to perfect the beginning of your
painting. If you are thinking and seeing your own
work and the work about you, you must observe
how general is the failure in the progress of works.
The fact is, finish cannot be separated from a per-
fect commencement.

Insist then, on the beauty of form and color to be
obtained from the composition of the largest masses,
the four or five large masses which cover your can-
vas. Let these above all things have fine shapes,
have fine colors. Let them be as meaningful of your
subject as they possibly can be. It is wonderful how
much real finish can be obtained through them,
how much of gesture and modeling can be obtained
through their contours, what satisfactions can be
obtained from their fine measures in area, color and
value. Most students and most painters in fact rush
over this; they are in a hurry to get on to other
matters, minor matters.

In dealing with these four or five masses in por-
traiture, the mass of the face is the most important
and should be considered as principal to the other

masses, even though the other masses be more brilliant or striking in themselves. Also the mass of the head should be considered as principal to any feature of the head. The beauty of the larger mass is primary to and is essential to the lesser mass.

Paint over and over, scrape and re-commence in your effort to find out and establish the beauty of color and design possible in the larger masses. When you scrape, do it like a good mechanic. Paint thin over proper light surfaces, but paint either thin or thick to get your desired effect. Permit no hurrying on to the lesser masses before all has been done that is possible with the larger masses.

Determine to get in these larger masses all that is possible of completion, all the drawing, color, design, character, construction, effect. Remember that the greatest beauty can be expressed through these masses, that the distinction of the whole canvas depends on them.

When later you come to the painting of the features of the face, consider well the feature's part in relation to the idea you have to express. It will not be so much a question of painting that nose as it will be painting the *expression* of that nose. All the features are concerned in one expression which manifests the state of mind or the condition of the sitter.

No feature should be started until you have fully comprehended its character and have established in your mind the manner of its full accomplishment. To stop in the process of drawing the lines of a feature to inquire "what next" is surely to leave a record of disconnection.

No feature should be drawn except in its relation to the others. There is a dominating movement through all the features. There is sequence in their relationship. There is sequence in the leading lines

of the features with the movements of the body.
This spirit of related movement is very important
in the drawing or painting of hair. Hair is beautiful
in itself, this should not be forgotten, but it is the
last position of importance it takes in the make-up
of a portrait. The hair must draw the grace and
dignity—perhaps the brains—of the head. The
lights on the hair must be used to stress the con-
struction, to vitalize, accentuate and continue move-
ment. The outline of the hair over the face must
be used as a principal agent for the drawing of the
forms of the forehead and temples, and must at the
same time partake of the general movement of the
shoulders and of the whole body. The hair is to be
used as a great drawing medium. It is to be ren-
dered according to its nature, but it is not to be
copied. Think well on this; it is very important.

The eyebrows are hair in the last instance. To a
good draftsman they are primarily powerful evi-
dences of the muscular actions of the forehead,
which muscular actions are manifestations of the
sitter's state of being. The muscles respond instantly
to such obvious sensations as surprise, horror, pain,
mirth, inquiry, etc., and the actions of the muscles
are most defined in their effect on that strongly
marked line of hair, the eyebrow. However subtle
the emotion, the eyebrow by its definiteness marks
the response in the muscular movement.

In certain heads, the eyebrow, while normal, still
holds a very positive gesture. There are those, there-
fore, who carry in repose an expression of sadness,
boredom, surprise, dignity, and some accentuate
the force or direction in the action of looking. To a
good draughtsman the eyebrow is a living thing. It
develops a habit which it expresses in repose and it
flashes intelligence of every changing emotion. It
draws the shape of the lower forehead and temples

—the squareness, curve and bulk. After all that, it is a series of small hairs growing out of the skin.

The eyebrow must not be drawn hesitatingly. It must be conceived as a whole; your conception, your brush, the quantity of paint in right fluidity must be all ready before you touch the canvas.

By the *spring* in the drawing of the eyelash the quick action of the eye may be suggested. The upper eyelid and lash generally cast a shadow scarcely observed yet very effective on the eyeball. The white of the eye is more often the same color as the flesh about it than the average painter is likely to think it to be. The pupil is larger in quiet light, becoming very small by contraction when looking into brilliant light. The highlight in the pupil is a matter of drawing although best done with one quick touch. Its direction, shape, edges, and its contrast in color and value to the pupil give shape, curve, brilliancy or mark the contrary. The right brush, the right paint, a perfect control of the hand are necessary for this. For some, a maul stick to steady is of great value here. (There is a time and place for all things, the difficulty is to use them only in their proper time and places.)

The highlight on the end of the nose is likewise a matter of important drawing, although generally executed in a simple quick touch. By its shape it defines the three angles of the end of the nose.

The lines and forms in the clothes should be used to draw the body in its sensitive relationship with the head. The wrinkles and forms of the clothes are building material not for tailoring in your hands but for established basic lines rising to the head. There is an orchestration throughout the whole canvas. Nothing is for itself, but each thing partaking of the other is living its greatest possibility, is surpassing itself with vitality and meaning and is

part of the making of a great unity. So with the works of the great masters.

Do not tell me that you as students will first learn how to draw and then afterwards attend to all this.

It is only through such motives that you can learn to draw. This kind of thought *is* drawing, the hand must obey the spirit. With motive you will become clairvoyant of means, will seize and command them. Without motive you will wabble about.

Realize that your sitter has a state of being, that this state of being manifests itself to you through form, color and gesture, that your appreciation of him has depended on your perception of these things in their significance, that they are there of your selection (others will see differently), that your work will be the statement of what have been your emotions, and you will use these specialized forms, colors and gestures to make your statement. Plainly you are to develop as a seer, as an appreciator as well as a craftsman. You are to give the craftsman in you a motive, else he cannot develop.

All that I have said argues the predominant value of gesture. Gesture expresses through form and color the states of life.

Work with great speed. Have your energies alert, up and active. Finish as quickly as you can. There is no virtue in delaying. Get the greatest possibility of expression in the larger masses first. Then the features in their greatest simplicity in concordance with and dependent on the mass. Do it all in one sitting if you can. In one minute if you can. There is no virtue in delaying. But do not pass from the work on mass to features until all that can be said with the larger forms has been said—*no matter how long it may take,* no matter if accomplishment of the picture may be delayed from one to many days.

Hold to this principle that the greatest drawing, the greatest expression, the greatest completion, the sense of all contained, lies in what can be done through the *larger* masses and the larger gestures.

¶WHEN we know the relative value of *things* we can do anything with them. We can build with them without destroying them. Under such conditions they are enhanced by coming into contact with each other.

The study of art is the study of the relative value of things. The factors of a work of art cannot be used constructively until their relative values are known. Unstable governments, like unstable works of art, are such as they are because values have not been appreciated.

The most vital things in the look of a face or of a landscape endure only for a moment. Work should be done from memory. The memory is of that vital movement. During that moment there is a correlation of the factors of that look. This correlation does not continue. New arrangements, greater or less, replace them as mood changes. The special order has to be retained in memory—that special look, and that order which was its expression. Memory must hold it. All work done from the subject thereafter must be no more than data-gathering. The subject is now in another mood. A new series of relations has been established. These may confound. The memory of that special look must be held, and the "subject" can now only serve as an indifferent manikin of its former self. The picture must not become a patchwork of parts of various moods. The original mood must be held to.

The artist sees only that in the model which may help him to build up the look he would record. His

work is now very difficult. With the model before him he works from memory. He refers to the model, but he does not follow the new relations which differing moods establish. He chooses only from the appearance before him that which relates to his true subject—the look which first inspired him to work. That look has passed and it may not return. He is very fortunate if he can evoke again that look in the subject.

It is very difficult to go away from a subject after having received an impression and set that impression down from memory. It is yet more difficult to work from memory with the "subject" in its changing moods still before you. All good work is done from memory whether the model is still present or not. With the model present there is coupled with the distracting changes in its organization which must not be followed, the advantage of seeing, nevertheless, the material—the raw material one might say—of which the look was made.

Were the student constantly in the habit of memory-practice there is little doubt but that he would dispense with the presence of the model at the time of the actual accomplishment of his work. But this would mean a form of study which has not yet come in vogue. There is no form of study more fascinating than this—that is, after the first disheartening steps are taken. The first steps are disheartening because while we may have learned copying right well the effort to put down what we actually know—that is, what we can carry away with us—is often a revelation of the very little understanding we had in the presence of the model.

I think it is safe to say that the kind of seeing and the kind of thinking done by one who works with the model always before him is entirely different from the kind of seeing and thinking done by

one who is about to lose the presence of the model
and will have to continue his work from the knowl-
edge he gained in the intimate presence.

The latter type of worker generally manifests a
mental activity of much higher order than his ap-
parently safe and secure confrère. He must know
and he must know that he knows before the model
is snatched away from him. He studies for informa-
tion.

A good painting is a remarkable feat of organiza-
tion. Every part of it is wonderful in itself because
it seems so alive in its share in the making of the
unity of the whole, and the whole is so definitely
one thing.

You can look at a good painting in but one way.
That is, the way it is made. Whether you will or
not you must follow its sequences.

There are some paintings, very remarkable for
the skill they display, which are, however, a mere
welding together of factors which belong to many
different expressions of nature. Many a school draw-
ing of this character have I seen held up as an ex-
ample, given a prize, and yet being but a mere
patching together of many concepts—unrelated
factors nevertheless cunningly interwoven—there
is not in them that surge of life, that unity which
is the mark of true organization.

If you wish your work to have organization your
concept of the motive which is the incentive to
your flight must be as certain and you must hold
as well to it as you would have your organization
certain and true to itself in all of its parts.

No vacillating or uncertain interest can produce
a unity.

I have often thought of an art school where the
model might hold the pose in one room and the
work might be done in another. The pupils would

have their places in both rooms, one for observation and the other for work. The pupil could return to the model room for information. In getting the information he could view the model from *his* place or could walk about and get an all-around concept; he could also make any sketches he might desire to make—for information—but these drawings are not to be carried into the work room. Into this room he only carries what he *knows*.

It would be a wonderful school and the pupils in it would not only enjoy their work and profit more but they would be a much better class of students. For this class of work would demand such activity of mind and such energy that the practitioners of idle industry that now occupy so many places in school studios would eliminate themselves.

One might ask why this plan is not tried. The reason is the usual sad one. Good art schools are generally self-supporting. They barely pay their expenses. Innovations are financial risks. Besides, in this case the students have to be convinced, and, as I have said before, the initial steps in this kind of study are very discouraging.

Some tentative efforts have been made in memory study but perhaps the nearest we have come to it in any effective way has been through the introduction of the five, ten, or thirty minute poses. In these, mental activity, alertness, the quick seizing of essentials have been stimulated. We have proved that thirty minutes of high-pitch mentality and spirit is worth more than a whole week below par. And in such rapid work where seeing and doing is accomplished in five, ten, or thirty minutes the seeing must be certain, selective, and the memory must be good. This system of quick action has been of service.

In the old days, when a drawing was begun on

Monday and finished on Saturday, the student who did not know how to *begin* a drawing "began" one a week and spent a week *finishing* the thing he had not known how to begin. A thing that has not been begun cannot be finished.

But it took a terrible battle to introduce the Quick Sketch. It will not be easy to introduce this Concept-and-Carry method of study. A few individuals throughout the history of art have adopted this method in spite of the school conventions and these individuals are known to us through their works.

It should be noted that in this *memory* form of study it is not proposed that the model should be used less. It is proposed that the model should be used *more*. This is a thing that it would be well to understand. In fact, in observing the work of many students or artists where the model is before them for every stroke we may be impressed with the idea that it is the model who is using the artist instead of the artist using the model. This is certainly the case where the artist is following the moods of the model. Sometimes we see that the artist is not a willing slave, however, for we hear him complaining that "the model has moved," showing that somewhere in his mysterious consciousness there is a desire to do that thing which he started out to do.

The development of an ability to work from memory, to select factors, to take things of certain constructive values and build with them a special thing, your unique vision of nature, the thing you caught in an instant look of a face or the formations of a moment in the sky, will make it possible to state not only that face, that landscape, but make your statement of them as they were when they were most beautiful to you.

By this I mean that you will make an organization in paint on canvas; not a reproduction, but an organization, subject to the natural laws of paint and canvas, which will have an order in it kin to that order which has so impressed you in nature—in the look of a face, in the look of a landscape.

Faces are not permanently beautiful to us, nor are landscapes. There seem to be moments of revelation, moments when we see in the transition of one part to another the unification of the whole. There is a sense of comprehension and of great happiness. We have entered into a great order and have been carried into greater knowledge by it. This sometimes in a passing face, a landscape, a growing thing. We may call it a passage into another dimension than our ordinary. If one could but record the vision of these moments by some sort of sign! It was in this hope that the arts were invented. Signposts on the way to what may be. Signposts towards greater knowledge.

There are those who have found the sign and through their works we can to some degree follow, as we do at times when hearing music or in association with the works of the masters of other arts.

Everyone in some measure has these moments of clearer understanding, and it is equally important for all to hold and fix them.

It is really not important whether one's vision is as great as that of another. It is a personal question as to whether one shall live in and deal with his greatest moments of happiness.

The development of the power of seeing and the power to retain in the memory that which is essential and to make record and thus test out how true the seeing and the memory have been is the way to happiness.

¶WHAT were the signs in that landscape, in the air, in the motion, in our companionship, that so excited our imagination and made us so happy?

If we only knew what were those signs we could paint that country, could paint what it was to us.

What delight we have had in the momory of it! What is that memory?

We do not remember it, nor did we see it as any single thing, place or time.

Somehow times, places, things overlapped. Memories carried into each other.

That time we sat in the evening silence in the face of the mesa and heard the sudden howl of a pack of coyotes, and had a thrill and a dread which was not fear of the pack, for we knew they were harmless. Just what was that dread—what did it relate to? Something 'way back in the race perhaps? We have strange ways of seeing. If we only knew —then we could tell. If we knew what we saw, we could paint it.

Letter to the Class, Art Students League, 1916:

¶I OFFER you this process of making a study. It is a process I might or might not use myself. It is one way of doing the work, but there are many ways. This is only one of them. And it may prove a good experiment to you. One advantage the process has is that it is economical as to paint, and another advantage rests in the fact that you may accomplish drawing and design first, and later de-

velop the color to its completion, thus separating two difficulties.

You start by making a very simple drawing on your canvas, paying particular attention to the exact location, size and shape of all the larger masses: the face, its light and shade masses, the hair, collar and shirt, the tie, his coat and the background. In this I have named seven areas, and together they cover the total area of the canvas. You do not go into details, but you devote yourself to making the finest design you can possibly make with the seven named shapes.

Your palette is clean. You now estimate the value and color of each of these seven areas, and you mix a tone for each of them, allowing for each a quantity of pigment a little in excess of your estimate of the quantity necessary to cover generously the area in question.

You work at these seven tones on your palette until you are quite sure you have made mixtures that closely approximate in color and value the (1) light of the face, (2) shade of the face, (3) hair, (4) collar and shirt, (5) tie, (6) coat, (7) background. Of course each of these areas, or parts of the picture, have variations of light and shade, and of color, but at this stage of your work you disregard them. Your palette presents but seven notes, each to represent flatly its corresponding area.

In making these notes you will find advantage in trying them out by assembling them, maybe several times, in a miniature picture on the palette, until you are sure you have made the most distinguished assemblage possible in this way. Seven notes which are effective and beautiful in their relation to each other and which, assembled, will give the clarity of the flesh and the collar and shirt, and the richness

and contrasting power of the darker notes, the hair, tie, coat, background.

Let us assume that the model is a man of good healthy complexion, black hair, a soft shirt and collar nearly white but of a blue-green tint. A rich purple tie rather deep in tone, a gray coat, and the background a rug designed in dull red, dull yellow and green-blue low in tone and unified by obscurity.

Now, all of the areas of the subject having their correspondents in color, value and quantity on the palette; and no other pigments allowed to remain, the palette presents in a general way precisely the notes that are to be employed in the picture.

The palette itself already looks like the subject, and the student who having drawn, leaving only essential lines, the placement, proportions and essential movement of the subject, will be able to proceed to lay these colors on the areas for which they are intended with a greater attention to their shapes, their drawing power, their fullness and purity as pigments, than would be possible were they mixed in the usual way.

My suggestion that you might use such a mode of set palette is addressed to you after seeing you at your work, gathering somewhat your aims, and observing your need of a more simple process in the doing of what you are trying to do.

This process is only one out of hundreds of processes. There are many ways of painting pictures, and there are many kinds of pictures, each claiming special procedure.

I offer this one process, without prejudice, because I think that it will fit the ends I see you working for. You will find that by its use you will be able to acclaim the notes which give life to your subject; to make your canvas more rich and full,

with harmony and contrast of color. It will help you in the simple and net statements of value whether they be values of color or values of black and white.

I think you will see that by this detached painting of the picture on the palette in terms of color and of value, freed from the struggle with drawing, you will be able to weigh the powers of the colors and values; to establish the harmonies and contrasts; to become simpler; clearer; more positive in your transitions and to have, when the palette is thus set, a free mind to deal with the designs of forms, drawing and the characterization.

There will be less confusion, less likelihood of falling into exasperated and partial efforts to cover areas with insufficient quantities of paint, and these quantities of paint will have been better considered as to their general color and value in relation to the other colors and other values.

I do not say that with the few flat tones I have indicated for this portrait, a Monet-like impressionistic picture may be painted, but I do say that any one of you who might desire to paint such a picture, or one with a full iridescence of color, would do well first to acquire the ability and habit of registering on your canvas, in any way you can, an impression in large of the general shapes which go to make up the character of the subject.

On the other hand, I am ready to say that with the palette carefully built on this principle, the foundation of a picture that is to be a brilliant and forceful statement in color, color-vibration, mass, mass organization, in character, character-signification, may be laid, and after the first lay-in with this palette the palette may be augmented and arranged in the same way as before with additional divisions of color and value, to vitalize and complete the work already established in its broader planes.

For the present, however, you as students should devote yourselves to the power of simple expressions, to do all that can be done and learn how much can be said with the simpler and more fundamental terms.

It should be well understood that the principle of this form of set-palette is that a totally new palette is organized and set for each subject. It is possible to set a palette, very scientifically arranged, that will be serviceable for many subjects, but in presenting this I have looked to economy of paint and to the powers of concentration on a certain scheme.

Note also that after the palette is arranged you have in reserve your full set of colors, in their tubes, so that if in practice a note you have made should prove false, you can mix a new one to replace it, removing of course the false note from the palette. It is at all times important to remove any colors or mixtures that have no place in the scheme.

Your regular stock of colors should be as nearly as possible a well-balanced

Red	Red-orange	Orange	Orange-yellow	Yellow	Yellow-green
R	RO	O	OY	Y	YG

Green	Green-blue	Blue	Blue-purple	Purple	Purple-red
G	GB	B	BP	P	PR

in correspondence with the spectrum band, and with these you may have pigments that will serve as neutrals.

You will find at first that the study of your color scheme and the setting of your palette will take considerable time. With experience this time will be lessened. But in any case do not think you are wasting time because you are not fussing paint on your canvas. What you are doing has to be done anyway, and it will take its time whether you do it in the beginning or through the work. I am safe in

saying it will take less time and be better done if done at first.

Before closing this letter I want to state again that this form of set palette I have proposed is only one of many forms. I do not want to limit you to it. I offer it rather as a starting point for those of you who wish to use it as such. Nor do I want to disturb those who are satisfied with their present mode. I want you to act on your own judgment.

Backgrounds:

¶WITH the model before it, the background is transformed.

Before the model takes his place, the wall is an identity in itself and is forward.

When the model takes his place, the background recedes and exists only as a compliment to the figure.

Do not look at the background to know its colors or its shapes. Look at the model. What you will see of the background while looking at the model will be the background of that model.

All the beauty that can exist in the background rests in its relation to the figure. It is by looking at the figure that you can see this relation.

With your eyes well on the model, the value, tones, shapes which you apprehend in the background are those only which are complementary to the figure.

The shapes, tones and values you will apprehend in the same background will differ with each new subject you place before it.

The characters of each new subject before the background will claim of it their complements.

We are instinctively blind to what is not relative. We are not cameras. We select. We do this always when we are not painting. When you are sitting in conversation with a young girl and are thinking the while how beautiful she is, suddenly stop and ask yourself what has been her background. Surely it was not all those incongruous things that are now leaping into your consciousness from behind her. And surely, too, while you were sitting there and thinking her so beautiful you had created (unconsciously) out of chaos a wonderfully fitting setting which was back of her and around her and fully sufficient to her.

In ordinary life we see backgrounds right—in fact, as they are. When we start painting we are apt to destroy the background by looking at the multitude of things behind the model.

Behind the model there are a multitude of things subject to all sorts of change according to our interest in them. They are the raw material of a background. The background is a creation in our consciousness.

Another way of saying it is to say that the head in space creates its own background. That the background becomes an extension of the head; and that it is all the canvas that is the head—not just that part the material head occupies.

The background of our beautiful girl is a continuation of her. If her beauty is one of great dignity the forms of our background will be in harmony with or will be gracious complements to this dignity seen in her face.

If she is merely *chic,* we will find in the background the echoes and the complements of *chic.*

This will happen even though the material background is precisely the same in each case.

All things change according to the state we are in. Nothing is fixed. I lived once in the top of a house, in a little room, in Paris. I was a student. My place was a romance. It was a mansard room and it had a small square window that looked out over housetops, pink chimney pots. I could see l'Institut, the Pantheon and the Tour Saint Jacques. The tiles of the floor were red and some of them were broken and got out of place. There was a little stove, a wash basin, a pitcher, piles of my studies. Some hung on the wall, others accumulated dust on their backs. My bed was a cot. It was a wonderful place. I cooked two meals and ate dinner outside. I used to keep the camembert out of the window on the mansard roof between meals, and I made fine coffee, and made much of eggs and macaroni. I studied and thought, made compositions, wrote letters home full of hope of some day being an artist.

It was wonderful. But days came when hopes looked black and my art student's paradise was turned into a dirty little room with broken tiles, ashes fell from the stove, it was all hopelessly poor, I was tired of camembert and eggs and macaroni, and there wasn't a shade of significance in those delicate little chimney pots, or the Pantheon, the Institut, or even the Tour Saint Jacques.

The material thing is the least part of a background or an environment. And it should be noted, too, that a background is also an environment, for when you paint a background you are painting all that volume of space which is the setting of your subject. And this fact should never be lost sight of.

The background is more air than it is anything else. It is the place in which the model moves. It is the air he breathes.

The dimensions of a background are of very great importance. The spaces on either side of the head and above the head can do so many things good and bad to the head and the figure that it is remarkable how little attention is generally paid to them. A figure can be dwarfed by its placement, and if there is no sense of distance back of it and on this side of it it will most surely be flattened.

From my point of view the simpler a background is the better the figure in front of it will be, and also I will add, the better the figure is the less the observer will need entertainment in the background.

I am quite sure many a gold chair has been hauled in because the artist has failed to get distinction and richness in the mien of the sitter, and he counts on the chair to supply the deficiency. But a cocked hat won't make a general.

There are backgrounds so well made that you have no consciousness of them.

The simpler a background is the more mastery there must be in it: A full and satisfying result must be accomplished with extremely limited means.

At times secreted in the appearance of a simple tone there is a gamut of color, a shifting across the spectrum which keeps the thing alive, illusive, and creates the mystery of depth.

On the other hand, one tone with the very slightest change will do the thing. In this case the tone is in the finest choice of relation to the dominant color of the figure.

A background is not to be neglected. It is a structural factor. It is as important to the head before it as the pier is important to the bridge it carries. The background is a support of the head.

Many an artist has fussed all day with a face, changing and changing and never getting it right because the fault should have been found in the background which he has neglected.

The background must travel along and keep pace with every advance of the picture. A right eye travels all over the canvas, for it is an organization of the whole that makes any part.

There are echoes everywhere of the feature you are making. A touch on the face may be the causation of a touch on the foot or, on the contrary, may demand its removal.

The eye must be alert; must see the influence of one thing on another and bring all things into relation.

The background as put in in the beginning may have been excellent, but the work that has gone on before it may demand its total reconstruction. Nothing is right until all is done and a total unity has been accomplished.

It is important to stress attention to the background, for it is a most common habit to neglect it.

If there are objects in the background they must not be painted because they are interesting in themselves. Their only right of existence is as complementary or harmonic benefits to the head or the figure. In other words: when you are painting the background or the things in it you are still painting the head. Your eye is still on the head, you see these things of the background in a relative way only.

To paint otherwise is to digress and shift from one subject to another, to paint many pictures in one.

When we delight in a thing in nature all our accounting of its environment is selective.

Seeing beauty in nature is a compositional act. Two people may declare to each other the wonder of a sunset or the loveliness of a woman, but, although they agree, each has made his own selection.

Two painters before a sunset or a woman put down on canvas the order of their seeing, and thus they communicate to each other their separate ways.

In drawing, Rembrandt with a cast shadow or
just a line or two realized for us the most complete
sense of space, that is, background, environment.
He could do this because he saw and he had the
genius of selection. Look at his simplest drawings
and you will see that he was a supreme master in
this.

A weak background is a deadly thing.

Every head claims its own kind of background.

There are backgrounds that should seem only to
be air. It takes some consideration, not only of color
and value, but as well of the way the paint is ap-
plied, and the thickness or thinness of it, to make
such a background.

Many a background has been spoiled simply be-
cause the artist has tried to cover it with an insuffi-
cient amount of paint; because it was a trouble to
paint it all over, because his brush strokes were too
much in evidence, because he thought too little of
it and did not realize the function it had to perform.

The commonest fault is that he determines its
color, its value, and its content by looking at it and
does not realize its marvelous power of change, and
that it is wholly a matter of relation.

¶MARY ROGERS' approach to nature was
purely a spiritual one. Her technique in every in-
stance was evoked by the spirit of the things that
she wished to express.
There are moments in our lives, there are mo-

ments in a day, when we seem to see beyond the usual—become clairvoyant. We reach then into reality. Such are the moments of our greatest happiness. Such are the moments of our greatest wisdom.

It is in the nature of all people to have these experiences; but in our time and under the conditions of our lives, it is only a rare few who are able to continue in the experience and find expression for it.

At such times there is a song going on within us, a song to which we listen. It fills us with surprise. We marvel at it. We would continue to hear it. But few are capable of holding themselves in the state of listening to their own song. Intellectuality steps in and as the song within us is of the utmost sensitiveness, it retires in the presence of the cold, material intellect. It is aristocratic and will not associate itself with the commonplace—and we fall back and become our ordinary selves. Yet we live in the memory of these songs which in moments of intellectual inadvertence have been possible to us. They are the pinnacles of our experience and it is the desire to express these intimate sensations, this song from within, which motivates the masters of all art.

Mary Rogers was one of those who had the simple power to listen to the song and to create under the spell of it. She knew the value of revelation and her spirit had that control over mentality which was the secret of her gift for employing at all times in her work that specific technique evoked by the song. She was master. Her work is a record of her life's great moments.

Her statement is joyous and clear.*

* International Studio, May, 1921.

¶I WANT to see these houses solid, I want them to feel like houses. I don't care about your drawing and your values—they are your affair. They will be good if you make me sense the houses and they will be bad, however "good" they are, if you do not make those houses live.

I want more than the outline of houses and I want more than the frames of windows. It is impossible for me to see only what the eye takes in, for the surfaces are only symbols. The look of a wall or a window is a look into time and space. The wall carries its history, what we see is not of the moment alone.

Windows are symbols. They are openings in. To draw a house is not to see and copy its lines and values, but to use them.

¶AT NOONDAY the landscape is just as fine, just as mysterious and just as significant as it is at twilight.

By one with perception to grasp it there is as little seen of the unessential at noon as the obscurity of night can blot out from the casual observer.

It is true that obscurity may assist selection, may at times force it.

Perhaps we delight in evening because we have had the day.

It is seldom that the appearance of night can be produced by a very black drawing. The beauty of night is not so much in what you cannot see as in what you can see. It is a fine thing, after the brilliant reds and blues and yellows of daylight, to see the close harmony of evening and night. Night can be painted so that it will be beautiful and true with

a palette that does not drop into black but has instead a surprising richness of tone.

¶THERE is nothing in all the world more beautiful or significant of the laws of the universe than the nude human body. In fact it is not only among the artists but among all people that a greater appreciation and respect for the human body should develop. When we respect the nude we will no longer have any shame about it.

¶THE painting of hair. By the hair I mean the head or that part of the head which is under the hair—for in art hair is only important as hair after it has performed another very expressive function. The hair is used to give shape to the head. A beautifully shaped head with poor hair is more important to us than a poorly shaped head and beautiful hair. The hair is used to *draw* the head. Therefore the terms of hair should be very simple as befits the dignity of a well-shaped head. Hair also is a wonderful means of vitalization. That is, by a wise use of hair the spirit of a facial expression, or a whole body expression, may be greatly enhanced. The features of the face have an anatomical responsibility, they must be in their places; hair has a certain irresponsibility. It may of itself do many things. You can make a constructive use of it. It is a great instrument in the hands of a wise draftsman or a wise colorist. Perhaps you recall George Moore's story how an Irish editor, Gill, whose beard was trimmed through the whim of a French barber to the style of Henry IV, developed

a latent character along the line which his new appearance suggested.

Sometimes, is it not better to make a form turn by changing the color value rather than by changing the black and white value? I am not, however, one of those who totally repudiate black and white value in favor of color value. All the means that are possible are ours to use. Under some circumstances a change in black and white value produces the sense of a change in color. The *constant* hatching of new colors is the procedure of one who has become academic, who has a receipt. There are times to hold a note and there are times to change it. Some painters, addicted to the habit, change their notes with the ticking of the clock. It is all a matter of measures of silence, measures of noise, measures of color; some broad, expansive, and others quick and short, lines which move swiftly, fluently, softly, scratch, halt, jump—all kinds of lines for all kinds of purposes. The thing you have in hand is a construction. The means are used in the measures the subject demands. The value of a picture rests in its constructive beauty. Its story, the fact that it is about a man, a boy, a landscape, an event which transpires, is merely incidental to its creation. The real motive, the real thing attained is the revelation of what you can perceive beyond the fact.

In nature it is the delicate yet strong turn of the *whole* neck which occupies us. We merely sense the minor variations of form in the muscles and bones. Sometimes, however, the sterno-clido becomes the dominant interest. In a spirited movement of the head that muscle grips our whole attention because it is a great sign of *will* in the gesture. In such cases the rotundity of the neck—

its sure solidity—must exist, but as a secondary consideration.

The wise draftsman brings forward what he can use most effectively to present his case. His case is his special interest—his special vision. He does not *repeat* nature.

In the sleeve there is an arm, well shaped, shoulder-joint, elbow, wrist-joints, a unified running movement through all; a gesture in perfect harmony with the head. The body is a solid. Like the arm but larger. Paint the drapery to make one know the dignity and the beauty of these shapes in their very largest sense. The collar must go *around* the neck, must tell of its trip around the beautiful form. The collar rests on the fullness of the shoulder and chest. Its function is to define the graciousness and the strength of these. Later it can be a collar, have its own incidental whims, but first of all it must accomplish its greater function. It had better define the human form even if it never gets to the point of being very much of a collar. The arm, even if the drapery looks so, must never become flat. The drapery must speak first of the shape, direction and the beautiful volumes of the arm. Drapery, like hair, is to be *used*—not copied; rhythms, echoes, continuations—not wrinkles for the sake of fact, but these things selected and used for their constructive value only.

When a fine dancer appears before you in a very significant gesture, you are caught only by the folds of her drapery which respond to the great will in her movement. She has established in you a trend of interest. What enters your vision is only the sequences of this established interest. When gamblers play in luck, when they continue to win, seem to

have a knowledge of how the card will turn, they may be said to have fallen in with one of the courses nature takes. They do not know it, but there are sequences and sequences, untold numbers of them overlaying, intermingling. Every movement in nature is orderly, one thing the outcome of another, a matter of constructive, growing force. We live our lives in tune with nature when we are happy, and all our misery is the result of our effort to dictate against nature. In moments of great happiness we seem to be with the universe; when all is wrong we seem to be alone, disjointed. Things are going on without us.

The effect of sensing the gesture of the master dancer, hearing music, seeing the greater works of creative masters, is extension.

The art student of these days is a pioneer. He lives in a decidedly colorless, materialistic age. The human family has not yet come out of the woods. We were more barbarian, we are still barbarians. Sometimes in the past we shot ahead, in certain ways, ahead of where we are now. We gave flashes of what is possible in man. We have yet as a body to come up to the art of living. The art student of today must pioneer beyond the mere matters of fact.

There is nothing in the juggler's skill of copying things. It is a question of seeing significances and apprehending the special forms and colors which will serve as building materials. A good picture is a well-built structure. There is material in the model before you for all kinds of structures. All these structures will be like the model, but beyond likeness there will be a manifestation of something more real, more related to all things, and more unique in itself. Infinite simplicity. A direct purpose and most exacting choice of the terms of expression. I believe

the great artists of the future will use fewer words, copy fewer things, essays will be shorter in words and longer in meaning. There will be a battle against obscurity. Effort will be made to put everything plain, out in the open. By this means we will enter into the real mystery. There will be fewer things said and done, but each thing will be fuller and will receive fuller consideration. Now we waste. There is too much "Art," too much "decoration," too many things are made, too many amusements wasted. Not enough is fully considered.

We must paint only what is important to us, must not respond to outside demands. They do not know what they want, or what we have to give.

I think I have made it apparent that the model as he stands before you, however still he may appear to be, is not static.

During the time of posing he drifts through many moods.

While his body occupies practically the same place there is constant change. A flow runs through his body. The forms reorganize, new dominances occur.

Every emotion has its expression throughout the body. The door opens, someone comes into the room. The look of the eye has its correspondence in every part of the body. The model sinks into reverie, every gesture of the body, externally and internally, records it.

I refer you again to Rembrandt's drawings. In them Rembrandt seems to have drawn states of being. He expressed with the flow of movement through forms which are in response to states of being. Hence the intimate life of his work.

Solidity:

¶IF I hold any object up in front of you, you have a very positive sense of its solidity. Your estimate of it as a matter of bulk is, most likely, very exact. You have also a very fair judgment of its weight. You know about how far it is from your eyes and about how far it is from the background, and from any other objects in its vicinity.

If the object happens to be a human head you are highly sensitive to its progressions and regressions of form. Knowing heads so familiarly, you immediately remark any absences of the normal in its shape. If a head were only half thick through you would know it and you would be shocked by it. If it were flat it would horrify you. We are very appreciative of the solid. Yet, most paintings and most drawings produce the appearance of flatness. Backgrounds often crowd forward and take their places on the same plane with the head, and an ear will not stay back on the side of the head, but contests with the nose for first-plane prominence. Distances across the canvas are generally very nearly correct, but distances *in*, following the line of vision, hardly exist. It is a question to solve. The old sentimental idea that an artist does not use his brains prohibits an investigation, and as this old sentimental idea still holds great sway there are as yet only a comparative few who risk falling from the clouds by setting to work that dangerous and earth-earthy machine, the brain.

I have heard it very often said that an artist does not need intelligence, that his is the province of the

soul. All very lovely, but heads painted by such artists are generally very flat and a great medium of expression is lost to them. They recognize and make much of the measures across their flat surfaces, but miss all the wonder of depth. If flat across the canvas there are to be found beautiful compositional measures, then deep in there are other measures, more mysterious and meaningful, and which complement the flat measures and make even these more beautiful.

If a man has the soul of an artist he needs a mastery of all the means of expression so that he may command them, for with his soul in activity he has much to say. If he refuses to use his brain to find the way to signify the meaningful depth of nature on his flat canvas with his colors, he should also refuse to use his hands and his brushes and his colors, and the canvas itself. However, all these, the canvas, paints, brushes, hands and brains are but tools to be guided by the soul of man. The brain can prove to be a wonderful tool, can be a willing slave, as has been evidenced by some men, but of course it works poorly when it has not the habit of usage. An automobile can become a source of delight, but the first time you drive you are as apt to go up a tree as to go up the road.

It seems absurd that one should argue the use of the brain in art or anything else, but absurd as it seems, there are yet excellent grounds for continuing the argument. Every day I am meeting some one who regards the advent of Jay Hambidge or Denman Ross, or Maratta or any student of the laws of nature in construction, as dangerous to our art. Indeed they are dangerous to art as it is today, for what they propose is that there should also be some common horse-sense along with a strengthen-

ing of the soul, and this may result in a considerable change. The whole fact is that art and science are so close akin that they might very well be lumped together. They are certainly necessary to each other and the delights of either pursuit should satisfy any man. I am naturally not speaking of commercial science or commercial art in saying this.

Well, suppose we use our brains. We see things solid. Solidities are important to us in nature. In solidities there are measures that greatly affect us. There are rhythms in the ins and outs of form. Music, the freest and to many the most impressive of arts deals in measures which seem to go in every direction. They combine, they move together, they deflect and they oppose. Music is a structure of highly mathematical measures. According to the selection and relative value of these measures the music is great or small in its effect on us.

The mind is a tool, it is either clogged, bound, rusty, or it is a clear way to and from the soul. An artist should not be afraid of his tools. He should not be afraid to know.

If the painting appears flat, if only the crosswise measures are of value, if the measures *in* are non-expressive, then it is time to investigate; to use the mind, to experiment, to find a way, with flat paint on a flat canvas, to use this third dimension so that the mysterious fourth may be sighted.

I am certain that we do deal in an unconscious way with another dimension than the well-known three. It does not matter much to me now if it is the fourth dimension or what its number is, but I know that deep in us there is always a grasp of proportions which exist over and through the obvious three, and it is by this power of super-proportioning that we reach the inner meaning of things.

A piece of sculpture, a painting or the gesture of a hand may have all the simple measurements, but the artist may have so handled these as to make us apprehend quite others. The Sphinx is a demonstration of this. The great Greek and Chinese art and in fact art everywhere and at all times has to greater or less degree demonstrated this. Everywhere there are glimmers of it in all art, in all expression. Isadora Duncan, who is perhaps one of the greatest masters of gesture the world has ever seen, carries us through a universe in a single movement of her body. Her hand alone held aloft becomes a shape of infinite significance. Yet her gesture in fact can only be the stretch of arm or the stride of a normal human body.

What measures are apprehended in the glance of an eye?

If then our pictures are flat and lacking in the approach to significant dimensions, would it not be well to investigate our means? First, there must be the will for it. The absolute need for solidity must be felt before solidity can be attained.

Painters, through thought and study and association with their brothers, the scientists, have learned the power of color values in form modeling, and they have added this power to black and white values. If you look at a Sung period drawing you will see that the Chinese master has effected a tremendous solidity in the use of a line.

If you want to know how to do a thing you must first have a complete desire to do that thing. Then go to kindred spirits—others who have wanted to do that thing—and study their ways and means, learn from their successes and failures and add your quota. Thus you may acquire from the experience of the race. And with this technical knowledge you may go forward, expressing through the play of

forms the music that is in you and which is very personal to you.

Receipts are for slaves.

¶I LOVE the tools made for mechanics. I stop at the windows of hardware stores. If I could only find an excuse to buy many more of them than I have already bought on the mere pretense that I might have use for them! They are so beautiful, so simple and plain and straight to their meaning. There is no "Art" about them, they have not been *made* beautiful, they *are* beautiful.

Some one has defined a work of art as a "thing beautifully done." I like it better if we cut away the adverb and preserve the word "done," and let it stand alone in its fullest meaning. Things are not done beautifully. The beauty is an integral part of their being done.

¶AS BUSY as a real boy is busy, I do not know why he is leaning over there, but I enjoy him and I understand his eager interest in what he is doing.

A tree growing out of the ground is as wonderful today as it ever was. It does not need to adopt new and startling methods.

Color:

¶THE possibilities of color are wonderful. A study entrancingly interesting and unlimited. It is

a wise student who has a perfectly clean, well-kept palette—glass over a warm white paper on a good-sized table, always clean—and uses such a palette to make continual essays with color—thousands of little notes, color combinations, juxtapositions of all the possible intensities of a well-selected spectrum palette. Many artists just paint along, repeat over and over again the same phrases, little knowing the resources of the materials before them, and in many cases simply deadening their natural sense of color instead of developing it.

The backgrounds that are dark are very difficult to paint. That is, to make them seem like fine, breathable air. Of course it is easy to get away with a dark background, and it by its nature cannot be crude, but it can be heavy, snuffy, black.

The effect of brilliancy is to be obtained principally from the oppositions of cool colors with warm colors, and the oppositions of grave colors with bright colors. If all the colors are bright there is no brightness.

However much you may use "broken color," hold on to the few simple larger masses of your composition, and value as most important the beauty and design of these larger masses, or forms, or movements. Do not let beauty in the subdivisions destroy the beauty or the power of the major divisions.

Whatever you feel or think, your exact state at the exact moment of your brush touching the canvas is in some way registered in that stroke. If there is interesting or reasonable sequence in your thoughts and feelings, if there is order in your progressive states of being as the paint is applied, this will show, and nothing in the world can help it from showing.

There is a super color which envelops all the colors. It is this super color—this color of the whole, which is most important.

Dirty brushes and a sloppy palette have dictated the color-tone and key of many a painting. The painter abdicates and the palette becomes master.

Employ such colors as produce immensity in a small space. Do not be interested in light for light's sake or in color for color's sake, but in each as a medium of expression.

There is a color over all colors which unites them and which is more important than the individual colors. At sunset the sun glows. The color of the grasses, figures and houses may be lighter or darker or different, but over each there is the sunset glow.

A human body bathed in the color of the atmosphere surrounding it, luminous and warm in its own color.

The color of a background is not as it is, but as it appears when the artist is most deeply engaged with the figure in front of it. It is not seen with a direct eye.

If you look past the model at the background it responds to your appeal and comes forward. It is no longer a background.

Get a right height of chair and sit at your painting table. Take as true a Red, Yellow and Blue as you can choose. Mix neighbor with neighbor until you have three new notes, Orange, Green, Purple. Set all six in a line and mix neighbor with neighbor

until you have six more---RO. OY. YG. GB. BP.
PR. You have now before you a homogeneous
palette, analogous to the spectrum band. They are
PR. R. RO. O. OY. Y. YG. G. GB. B. BP. P.

This is a first step taken in the direction of an
acquaintance with the possibilities of pigment
colors.

You can make hundreds of experiments on the
glass of your palette the memories of which will
sink into you to come into service in cases of actual
need when at the work of painting.

The studies H. G. Maratta has made in the
formation of palettes and generally in the science of
color are of a decided educational value. Many of
us have benefited greatly through his work. He told
me many years ago that his first intention was to
write a book, but decided, upon consideration, that
a practical demonstration with colors instead of the
names of colors would be better. So he made the
colors and they were his book. Many artists bought
his colors and opened the box thinking the magic of
picture-painting would jump out. Others bought
them knowing that they would have to dig, and
they dug. It was mighty well worth while.

The works of such men are available to the stu-
dent and the wise student will be keen to know
what is going on in the world.

Such works are really gifts, for the making of
them represents much study and is certainly not a
commercial proceeding.

If you have not read, and studied, for here again
you must dig, the works of Denman Ross, get them

by all means, for you must want to get the wisdom and the practical advice they contain, and what they suggest.

Understand that in no work will you find the final word, nor will you find a receipt that will just fit you. The fun of living is that we have to make ourselves, after all.

It is a splendid thing to live in the environment of great students. To have them about you in person if you can. If not in person, in their works. To live with them. Great students agree and disagree. They stir the waters.

Many things that come into the world are not looked into. The individual says "My crowd doesn't run that way." I say, don't run with crowds.

I suggest many other books. There are many theories on color. Look them up. Get acquainted. There may be something you want to know.

Personal experimentation is revealing, and, once you get into it, immensely engaging.

Remember that pigment is one thing and light is another. A palette is set in accord with the spectrum band. But combinations of light and combinations of pigments produce differing results.

Signac's book *Néo-Impressionnisme* is a book that should interest any student. It is a pity it has not been translated into English. But if you know French it will be good to read. It is an argument in favor of the total division of color in painting, but

that does not matter. In making his argument he tells in a simple way many valuable things.

I think the true Yellow is rather more green than the yellow generally accepted as "true." I am speaking of paint and I am thinking of the functioning power of the pigment.

Black is always thought of as a neutralizer of color. It should be better remembered that white is also a neutralizer of color, except perhaps in its effect on a very deep blue, blue purple, purple or purple red, so deep that their color cannot be appreciated. In such cases the neutralizing white has a reverse effect when only a slight quantity is added. It serves to bring the color up out of the depths. Except for this service white is a neutralizer.

In the painting of light, in modeling form, keep as deep down in color as you can. It is color that makes the sensation of light. Play from warm to cold, not from white to black.

The tendency to put in more and more white is so usual that it would be well to restrict the white. Keep it off the palette. Allow only so much of it in the pigments which must have it, and allow them much less than you think they should have.

A set palette may look quite impossible for its want of white in comparison with the subject before you. It certainly is, any paint is, if you expect to *reproduce* the thing in nature. But your work is not, and cannot be, a reproduction. Nature has its laws. Your pigments and your flat canvas have other laws. You must work within the laws of your material.

Your palette may look impossible but it may be that by adding more white you will make it more impossible. The pictures that produce the sensation of light and form are really deep in color. Try something white against them. The pictures which are overcharged with white paint look whiter but they do not have the look of light.

Form can be modeled in black and white, but there are infinitely greater possibilities in modeling through the warmth and coolness of color.

There are three methods. The first is black and white modeling. This was largely practiced by the old masters who relieved themselves of a double difficulty by building their pictures up in monochrome and later applying glazes of transparent color. Form was almost wholly dependent on the monochrome substructure.

The second method is color modeling to the exclusion of black and white monochrome. Many have professed this method, but few have practiced it.

The third method is the union of the first and second. In this method there is a recognition of advantages to be derived from both, requiring a wise proportioning and selection in order that the two methods may amalgamate in such a way as to strengthen each.

For the motives of the old masters their choice of technique was undoubtedly well made. Their works evidence it.

For our time other choices may be necessary, for we are different. We may be better or worse in being different, but so we are, and our methods must be suited to our needs.

As an example let us take a hand. With a great

old master the hand becomes a symbol. He made the symbol by making a hand magnificent, monumental, but of such a material definiteness that it is photographically perfect.

The hand made by a true modern will not lend itself so readily to the black and white reproduction. It is made with different agents because it is conceived in a new way.

What the modern man finds of interest in life is not precisely the same as of old, and he makes a new approach, deals in another way because the symbol to be made is not the same.

The old method, great as it was, required a mode of procedure which I believe is rarely practical in these days. It meant a building up in black and white, the design finished in this medium. Then weeks of drying. Then a return to the subject and the color applied. It was a cool and calmly calculated procedure.

It seems to me that the present day man, with all his reverence for the old master, is interested in seizing other qualities, far more fleeting. He must be cool and he must calculate, but his work must be quick.

All his science and all his powers of invention must be brought into practice to capture the vision of an illusive moment. It is as though he were in pursuit of something more real which he knows but has not as yet fully realized, which appears, permits a thrilling appreciation, and is gone in the instant.

At any rate the best things in the best pictures of these days are not seizable by the old methods, nor do they seem to come through the agents that symbolize for the men of the past.

In speaking this way I do not mean by my "modern man" anyone who is in or out of the "modernist school" or in or out of any school. I

mean the modern man whoever or wherever he may be. Nor am I speaking of the generality of work as it appears in our exhibitions. I am speaking of something of which we have a glimmer, sometimes very faint, here and there.

For the same reason that I have indicated my preference for the employment of both methods in the matter of color values and black and white values, I prefer the use of pure colors together with grave colors.

There are artists who declare with almost a religious fervor that they only use "pure colors." But generally in seeing their pictures I find that they have more or less degraded these colors in practice.

I believe that great pictures can be painted with the use of most pure colors, and that these colors can be so transformed to our vision that they will seem to have gradations which do not actually exist in them. This will be brought about by a science of juxtaposition and an employment of areas that will be extraordinary.

But even so, there is a power in the palette which is composed of both pure and grave colors that makes it wonderfully practical and which presents possibilities unique to itself.

In paintings made with such a palette, if used with great success, we find an astounding result. It is the grave colors, which were so dull on the palette that become the living colors in the picture. The brilliant colors are their foil. The brilliant colors remain more in their actual character of bright paint, are rather static, and it is the grave colors, affected by juxtaposition, which undergo the transformation that warrants my use of the word "living." They seem to move—rise and

fall in their intensity, are in perpetual motion—at least, so affect the eye. They are not fixed. They are indefinable and mysterious.

In experimentation I have seen an arrangement of a bright color and a very mud-like neutral pigment present the phenomenon of a transference of brilliancy—the neutral presenting for a moment a sizzling complementary brilliance far overpowering the "pure color" with which it was associated.

On a picture, because there are many conflicting associations, such an extreme occurrence could not be possible, but the fact exists and the impression is made on our keener consciousness.

If new colors were made far more brilliant than the present "pure" colors; then the present colors would fall into the rank of neutrals, and when juxtaposed with their superiors, which would be more or less static, the same change might be effected in them.

It would be their turn to make this thing happen in the eye of the observer. For it is an effect on the sensitive eye and a consequent stirring of the imagination which produces the illusion.

The fact is that a picture in any way, in color, form, or in its whole ensemble but sends out agents that stimulate a creation which takes place in the consciousness of the observer.

That is the reason association with works of art is enjoyable.

It is also the reason they tire some and irritate others.

Generally in pictures which give the illusion of fine color and form we find one, less often two,

areas made up of pure color. This, or these notes are possibly the most obvious and striking notes, but it may be found that however beautiful they are in themselves they are only foils to the mysterious tones they serve to complement. It is these ever-changing mysterious tones which keep up the interest in the picture.

Have you not seen many pictures that bowled you over at first sight, staggered you on the next, and did not stir you thereafter?

Artists have been looking at Rembrandt's drawings for three hundred years. Thousands and thousands of remarkable drawings have been made since, but we are not yet done looking at Rembrandts. There is a life stirring in them.

If it is possible that there are "mysterious" colors in a picture it is also possible that there are "mysterious" lines and forms.

The picture that bowls you over at first sight and the next day loses even the power to attract your attention is one that looks always the same. It has a moment of life but dies immediately thereafter.

¶ALL manifestations of art are but landmarks in the progress of the human spirit toward a thing but as yet sensed and far from being possessed.

The man who has honesty, integrity, the love of inquiry, the desire to see beyond, is ready to appreciate good art. He needs no one to give him an art education; he is already qualified. He needs but to see pictures with his active mind, look into them for the things that belong to him, and he will find soon enough in himself an art connoisseur and an art lover of the first order.

Do not expect the pictures to say the expected; some of the best will have surprises for you, which will, at first, shock you. There are many surprises to come to the most knowing, just as Wagner opened new roads in music and disturbed to distraction those who believed no further roads were possible.

There will be new ideas in painting and each new idea will have a new technique.

¶ART is the inevitable consequence of growth and is the manifestation of the principles of its origin. The work of art is a result; is the output of a progress in development and stands as a record and marks the degree of development. It is not an end in itself, but the work indicates the course taken and the progress made. The work is not a finality. It promises more, and from it projection can be made. It is the impress of those who live in full play of their faculties. The individual passes, living his life, and the things he touches receive his kind of impress, and they afterwards bear the trace of his passing. They give evidence of the quality of his growth. The impress is made sometimes in material form, as in sculpture or painting, and sometimes in ways more fluid, dispersed, but none the less permanent and none the less revealing of the principles of growth.

Art appears in many forms. To some degree every human being is an artist, dependent on the quality of his growth. Art need not be intended. It comes inevitably as the tree from the root, the branch from the trunk, the blossom from the twig. None of these forget the present in looking backward or forward. They are occupied wholly with the fulfillment of their own existence. The branch does not

boast of the relation it bears to its great ancestor the trunk, and does not claim attention to itself for this honor, nor does it call your attention to the magnificent red apple it is about to bear. Because it is engaged in the full play of its own existence, because it is full in its own growth, its fruit is inevitable.

The Brush Stroke:

¶THE mere matter of putting on paint.

The power of a brush stroke.

There is a certain kind of brush stroke that is both bold and bad.

There are timid, halting brush strokes.

Strokes that started bravely but don't know where to go. Sometimes they bump into and spoil something else, or they may just wander about, or fade into doubtfulness.

There are strokes in the background which come up against the head and turn to get out of the way.

Strokes which look like brush strokes and bring us back to paint.

There are other strokes which inspire a sense of vigor, direction, speed, fullness and all the varying sensations an artist may wish to express.

The mere brush stroke itself must speak. It counts whether you will or not. It is meaningful or it is empty. It is on the canvas and it tells its tale. It is showy, shallow, mean, meagre, selfish, has the skimp of a miser; is rich, full, generous, alive and knows what is going on.

When the brush stroke is visible on the canvas it has a size, covers a certain area, has its own texture. Its tiny but very expressive ridges catch light in their own way. It has its speed and its direction. There is a lot it has of itself, and the strokes tell their tale in harmony with or in opposition to the motive of the picture.

On account of the shiny character of paint it is necessary to adhere to a general movement in brush direction to avoid a stroke which will shine even though the picture hangs in its proper light.

It sometimes happens that drawing dictates a sweep in a certain direction while to avoid the "shine" the opposite direction must be taken. Here is where one's ingenuity and skill is brought into play. It is like walking well walking backward. It's a feat one has to accomplish.

We often hear, "If somebody would only invent an oil paint that would not shine!" Few want to give up *oil* paint, but all have distressing moments over the technical avoidances of a destroying shine.

Sometimes the stroke may be made in the direction *drawing* dictates, and the shine can be killed by a very delicate and skillful blending stroke with a clean brush; thus breaking down the light-catching ridges of the original strokes. This is difficult to accomplish without a resultant weakening or softening of the original stroke.

Sometimes this blending or flattening stroke can be made at once. Other times better to do it later when the paint is more set.

In this latter case where the shine is not removed at once the artist will be bothered by the falseness of the note, due to the presence of the reflected light, and he will be much troubled, for he must consider it as it is to appear when flattened, not as it is with the shine on it, and he must work accordingly.

There are few outsiders who have any dream of the difficulties an artist has to meet in the mere putting on of his paint.

There are strokes which depress whole canvases with a down-grade movement and a down-grade feeling as a result.

Some backgrounds which should give a rising sense seep downward with thin paint and strokes which seem to be weeping.

There are the attenuated strokes.

Strokes which seem to stretch the paint in an effort to make it cover.

Miserly strokes.

There are rich, fluent, abundant strokes.

Strokes that come from brushes which seem full charged, as though they were filled to the hilt and had plenty to give.

Strokes which mount, carry up, rise.
See Greco's pictures.

Strokes which are placid.
An evening scene by Hiroshigi.
The horizontal.

The stroke of the eyebrow as it rises in surprise.

A stroke in the ear which connects with the activities of the other features.

A stroke which gives the indolence, voluptuousness, caress, fullness, illusiveness, vital energy, vigor, rest and flow of hair.

Strokes which end too soon.

Dull strokes and confused strokes on youthful, spirited faces.

The stroke of highlight in the eye. Much meaning in whether it is horizontal, pointing up, pointing down, or high or low on the pupil.

Bad strokes which are bad because a brush or condition of paint was chosen which could not render them.

For things which require a greater steadiness of hand than you can command, use a maul stick.

Strokes carry a message whether you will it or not. The stroke is just like the artist at the time he makes it. All the certainties, all the uncertainties, all the bigness of his spirit and all the littlenesses are in it.

Look at the stroke of a Chinese master. Sung period.

There are strokes which comprehend a shape.

There are strokes which are doubtful of shape.

The stroke which marks the path of a rocket into the sky may be only a few inches long, but the spirit of the artist has traveled a thousand feet at the moment he made that stroke.

There are whole canvases that are but a multitude of parsimonious, mean little touches.

There are strokes which laugh, and there are strokes which bind laughter, which freeze the face into a set immovable grimace.

Strokes which carry the observer with exact degrees of speed.

Strokes which increase their speed, or decrease it.

Strokes with one sharp defining edge carrying on its other side its complement, soft, merging.

It is wonderful how much steadiness can be commanded by will, by intense desire.

Use a maul stick—use anything when you *have* to.
Don't use them except when you have to.

If possible, transmit through your free body and hand.

Whatever feeling, whatever state you have at the time of the stroke will register in the stroke.

Many a canvas carries on its face the artist's thought of the cost of paint. And many a picture has fallen short of its original intention by the obtrusion of this idea.

It is not necessarily the poor who think of the cost of paint. Many an artist has starved his stomach and remained a spendthrift in paint.

The reverse is also true.

Strokes with too much or too little medium.

The stroke in itself; in its own texture, that is, the texture it has of itself apart from the texture it is intended to reproduce, is a thing on the canvas, is an idea in itself, and it must correlate with the ideas of the picture.

The stroke may make or it may destroy the integrity of the forms.

There is a fine substance to flesh. "Just any kind" of a stroke won't render it.

A brush may be charged with more than one color and the single stroke may render a complete form in very wonderful variation and blend of color. Not easy by any means and often abused.

There are good reasons for all the varying shapes, sizes, lengths, and general details of brushes. Some artists have special brushes made for special pur-

poses and sometimes they modify brushes, and all who are wise take wonderful care of their brushes.

Varnish will somewhat lessen the shine of brush marks, because it fills the interstices and flattens the surface. But varnish has its drawbacks, and just enough and no more than enough to lock up the picture should be the limit of its use.

Every student should acquaint himself with the qualities and uses of varnish by reading and comparing the books which deal specifically with the chemistry of painting.

The sweep of a brush should be so skilled that it will make the background behind a head seem to pass behind the head—not up to it—and make one know that there is atmosphere all around it.

The stroke that gives the spring of an eyelid or the flare of a nostril is wonderful because of its simplicity and certainty of intention.

There are brittle and scratchy strokes, lazy, maudlin, fatly made and phlegmatic strokes.

One of the worst is the miserly stroke.

Get the full swing of your body into the stroke.

Painting should be done from the floor up, not from the seat of a comfortable chair.

Have both hands free. One for the brush and the other for reserve brushes and a rag.

Rag is just as essential as anything else. Choose it well and have plenty of it in stock, cut to the right size.

In having the best use of your two hands the thumb palette is eliminated. Have a table, glass top, white or buff paper under the glass. Have a brush cleaner. Make it yourself. The things sold in shops are toys.

Get the habit of cleaning your brush constantly as you work. The rag to wipe it. Thus the brush can hold the kind of paint you need for the stroke.

Great results are attained by the pressure, force or delicacy with which the stroke is made.

The choice of brushes is a personal affair to be determined by experience.

Too many brushes, or too many sorts of brushes cause confusion. Have a broad stock, but don't use them all at once.

It is remarkable how many functions one brush can perform.

Use not too many, but use enough.

Some painters use their fingers. Look out for poison. Some pigments are dangerous—any lead white, for instance.

Silk runs, is fluent, has speed, almost screams at times.

Cloth is slower, thicker, the stroke is slower, heavier.

Velvet is rich, caressing, its depths are mysterious, obscure. The stroke loses itself, not a sign of it is visible. So also the shadows in hair.

Strokes which move in unison, rhythms, continuities throughout the work; that interplay, that slightly or fully complement each other.
See pictures by Renoir.

Effects of perspective are made or defeated by sizes of strokes, or by their tonalities.

There are brush handlings which declare more about the painter than he declares about his subject. Such as say plainly: "See what vigor I have. Bang!" "Am I not graceful?" "See how painfully serious I am!" "I'm a devil of a dashing painter—watch this!"

Velasquez and Franz Hals made a dozen strokes reveal more than most other painters could accomplish in a thousand.

Compare a painting by Ingres with one by Manet and note the difference of stroke in these two very different men. The stroke is like the man. I prefer Manet of the two. But that is a personal matter. Both were very great artists.

Compare the paintings if they are within your reach, if not compare reproductions. Compare also Ingres' drawings with those of Rembrandt.

Manet's stroke was ample, full, and flowed with a gracious continuity, was never flip or clever. His "Olympia" has a supreme elegance.

Icy, cold, hard, brittle, timid, fearsome, apologetic, pale, negative, vulgar, lazy, common, puritanical, smart, evasive, glib, to add to the list and repeat a few. Strokes of the brush may be divided into many families with many members in each family. A big field to draw from and an abundant series of complements and harmonies among them; to use as units in the stress and strain of picture construction. Perhaps there is not a brush mark made that would not be beautiful if in its proper place, and it is the artist's business to find the stroke that is needed in the place. When it is in its proper place, even though it bore one of the hateful names I have given some of them, it is transformed, and it has become gracious or strong and must be renamed.

¶THE picture that looks as if it were done without an effort may have been a perfect battlefield in its making.

A thing is beautiful when it is strong in its kind.

What beautiful designs a fruit vendor makes with his piles of oranges and apples. He takes much trouble and I am sure has great pleasure in arranging them so that you can see them at their best.

A millionaire will own wonderful pictures and hang them in a light where you can't half see them. Some are even proud of the report, "Why, he has Corots in the kitchen—Daubignys in the cellar!"

If it is up to the artist to make the best pictures he can possibly make, it is up to the owners to present them to the very best advantage.

The good things grow better. There is always a new surprise each time you see them.

The man who has something very definite to say and tries to force the medium to say it will learn how to draw.

¶ORIGINALITY: Don't worry about your originality. You could not get rid of it even if you wanted to. It will stick to you and show you up for better or worse in spite of all you or anyone else can do.

An address to the students of the School of Design for Women, Philadelphia. Written in 1901

¶THE real study of an art student is generally missed in the pursuit of a copying technique.

I knew men who were students at the Academie Julian in Paris, where I studied in 1888, thirteen years ago. I visited the Academie this year (1901) and found some of the same students still there, repeating the same exercises, and doing work *nearly* as good as they did thirteen years ago.

At almost any time in these thirteen years they have had technical ability enough to produce masterpieces. Many of them are more facile in their trade of copying the model, and they make fewer mistakes and imperfections of literal drawing and proportion than do some of the greatest masters of art.

These students have become masters of the trade

of drawing, as some others have become masters of
their grammars. And like so many of the latter,
brilliant jugglers of words, having nothing worth
while to say, they remain little else than clever
jugglers of the brush.

The real study of an art student is more a de-
velopment of that sensitive nature and appreciative
imagination with which he was so fully endowed
when a child, and which, unfortunately in almost
all cases, the contact with the grown-ups shames
out of him before he has passed into what is under-
stood as real life.

Persons and things are whatever we imagine
them to be.

We have little interest in the material person or
the material thing. All our valuation of them is
based on the sensations their presence and existence
arouse in us.

And when we study the subject of our pleasure
it is to select and seize the salient characteristics
which have been the cause of our emotion.

Thus two individuals looking at the same objects
may both exclaim "Beautiful!"—both be right, and
yet each have a different sensation—each seeing
different characteristics as the salient ones, accord-
ing to the prejudice of their sensations.

Beauty is no material thing.

Beauty cannot be copied.

Beauty is the sensation of pleasure on the mind
of the seer.

No *thing* is beautiful. But all things await the
sensitive and imaginative mind that may be aroused
to pleasurable emotion at sight of them. This is
beauty.

The art student that should be, and is so rare, is
the one whose life is spent in the love and the
culture of his personal sensations, the cherishing of

his emotions, never undervaluing them, the pleasure of exclaiming them to others, and an eager search for their clearest expression. He never studies drawing because it will come in useful later when he is an artist. He has not time for that. He is an artist in the beginning and is busy finding the lines and forms to express the pleasures and emotions with which nature has already charged him.

No knowledge is so easily found as when it is needed.

Teachers have too long stood in the way; have said: "Go slowly—you want to be an artist before you've learned to draw!"

Oh! those long and dreary years of learning to draw! How can a student after the drudgery of it, look at a man or an antique statue with any other emotion than a plumbob estimate of how many lengths of head he has.

One's early fancy of man and things must not be forgot. One's appreciation of them is too much sullied by coldly calculating and dissecting them. One's fancy must not be put aside, but the excitement and the development of it must be continued through the work. From the antique cast there should be no work done if it is not to translate your impression of the beauty the sculptor has expressed. To go before the cast or the living model without having them suggest to you a theme, and to sit there and draw without a theme for hours, is to begin the hardening of your sensibilities to them— the loss of your power to take pleasure in them. What you must express in your drawing is not "what model you had," but "what were your sensations," and you select from what is visual of the model the traits that best express you.

In drawing from the cast the work may be easier. The cast always remains the same—the student has

but to guard against his own digressions. The living model is never the same. He is only consistent to one mental state during the moment of its duration. He is always changing. The picture which takes hours—possibly months—must not follow him. It must remain in the one chosen moment, in the attitude which was the result of the sensation of that moment. Most students wade through a week of changings both of the subject and their own views of it. The real student has remained with the idea which was the commencement. He has simply used the model as the indifferent manikin of what the model was. Or, should he have given up the first idea, it was then to take on another, having destroyed the work which was the expression of the former.

The habit of digression—lack of continued interest—want of fixed purpose, is an almost general failing. It is too easy to drift and the habit of letting oneself drift begets drifting. The power of concentration is rare and must be sought and cultivated, and prolonged work on one subject must not be mistaken for concentration. Prolonged work on one subject may be simply prolonged digression, which is a useless effort, as it is to no end.

Your model can be little more than an indifferent manikin of herself. Her presence can but recall to you the self she was when she so inspired you. She can but mislead if you follow her. You need great time to paint your picture. It took her a moment, a glance, a movement, to inspire it. She may never be just as she was again. She changes momentarily. As she poses she may be in the anguish of fatigue. Who can stand all those hours, detained from their natural pursuits without being bored? At least there is a drifting of the mind, pleasant, gay, sad, trivial —and, imperceptibly the forms and the attitude

change to the expression of the thought, and it gets into the brush of the careless artist and it comes out in the paint.

Few paintings express one idea. They are generally drifting composites wandering through the poses of many frames of mind of the sitter, and the easy driftings of the view of the artist. They present the subject, but the parts are as seen under different emotions, and their only excuse is that they are so wonderfully well done.

Why do we love the sea? It is because it has some potent power to make us think things we like to think.

A "still life" in great art is a *living thing*. The objects are painted for what they suggest, and their presentation has no excuse if it is not to carry to the mind of the observer the fancy they aroused in the artist. If they do not do this and are but simply wonderfully well copied, then there is no communication between the artist and the observer, and the latter gets no more than he would if he were to see the same things in nature. Chardin was a great painter of still life.

When a student comes before his model his first question should be: "What is my highest pleasure in this?" and then, "Why?" All the greatest masters have asked these questions—not literally—not consciously, perhaps. And with them this highest pleasure has grown until with their great imaginations, they have come to something like a just appreciation of the most important element of their subject, having eliminated its lesser qualities. With their prejudice for its greater meaning, their eyes take note only of the lines and forms which seem to be the manifestation of that greater meaning.

This is selection. And the result is extract.

The great artist has not reproduced nature, but has expressed by his extract the most choice sensation it has made upon him.

A teacher should be an encourager.

An artist must have imagination.

An artist who does not use his imagination is a mechanic.

No material thing is beautiful.

All is as beautiful as we think it.

There is a saying that "love is blind"—perhaps the young man is the only one who appreciates her.

There are many artists who cast upon the floor and trample under foot their very best production simply because it was done hurriedly under the inspiration of an idea; the work has expressed the idea, but remains otherwise incomplete, "unfinished" they say, and then they save and frame and put under glass a work that is but a clever composite of a series of incomplete ideas, seemingly finished. The latter has taken time, work, study, looks knowing, shows erudition. There has been no shirking. They call it serious—and serious it is.

The other is but a butterfly of the imagination. However, butterflies are beautiful.

Such a proposition as this should not send art students off to the making of hasty dashes at ideas and end in reducing art to a scribble or two, for there is a check to that in the works of most of the masters. There are the old Dutch, whose butterflies lived through the most completed development, as well as those of such as Whistler, which may have been done with the least amount of detail. All are complete. Each beautiful in its kind.

An art student should read, or talk a great deal with those who have read. His conversations with his intimate fellow-students should be more of his life and less of paint.

He should be careful of the influence of those with whom he consorts, and he runs a great risk in becoming a member of a large society, for large bodies tend toward the leveling of individuality to a common consent, the forming and the adherence to a creed. And a member must be ever in unnecessary broil or pretend agreement which he cannot permit himself to do, for it is his principle as an art student to have and to defend his personal impressions. Somebody, I think it was Corot, said that art is "nature as seen through a temperament."

There are, however, societies of a very few—little cliques which form by sympathy and which believe in and sustain the independence of their members, and which live by the variety of individualities expressed. Such was that coterie of which Manet, Degas, Monet, Whistler and others of special distinction were the outcome. Rossetti, Burne-Jones, the pre-Raphaelites, formed another. Many are the little congresses among the students in Paris made up of men from all countries, who draw together through similar sympathy.

The reproduction of things is but the idle industry of one who does not value his sensations, and who was done with his imaginings when he passed out of childhood and consented that the prancing horse he had bestrode in those happy days had only been a broken broomstick.

Old Walt Whitman, to his last days, was as a child in the gentleness and the fullness of his fancy. A few flowers on his window-sill were enough to arouse in him the pleasantest sensations and the most prophetic philosophy.

Walt Whitman was such as I have proposed the real art student should be. His work is an autobiography—not of haps and mishaps, but of his deepest thought, his life indeed.

No greater treasure can be given us. Confessions like those of Rousseau or those of Marie Bashkirtseff are thin in comparison with this life expressed by Whitman, which is so beautiful, in the reading of which we find ourselves.

Whitman died a few years ago, but Whitman lives on in his work, which is his life, and which will expand and be greater the more it is known. Like Shakespeare, who met so few in his fifty odd years, and knew us all so well down to this day. Think of the brilliant writers whose touches on the hearts of their publics have not lasted out even their own lifetimes.

Permit me to quote these lines of Walt Whitman's, written of his own work:—

" 'Leaves of Grass,' indeed (I cannot too often reiterate) has mainly been the outcropping of my own emotional and other personal nature—an attempt from first to last, to put a person, a human being (myself, in the latter half of the nineteenth century, in America) freely, fully and truly on record. I could not find any similar personal record in current literature that satisfied me. But it is not on 'Leaves of Grass' distinctively as literature, or a specimen thereof, that I feel to dwell or advance claims. No one will get at my verses who insists upon viewing them as a literary performance, or attempt at such performance, or as aiming mainly towards art or æstheticism," and then close at hand he quotes from another. A picture of unknown authorship is the subject. "Rubens, asked by a pupil to name the school to which the picture belongs, replies, 'I do not believe the artist, unknown and perhaps no longer living who has given the world this legacy, ever belonged to any school or ever painted anything but this one picture, which is a personal affair—a piece out of a man's life.' "

And he quotes from Taine:—

" 'All original art is self-regulated; and no original art can be regulated from without. It carries its own counterpoise and does not receive it from elsewhere —lives on its own blood.' "

One of the great difficulties of an art student is to decide between his own natural impressions and what he thinks should be his impressions. When the majority of students and the majority of so-called arrived artists go out into landscape, saying they intend to look for a "motive," they too often mean, unconsciously enough, that it is their intention to look until they have found an arrangement in the landscape most like some one of the pictures they have seen and liked in the galleries. A hundred times, perhaps, they have walked by their own subject, felt it, enjoyed it, but having no estimate of their own personal sensations, lacking faith in themselves, pass on until they come to this established taste of another. And here they would be ashamed if they did not appreciate, for this is an approved taste, and they try to adopt it because it is what they think they should like whether they really do so or not.

Is it not fine to see the development of oneself? The finding of one's own tastes. The final selection of a most favorite theme; the concentration of all one's forces on that theme; its development; the constant effort to find its clearest expression in the chosen medium; an effort of expression which commenced with the beginning of the idea, and follows its progress step by step, becoming a technique born of the theme itself and special to it. The continuation through years, new elements entering as life goes on, each step differing, yet all the same. A simple theme on which a life is strung.

The study of art should go broadcast.

Every individual should study his own individuality to the end of knowing his tastes. Should cultivate the pleasures so discovered and find the most direct means of expressing those pleasures to others, thereby enjoying them over again.

Art after all is but an extension of language to the expression of sensations too subtle for words.

And we will acquire this greater power of revealing ourselves!

All the forms of art are to be a common language, and the artist will no longer distinguish himself by his tricks of painting, but must take rank only by the weight and the beauty of what he expresses with the wise use of the languages of art universally known.

Seeing:

¶IT IS harder to *see* than it is to express. The whole value of art rests in the artist's ability to see well into what is before him. This model is wonderful in as many ways as there are pairs of eyes to see her. Each view of her is an original view and there is a response in her awaiting each view. If the eyes of a Rembrandt are upon her she will rise in response and Rembrandt will draw what he sees, and it will be beautiful. Rembrandt was a man of great understanding. He had the rare power of seeing deep into the significance of things.

The model will serve equally for a Rembrandt drawing or for anybody's magazine cover. A genius is one who can see. The others can often "draw" remarkably well. Their kind of drawing, however,

is not very difficult. They can change about. They can make their sight fit the easiest way for their drawing. As their seeing is not particular it does not matter. With the seer it is different. Nothing will do but the most precise statement. He must not only bend technique to his will, but he must invent technique that will especially fit his need. He is not one who floats affably in his culture. He is the blazer of the road for what he has to bring. Those who get their technique first, expecting sight to come to them later, get a technique of a very ready-made order.

To study technique means to make it, to invent it. To take the raw material each time anew and twist it into shape. It must be made to serve a specific purpose. The same technique must never be used again. Each time it must be made new and fresh. A stock of set phrases won't do. The study is a development of wit.

An artist's warehouse, full of experience, is not a store of successful phrases ready for use, but is a store of raw material. The successful phrases are there, but they have been broken down to be made over into new form. Those who have the will to create do not care to use old phrases. There is a great pleasure in the effort to invent the exact thing which is needed. Use it. Break it down. Begin again. It is a great thing to be able to see. Seeing is without limit. It is a great thing when one has a fair measure of seeing. Then to invent the means of expressing it. To be a *master* of technique rather than to be the owner of a lot of it. Those who simply *collect* technique have at best only a second-hand lot. A great artist is one who says as nearly what he means as his powers of invention allow. An ordinary artist often uses eloquent phrases, phrases of established authority, and if he is skillful

it is surprising to see how he can nearly make them fit his ideas—or how he can make the ideas give way to the phrase. But such an artist is not having a good time. A snake without a skin might make a fair job of crawling into another snake's shedding, but I guess no snake would be fool enough to bother with it.

I have been trying to make this matter clear— this matter that the whole fun of the thing is in seeing and inventing, trying to refute a common idea that education is a case of collecting and storing, instead of making. It's not easy. But the matter is mighty well worth considering.

¶THERE are men who admire women's dress. They do not know what the material of the dress is. One may admire a tree without knowing it is a chestnut tree. A boat may be appreciated, painted by an artist, yet the artist may not have a sailor's interest in knowledge of sails. He paints what and as he sees. He has found it beautiful and it is beauty he has sought to render. The garments of a woman may be fine—rare—expensive—a certain kind, but to the artist the dress may be only part of the woman.

¶IF IN your drawings you habitually disregard proportions you become accustomed to the sight of distortion and lose critical ability. A person living in squalor eventually gets used to it.

There are mighty few people who think what they think they think.

There are pictures that manifest education and there are pictures that manifest love.

The ignorant are to be found as much among the educated as among the uneducated.

Education as we have it does as much to thwart the recognition of individual experience as lack of education limits it.

If you want to know about people watch their gestures. The tongue is a greater liar than the body.

There are hand shakes of great variety. Some are warm and mean that you are cared for.

Your enemy is not thinking of the skin on the back of his neck. Watch it.

Artists deal with gestures. They get to know a great deal about people.

A sitter may not say a word for an hour, but the body has been speaking all the time.

A work of art in itself is a gesture and it may be warm or cold, inviting or repellent.

To the Students of the Art Students League:

¶THE exhibition of the works of Thomas Eakins at the Metropolitan Museum should be viewed and studied by every student and, in fact, every lover of the fine arts.

Thomas Eakins was a man of great character. He was a man of iron will and his will was to paint and to carry out his life as he thought it should go. This he did. It cost him heavily, but in his works we

have the precious result of his independence, his generous heart and his big mind.

Eakins was a deep student of life and with a great love he studied humanity frankly. He was not afraid of what this study revealed to him.

In the matter of ways and means of expression— the science of technique—he studied most profoundly as only a great master would have the will to study. His vision was not touched by fashion. He cared nothing for prettiness or cleverness in life or in art. He struggled to apprehend the constructive force in nature and to employ in his works the principles found. His quality was honesty. "Integrity" is the word which seems best to fit him.

Personally, I consider him the greatest portrait painter America has produced. Being a great portrait painter, he was, as usual, commissioned to paint only a very few. But he had friends and he painted his friends. Look at these portraits well. Forget for the moment your school, forget the fashion. Do not look for the expected, and the chances are you will find yourself, through the works, in close contact with a man who was a man, strong, profound, and honest, and, above all, one who had attained the reality of beauty in nature as it is; who was in love with the great mysterious nature as manifested in man and things, who had no need to falsify to make romantic, or to sentimentalize to make beautiful. Look, if you will, at the great Gross clinic picture for the real stupendous romance in real life, and at the portrait of Miller for a man's feeling for a man. This is what I call a beautiful portrait; not a pretty or a swagger portrait, but an honest, respectful, appreciative man-to-man portrait.

But I have no intention to specify. I simply ask you to look. I expect the pictures to tell you, if you

can but see them from out of yourselves, and I expect them to fill you with courage and hope.

Eakins many years ago taught in the Pennsylvania Academy of the Fine Arts, and in those days it was an excitement to hear his pupils tell of him. They believed in him as a great master, and there were stories of his power, his will in the pursuit of study, his unswerving adherence to his ideals, his great willingness to give, to help, and the pleasure he had in seeing the original and worthy crop out in a student's work. And the students were right, for all this character you will find manifest in his work. Eakins's pictures and his sculptures are the recordings of a man who lived and studied and loved with a strong heart.

1917

¶THERE are many craftsmen who paint pleasantly the surface appearances and are very clever at it.

There are always a few who get at and feel the undercurrent, and these simply *use* the surface appearances selecting them and *using* them as tools to express the undercurrent, the real life.

If I cannot feel an undercurrent then I see only a series of things. They may be attractive and novel at first but soon grow tiresome.

There is an undercurrent, the real life, beneath all appearances everywhere. I do not say that any master has fully comprehended it at any time, but the value of his work is in that he has sensed it and his work reports the measure of his experience.

It is this sense of the persistent life force back of things which makes the eye see and the hand move in ways that result in true masterpieces. Techniques are thus created as a need.

It is necessary to work very continuously and valiantly, and never apologetically. In fact, to be ever on the job so that we may find ourselves there, brush in hand, when the great moment does arrive.

It is very possible that you know all these things and know them to be true. I simply recall them to you, to make them active again, just as I would like you to recall them to me, for sometimes our possessions sleep.

¶ALL the past up to a moment ago is your legacy. You have a right to it. The works of ancient masters, those of the student next to you, the remark let drop a moment ago; all is experience, race experience.

Don't belong to any school. Don't tie up to any technique.

All outward success, when it has value, is but the inevitable result of an inward success of full living, full play and enjoyment of one's faculties.

A man cannot be honest unless he is wise. To be honest is to be just and to be just is to realize the relative value of things. The faculties must play hard in order to seize the relative values.

¶THE very essential quality of all really great men is their intense humanity, and they all have an unusual power of thinking.

In these times there is a powerful demarcation between the surface and the deep currents of human development.

Events and upheavals, which seem more profound than they really are, are happening on the surface.

But there is another and deeper change in progress. It is of long, steady persistent growth, very little affected and not at all disturbed by surface conditions.

The artist of today should be alive to this deeper evolution on which all growth depends, has depended and will depend.

On the surface there is the battle of institutions, the illustration of events, the strife between peoples. On the surface there is propaganda and there is the effort to *force* opinions.

The deeper current carries no propaganda. The shock of the surface upheaval does not deflect it from its course.

It is in search of fundamental principle; that basic principle of all, which in degree as it is apprehended points the way to beauty and order, and to the law of nature.

On the surface, disaster is battled with disaster. Things change. But all improvement is due to what of fundamental law rises to the surface, through the search made by those of the undercurrent.

The law of the surface is a failure for the same reason that the Wright brothers could not have made their machine fly on the laws of Blackstone, which were not based on fundamental principle but rather on certain rights of man, which rights are now questioned.

The artist of the surface does not see further than material fact. He describes appearances and he *illustrates* events.

Some fractional part of him flows in the undercurrent. It is the best part of him but he and his

surface public underestimate it. He may be conscious of it. He may be conscious of it and ashamed of it. Or, he may repress it because it hurts his surface interests.

There are painters who paint pictures with spiritual titles but whose motives are purely materialistic.

Goya painted events, some of his subjects were historical, but I find his obvious subject a thin veil. Beyond the veil we see his realities. They are immeasurable.

We have seen superficial painters rise, have a storm of public approval, and then disappear from notice.

Even that other and very different popularity recently given Renoir and Cézanne I question.

If they had not been idealized out of their true characters, they might never have had such vogue as they have had.

Perhaps in order to make them as popular as they now are, it has been necessary to deny them the very most striking qualities; the very qualities which were necessary to them in doing the fine work they have done.

They have been stripped of humanity. We are told they had no interest in the personalities they painted, and this and that has been taken from them until they are only half themselves.

I have been told in face of one or other of their works that these men had no *character* interest, that in fact they loftily avoided seeing any such base element in the "motive."

And yet, of course, on the canvas before us there was a marvelous characterization, an employment of material, the paints and the model, in such a rare way as to make us realize deep down into the life of the subject.

The great masters in all the arts have been whole men, not half men. They have had marvelous fullness in all human directions, have been intensely humane in themselves and in their interests. And if they seem to select, it is because they have so much to select from.

It may be that what we take for absence of humanity is the very presence of it, our understanding of the word, or the emotion, being so different, so materialistic.

Renoir and Cézanne are quite unalike, yet an important likeness does exist in that their search has been toward a truer realization.

Renoir is rather Eastern in his sensibility, and Cézanne possesses qualities both Eastern and Western, and is of the future type. He had intense realization of what is beyond material and intense powers to employ materials constructively.

¶PEOPLE say, "It is only a sketch." It takes the genius of a real artist to make a good sketch—to express the most important things in life—the fairness of a face—to represent air and light and to do it all with such simple shorthand means. One must have wit to make a sketch. Pictures that have had months of labor expended on them may be more incomplete than a sketch.

Letter of Criticism:

¶THIS to me is the most beautiful in color. It has a fine quality of light and atmosphere. The

sky is fine, and has an area in good measure with the other forms. The several echoes of this blue sky in the lower blues of windows, umbrella and ground are effective—helping the sky and being helped by it. The roof and the reds of the foreground are excellent in effect on each other. This naturally includes the effects that the colors have in contrast, and the play in this way of the three big color areas of the picture, red, yellow-green and blue, is fine.

The sketch is an excellent impression in the key most true to the gayety of the subject and its warm light.

It remains, however, a slight sketch, made slight more because of lack of organization and concentration in the forms than that the forms are not much finished. Concentration; the play of one form into another, the balance of one form, or incident, or idea, or material, with the others, and all leading to one central interest. This is what the study lacks. All satisfying things are good organizations. The forms are related to each other, there is a dominant movement among them to a supreme conclusion.

Study some good satisfying pictures or reproductions of pictures that you very much admire and you will find this to be one of their great secrets. Some pictures, as portraits, are so organized that you are directed not only by obscure but by very obvious influences to the head.

In a composition like yours, it is rather by subtle influences that the eye of the spectator and his interest is guided, because in such a subject there are many rests for interest all over the canvas, but these are only *rests*. One must, in the good composition, go on to the supreme climax. It is in this way that a sense of fulfillment and completion is accomplished. These are things you must study. You can

study them in all good and satisfying works of art. No receipt about it. Just a principle. One finds it in great music. It is a question of getting results through balance, rhythm, cumulation, opposition, etc., and this applies to all the agents you employ in your work. I have remarked some good balances, but you have engaged other agents—such as figures, figures doing things, windows, etc., etc., and these, while serving well in certain color-notes, say at the same time too much and too little in themselves.

If you introduce an agent, that agent must enter into the order of things, must attain in its character a right amount of balance with the other things. If the agent is a figure and there are other figures, it must take its place in degree of prominence with the other figures as well as its degree of prominence as a color, form or line-note in the whole composition.

Your picture may express the idea of dazzle and confusion, but the picture must not be confused. What I have said is the most important criticism I have for you. It is an understanding of this principle that will make you progress not only in the way you have already attained, but in all other ways.

You will see that it means drawing, not imitative drawing but *constructive* drawing, and it means finish, but not the finish that is the ideal of the ignorant.

This sketch of yours could, for instance, be a finished work of art with no more detail, some less in parts, than it has now.

Work for order and balance of the excellent factors already on the canvas, the whole concerted, and every factor playing its part up to the dominant, as

though every part were willed to move towards the central idea. It could be a complete work—complete as art and even appreciable by the most ignorant art judge, who would like it deep down in his consciousness even if in the top of his head he were still begging for what he calls finish (more detail or more smoothness). And this same sketch could be carried much further as a statement of various interests, and if the organization, the concerted movement, were kept, the thing would still be large, full, a more complex subject, but equally simple.

Now, after all this, your sketch is very handsome, fine in color—showing your talent admirably. Why don't you take it as a subject to work out, to study, and to bring to a full completion. Suppose you take a larger sized canvas—say 26 by 32, or some such size, and go at this very subject—not in a flighty, hurried way, but as a *student*—like a builder—to make something that will be wholly satisfying to you. Not a picture to be more "finished" in the common sense, but one to be finished in this other sense, which will please *you*. You have the data for it in the sketch. If you can fight this thing out you will find yourself much advanced at the end of the fight even if you have failed in making a picture of it. But you won't fail if you keep your mind about you and work on the canvas only to get what you like. To do this there must be no flighty dashing at the thing. You must lay your plans and know what you are doing. You must determine the central motive to which all evidences converge (some convergences will be literal, others will not), and you must determine the lesser centres. You must make up your mind what work in the whole each part is to play. You can always

scrape, or let dry and work over. It can't be done in an afternoon. It may take some time and many intervals for consideration. The time does not matter if by it you get your whole idea of art moved forward.

On your big canvas you can decide to have practically no more detail than you have on this panel. This will mean that you must make the forms in their present state just as significant as they possibly can be.

A fine drawing by Phil May has very little detail in it, but what lines he did put down were so significant of his quality of idea that no more lines, or no more details, were necessary.

Of course, what I suggest will mean a battle for you—not a test of your grit in a sprint, but it's a good six-day go. It will take courage and it will take common sense. Don't begin to paint before you have quite satisfied yourself as to the placement of everything. You can make numerous little drawings, or panel sketches of the various parts. For instance, the people on the benches, no more finished, but better concerted.

Make up your mind what you want to put down and don't let anything prevent you from putting down just that. The big picture should be as charming and as free as the little sketch—but more concerted.

You have a lot of talent, a real flair for color, and you should be willing to work to a conclusion, to fight things out.

Study reproductions and pictures you like in this matter of rhythm, organization, concentration, balance, dominance. It's not so easy to do, but it can be done and it will be of very great service to you.

These suggestions I have given you are easily written and quickly read, but what they mean for you is a lot of hard concentrated work, and if you do it you will pass on from the tentative, the touch-and-get-away state. You are not to give up the quick sketch. That work is to go on always. Some things can only be seized in that way. This other work is the rounding out, and completing, from memory. When I say "completing," remember that I do not mean conventional finish.

I admire this other sketch of yours very much. The group of Indians has the burn of color. As a critic, I might say I wish they would turn around more, or, as they are doing something, there together, do it more to the observer's satisfaction.

As to the piano picture, there has been more thinking about the *style* of art the picture is in than thought of the subject. The subject has been bent to the manner rather than that the manner has been the outcome of the needs of the subject.

The red interior is vigorous, promising, but too much a riot of color—is more riotous in the *painting* than suggestive of the riot in nature.

I have seen many artists develop. I have seen many who have failed to push on although possessed of this brilliant talent for the noting of fresh and valuable sketches. There are many who make *near* masterpieces, near complete statements. That final bringing of things together, tying up, accentuation of the necessary, and elimination of the unnecessary, requires a force of concentration that few are capable of attaining. It's the last, final spurt of energy—the climax of all that has gone before. The majority fail at this point. Those who become masters do not. Finish with many "artists" is to

smooth over, close up—in fact it is a negation of all that brilliant courage of the original sketch. The finish I ask for is the fuller carrying out of the spirit and the fulfillment of the organization that is hinted at in the sketch.

¶THE appreciation of art should not be considered as merely a pleasurable pastime. To apprehend beauty is to work for it. It is a mighty and an entrancing effort, and the enjoyment of a picture is not only in the pleasure it inspires, but in the comprehension of the new order of construction used in its making.

¶GET up and walk back and judge your drawing. Put the drawing over near the model, or on the wall, return to your place and judge it. Take it out in the next room, or put it alongside something you know is good. If it is a painting put it in a frame on the wall. See how it looks. Judge it. Keep doing these things and you will have as you go along some idea of what you are doing.

¶I ONCE met a man who told me that I always had an exaggerated idea of things. He said, "Look at me, I am never excited." I looked at him and he was not exciting. For once I did not over-appreciate.

There are painters who paint their lives through without ever having any great excitements. One man said to me, "I lay it in in the morning, then I have luncheon and I take a nap, after which I finish." Certainly a well regulated way for a quiet gentleman and quite unlike the procedure of an

idea-mad enthusiast who works eighteen hours at a stretch.

One of the reasons that exhibitions of pictures do not attract a larger public is that so many pictures placidly done, placidly conceived, do not excite to imagination. The pictures which do not represent an intense interest cannot expect to create an intense interest.

It is often said "The public does not appreciate art!" Perhaps the public is dull, but there is just a possibility that we are also dull, and that if there were more motive, wit, human philosophy, or other evidences of interesting personality in our work the call might be stronger.

A public which likes to hear something worth while when you talk would like to understand something worth while when it sees pictures.

If they find little more than technical performances, they wander out into the streets where there are faces and gestures which bear evidence of the life we are living, where the buildings are a sign of the effort and aspiration of a people.

It may be that the enthusiast does not exaggerate and that an excited state is only an evidence of the thrill one has in really seeing.

When the motives of artists are profound, when they are at their work as a result of deep consideration, when they believe in the importance of what they are doing, their work creates a stir in the world.

The stir may not be one of thanks or compliment to the artist. It may be that it will rouse two kinds of men to bitter antagonism, and the artist may be more showered with abuse than praise, just as Darwin was in the start, because he introduced a new idea into the world.

The complaint that "the public do not come to

our exhibitions—they are not interested in art!" is heard with a bias to the effect that it is *all* the public's fault, and that there could not possibly be anything the matter with art. A thoughtful person may ponder the question and finally ask if the fault is totally on the public's side.

There are two classes of people in the world: students and non-students. In each class there are elements of the other class so that it is possible to develop or to degenerate and thus effect a passage from one class to the other.

The true character of the student is one of great mental and spiritual activity. He arrives at conclusions and he searches to express his findings. He goes to the market place, to the exhibition place, wherever he can reach the people, to lay before them his new angle on life. He creates a disturbance, wins attention from those who have in them his kind of blood—the student blood. These are stirred into activity. Camps are established. Discussion runs high. There is life in the air.

The non-student element says it is heresy. Let us have "peace!" Put the disturber in jail.

In this, we have two ideas of life, motion and non-motion.

If the art students who enter the schools today believe in the greatness of their profession, if they believe in self-development and courage of vision and expression, and conduct their study accordingly, they will not find the audience wanting when they go to the market place with expressions of their ideas.

They will find a crowd there ready to tear them to pieces; to praise them and to ridicule them.

Julian's Academy, as I knew it, was a great cabaret with singing and huge practical jokes, and as

such, was a wonder. It was a factory, too, where thousands of drawings of human surfaces were turned out.

It is true, too, that among the great numbers of students there were those who searched each other out and formed little groups which met independently of the school, and with art as the central interest talked, and developed ideas about everything under the sun. But these small groups of true students were exceptional.

An art school should be a boiling, seething place. And such it would be if the students had a fair idea of the breadth of knowledge and the general personal development necessary to the man who is to carry his news to the market place.

When a thing is put down in such permanent mediums as paint or stone it should be a thing well worthy of record. It must be the work of one who has looked at all things, has interested himself in all life.

Art has relations to science, religions and philosophies. The artist must be a student.

The value of a school should be in the meeting of students. The art school should be the life-centre of a city. Ideas should radiate from it.

I can see such a school as a vital power; stimulating without and within. Everyone would know of its existence, would feel its hand in all affairs.

I can hear the song, the humor, of such a school, putting its vitality into play at moments of play, and having its say in every serious matter of life.

Such a school can only develop through the will of the students. Some such thing happened in Greece. It only lasted for a short time, but long enough to stock the world with beauty and knowledge which is fresh to this day.

Schools have transformed men and men have transformed schools.

When Wagner came into the world it was very different from when he left it, and he was one of the men who made the changes.

Such people are very disturbing. They often create trouble, we can't sleep when they are around.

If the art galleries of the future are to be crowded with spectators it will depend wholly on the students.

If there had been no such disturbers as Wagner, auditoriums would not now be filled with listeners.

¶WHEN a drawing is tiresome it may be because the motive is not worth the effort.

Be willing to paint a picture that does not look like a picture.

The mere copying, without understanding, of external appearances can hardly be called drawing. It is a performance and difficult, but—

¶EVERY movement, every evidence of search is worthy of the consideration of the student.

The student must look things squarely in the face, know them for what they are worth to him.

Join no creed, but respect all for the truth that is in them.

The battle of human evolution is going on.

There must be investigations in all directions.

Do not be afraid of new prophets or prophets that may be false.

Go in and find out. The future is in your hands.

¶YOU can learn much by a cool study of the living eye. Examine it closely and record in your mind just what and where its parts are. In pictures eyes should fascinate, arrest, haunt, question, be inscrutable, they should invite into depths. They must be remarkable. You must have your anatomical knowledge so that you can use it without consciously thinking of it, and your technique must be positive and swift. Eyes express human sensitiveness and they must be wonderfully done.

I am sure there are many people—and there are artists—who have never seen a whole head. They look from feature to feature. You can't draw a head until you see it whole. It's not easy. Try it. When I first realized this it seemed that I had to stretch my brain in order to get it around a whole head. It seemed that I could go so far, but it was a feat to comprehend the whole. No use trying to draw a thing until you have got all around it. It is only then that you comprehend a unity of which the parts can be treated as parts.

¶THE dominant eye. Note that there is a compositional relation between the eyes—that is, one eye commands the greater interest. If you paint them equal, no matter what the position of the head, the observer will get no right conception of them. In life one eye always dominates the observer. In painting this domination must persist.

¶THE average idea of portraiture needs reconstruction.

When Rodin made his Balzac he made a great

portrait. It is probably not so much what Balzac looked like to the ordinary eye; but it is the man as Rodin understood him, and I think Rodin had unusual understanding.

¶KEEP your old work. You did it. There are virtues and there are faults in it for you to study. You can learn more from yourself than you can from anyone else.

After you have made a drawing from the model don't simply put it away. You are not half through with it. It's a thing to study.

If you are working from day to day on a drawing, take it home. Put it where you can see it well.

No one can get anywhere without contemplation. Busy people who do not make contemplation part of their business do not *do* much for all their effort.

Study the drawing out. When you take it back before the model you will have a state of mind far in advance of the state of the drawing.

If it is a drawing of a pose which is not to be continued, just the same, make your study of it—and redraw it. Use plenty of paper. Seriousness does not mean sticking to one piece of paper or canvas.

¶HE PAINTS like a man going over the top of a hill, singing.

¶MANY artists learn to draw a leg or arm in a certain state of action and use the same no matter how unfitting it may be to the subject in hand.

We see in a picture or decoration labeled "Labor," a man with the muscles in his arms and legs bulging as though he were accomplishing some mighty feat of strength, although the use of all this terrific muscular action may be no more than the carrying home of his dinner pail.

In drawing a man pulling on a rope, make your drawing state fully what muscles are affected by this action.

Develop the power of seeing the points of action; your keenness of sight of such muscular activities must be greater than that of the ordinary observer.

In buying a horse, if you are not acquainted with horses, you will fail to recognize the fine points. You will refer to your friend who is a judge of horses and from his expert knowledge, he will be able to tell at once the signs of the horse's power, fleetness or condition.

The art student must learn to read the state, temperament, action and condition of his subject through the outward signs, and use the same as a means of expressing and making special what is important to him in the subject.

¶IN THIS pose our model is as much an artist as any of you. He has a distinct idea of the action he wishes to express, and he keeps well to the idea. It is a piece of good acting. If you would but put as much mind, energy and imagination in your drawing as he does in taking and holding to the spirit of his pose, good work would result.

In drawing this outline you forget what the line signifies because your interest is in drawing the line only as a line. You must think more of what created

the line in nature; of the movement and the form
that created it. The line is nothing in itself.

Look at this drawing by Rembrandt. Your mind
is at once engaged by the life of the person repre-
sented. The beauty of the lines of the drawing rest
in the fact that you do not realize them as lines, but
are only conscious of what they state of the living
person.

Here are people represented in differing actions,
and each one sensed in his nature, you seem to
know all about them. It is the individual signifi-
cance of the persons in the action of the picture
that seizes you. You have been let into that life of
long ago.

In this other Rembrandt drawing we see people
in a tavern. Among them is an imposing client.
Note the way the lines force our understanding of
his pompous authority. How different each one
present carries himself. In the whole composition
there is a unity of line and there is a unity of group,
time and place, but each personage is an identity in
himself. Variety within unity.

We like to look at these drawings because they
carry to us just what was running through the mind
of Rembrandt. They express states of life as Rem-
brandt understood them. They are real historical
documents, not of governmental climaxes, but of
the real, intimate life of people while they uncon-
sciously live their lives.

Ordinary histories estrange us from the past. The
works of such as Rembrandt bring us near it.

The personages in the Rembrandt drawings are
seen as in the actions of their lives. Our model on
the stand before us is equally an individual, and is

at this moment doing one of the things which go to make up his or her life. This studio is no less a place where life is going on in its tragedy and comedy than any other.

The model on the stand is a piece of history, and if you know this you will draw more interestingly, because you will see more interestingly.

Life and art cannot be disassociated, nor can any artist, however he may desire it, produce a line of "sheer beauty," *i.e.,* a line disassociated from human feeling. We are all wrapped up in life, in human feelings; we cannot, and we should not, desire to get away from our feelings.

In fact lines are only beautiful to us when they bear a kinship to us. Different men are moved or left cold by lines according to the difference in their natures. What moves you is beautiful to you. To all men in a general way human lines have significance.

In all great paintings of still-life, flowers, fruit, landscape, you will find the appearance of inter-weaving human forms, the forms we unconsciously look for. We do but humanize, see ourselves in all we look at.

Because we are saturated with life, because we are human, our strongest motive is life, humanity; and the stronger the motive back of a line the stronger, and therefore the more beautiful, the line will be.

In looking at certain drawings of landscape by Cézanne, I found myself first filled with a delight-ful sense of intimacy, of warmth and human feel-ing.

Presently I became conscious that I was looking at a wonderful orchestration of human forms. In the trees, the rocks, the grasses—everywhere, were

variations on the human form, fragmentary but interplaying and forming a magnificent symphony.

Critics have written that Renoir was not interested in the people he painted, was only interested in color and form, that the who or what of the model was totally negligible to him. Yet one has only to look at those little children he painted, the one bending over his writing, the two girls at the piano, to cite instances; and it will be apparent that Renoir had not only a great interest in human character, in human feeling, but had also a great love for the people he painted.

He needed new inventions in technique, in color and form to express what he felt about life. His feeling was so great that his search was directed, and the result is as we have seen—great rhythms in form and color.

Because a line is beautiful in one picture is no argument that it will be beautiful in another. It is all a matter of relation.

The line in a great drawing is not a slave to anatomical arrests and beginnings. There is a line that runs right through the pointing arm and off from the finger tip into space. This is the principal line. This is the line which the artist draws and makes you follow.

It is not necessarily a visible line to the photographic eye. It is there nevertheless and is hidden in the science of the draftsman. All else that is visible is there only to make you sense this line, and it dominates.

Your eye does not follow the muscle and bone making of the arm. It follows the spirit of life in the arm.

Such a line runs through the whole figure, rising from point to point in measures which are not con-

trolled by the anatomical structure, except in the loosest way. These measures define another dimension—that fascinating fourth if you like—which has to do with your concept of the significance of the whole—that ultra something which has always engaged your interest more than mere facts of the person standing before you.

If you ask me how you are to locate these points on which your line is to rest in its progress, I can only tell you that you most certainly see them and you know them well in your deeper consciousness. It will take some deep sounding to bring them into your intelligence, which is blocked too much now with an eye-seeing vision of material things, things which, however, really do not and never have had much importance to you.

If in your composition of an arm, a figure, a whole canvas, you do come to see these measures and can fix them, you will find the minor forms, the little anatomies, falling wonderfully into their places, easier to do and to regulate as to their importance, than ever before.

The lines which are important in an "outline" drawing are not necessarily those which edge against the background—often the great line moves inward from this and travels across or down the forward body.

In considering lines as a means of drawing, it is well to remember that the *line* practically does not exist in nature. It is a convention we use.

I think I am safe in saying, until you became an art student, you never saw an outline—you never took the outline into consideration. You saw forms and these forms had character and motion.

If you use lines now as a means of drawing, try to find the way to make them express what you see

—forms of definite character and movement. Don't become a victim of line.

There is a certain kind of penmanship made in schools which seems to draw around the letters of a word like a wire, and there is another penmanship, much more human, that seems to be the word.

In drawing, there are lines which travel fast, which carry the eye over space with a surprising rapidity and land you at a nodal point, where you are forced to rest, and then take new departure at the same or a quite different speed. There are lines that are heavy, dragging, lines that have pain, and lines that laugh.

A canvas may be measured with inches, but the speed with which you travel over it is regulated by the artist.

A line may plunge you into silences, into obscurity, and may bring you out into noise and clarity.

The line around the edge of a figure on a white piece of paper represents the figure's mergence into the background—its place in air—and represents depths and textures. Some parts of the edge of a body are nearer you, some parts are further away; the outline will show these distances. At places, the bone of the body is near the surface and it is hard. At other places the body is soft. The outline defines these; hardness and softness.

¶I AM glad to hear of your plans and I wish I could be a helper, as you suggest. I understand from your letter that you would like me to write an article.

This brings up, however, the matter that we have several times discussed—whether the cobbler should stick to his last—whether the artist should paint, and put all his energies, his whole heart and mind

in what he is best at, both from inclination and experience, instead of lecturing, writing, going to meetings, or going into society. It was only last night that, talking to an artist friend, I regretted there was but one of me, for as I said, if there were two, I could then paint both the people and the landscape. As it is, there being but one of me, I spend six to eight hours a day in actual painting and the rest of the time getting ready for the work, or resting, and in my passage to and from the studio where I paint people, I see most beautiful landscape under rare effects slide by. And this is a true loss to me for I have the feeling, and have had considerable experience, in painting landscape.

I would like to be in many activities. I think that anyone who has had the pleasures of study and work for years may be full of regret because he cannot practice in all the arts.

Painting is a great mystery. No one has ever learned quite how to paint. No one has ever learned quite how to *see*.

Sometimes we do grip the concert in a human head, and so hold it that in a way we get a record of it into paint, but the vision and expressing of one day will not do for the next.

Today must not be a souvenir of yesterday, and so the struggle is everlasting. Who am I today? What do I see today? How shall I *use* what I know, and how shall I avoid being victim of what I know? Life is not repetition.

If painting were an accomplishment easy to repeat after "learning," there would be time and energy for other practices. But good painters (and I consider as *good* painters all those who work from the will of self-expression) have little time to go afield.

They are generally at work. And as far as socia-

bility is concerned, they are the most social people in the world, at least so I have found them.

I have just laid down a book and the caress of my hand was for the man who wrote it, for the great human sympathy of the man and his revealing gift to me through the book. I have never seen the man, do not know his outside, but I am intimately acquainted with him. His warmth is all about me. Insofar as I am capable I am his kin. I am not anxious to see how well he dances, or how well he paints. He has said what he wanted to say to me in the way he wanted and thought best to say it.

I do not like the very modern fancy which makes an actor of a man as soon as he has proven himself a pugilist.

It is true, no doubt, that if my writer is deflected from writing to dancing or painting, somewhat of his genius will appear in these arts. But why should he be deflected, since it is the man's self we want, and he has found and developed his best way of giving it.

¶PAINTING is the expression of ideas in their permanent form. It is the giving of evidence. It is the study of our lives, our environment. The American who is useful as an artist is one who studies his own life and records his experiences; in this way he gives evidence. If a man has something to say he will find a way of saying it.

The undercurrent and motive of all art is an individual man's idea. From each we expect what he has to give. We desire it. It is absolutely necessary for him to give it out.

What is the relation of the artist to the community? What good does a man's art do? There are those in the community who regard the artist as a

mere entertainer come with cap and bells to amuse
and perform graces before a paying public. The
true artist regards his work as a means of talking
with men, of saying his say to himself and to others.
It is not a question of pay. It is not a question of
willing acceptance on the part of the public. If he
is welcomed and paid it is very good, but whether
or no he must say his say. Whitman was not paid
for his work either in money or in appreciation at
the time he did it. What we have from him was a
gift, at first—and for long after—unwillingly re-
ceived. So also with Ibsen. They made good first.
They were ridiculed first. Stevenson, the inventor,
was laughed at. The Wright brothers were laughed
at in the beginning. Men have to give just as the
bird has to sing. The artist is teaching the world
the idea of life. The man who believes that money
is the thing is cheating himself. The artist teaches
that the object of a man's life should be to play as a
little child plays. Only it is the play of maturity—
the play of one's mental faculties. Therefore, we
have art and invention.

Art in the community has a subtle, unconscious,
refining influence.

It is a curious fact that the delicate acoustic ar-
rangements of a music hall can be impaired by the
music of inefficient, discordant orchestras, and for
this reason poor musical performances have been
forbidden in some places. If a poor performance
could affect adversely the acoustics of a hall, would
not an able performance tend to improve them?

It practically means that the presence of good
art will unconsciously refine a community and that
poor art will do it incalculable harm.

True art strikes deeper than the surface. There
is that which we call the subconscious. We do cer-
tain things and are influenced by certain things

without knowing why. We hear a band play a military selection, and, though we may not be at all martially inclined, we suddenly become conscious of the fact that we have walked in step to the music. And so with a good picture. Unconsciously we fall in with the rhythm of its music. The man looks at the picture; he attaches little importance to it; but it doesn't have to hit a man on the head to make an impression. The influence is all the greater because the man doesn't realize that it's there. Look at a Homer seascape. There is order in it and grand formation. It produces on your mind the whole vastness of the sea, a vastness as impressive and as uncontrollable as the sea itself. You are made to feel the force of the sea, the resistance of the rock; the whole thing is an integrity of nature.

Landscape is a medium for ideas. We want men's thoughts. It's the same in other things. It is said that Wells had the right idea about writing history when he wrote *The Outline,* for his object was not so much to give us the dates of the various occurrences, as to tell us of the conditions of humanity. And so the various details in a landscape painting mean nothing to us if they do not express some mood of nature as felt by the artist. It isn't sufficient that the spacing and arrangement of the composition be correct in formula. The true artist, in viewing the landscape, renders it upon his canvas as a living thing. Perhaps he feels the wind blowing across landscape. In this case he may *use* the tree to express the splendid power of the wind. It is a birch tree. It is a frail tree. It bends before the wind. You see the wind's effect in the branches and the leaves. Everything about the tree indicates the life and force of the wind. Thus the tree becomes an eloquent symbol; it is the medium through which the *idea of the wind* is expressed.

The next day the artist goes out again, his active mind open to impressions, displaying interest in all directions. Again the tree attracts his attention. This time it is the tree growing; the tree *resisting* the wind; the tree with its fecundity; the tree rising and spreading from its roots; the tree undergoing its complete cycle of growth from the roots, deriving its nutrition from the moisture in the ground and the sap in the trunk; the tree with the twigs and the leaves and the final flowering into blossoms; and in this tree the wind is blowing—the wind, which is to the tree as a chasing is to the cup.

There is the heart and the mind, the Puritan idea is that the mind must be master. I think the heart should be master and the mind should be the tool and servant of the heart. As it is, we give too much attention to laws and not enough to principles. The man who wants to produce art must have the emotional side first, and this must be reinforced by the practical.

The man who has great emotions might burst into tears—but that is as far as he will get if he has no practical side. The artist must have the emotional side first, the primal cause of his being an artist, but he must also have an excellent mind, which he must command and use as a tool for the expression of his emotions.

The idea, which is the primal thing for a picture, is all in the air; the expression on canvas is a case of absolute science as it deals with materials. A great artist is both a great imaginer and a great employer of practical science. First there must be the man, then the technique.

¶THERE are many ways of seeing things.

When you saw the thing and it looked beautiful to you, you saw it beautifully. Paint it as it looked then.

¶SOME students possess the school they work in. Others are possessed by the school.

¶LET a student enter the school with this advice:

No matter how good the school is, his education is in his own hands. All education must be self-education.

Let him realize the truth of this, and no school will be a danger to him. The school is a thing of the period. It has the faults and the virtues of the period. It either uses the student for its own success or the self-educating student uses it for his success. This is generally true of all schools and students of our time.

It is up to the student whether he becomes a school-made man or whether he uses the school as a place of experience where there are both good and bad advices, where there are strengths and weaknesses, where there are facilities, and much information to be had from the instructors, and much to be gained by association with the other students. He may learn equally from the strong and the weak students. There are models to work from and a place to work in.

The self-educator judges his own course, judges advices, judges the evidences about him. He realizes that he is no longer an infant. He is already a man: has his own development in process.

No one can lead him. Many can give advices, but

the greatest artist in the world cannot point his course for he is a new man. Just what he should know, just how he should proceed can only be guessed at.

A school should be an offering of opportunity, not a direction, and the student should know that the school will be good for him only to the degree that he makes it good. It is a field for activity where he will see much, hear much and where he must be a judge, selecting for his special need, and daily discovering his need.

When we have bred a line of self-educators there will then be no fear of schools. Those who have done distinguished work in the past, who have opened new roadways of vision and invented techniques specific to such visions have done it in spite of environment. They have learned what the schools had to offer, how much, how little. Strengths and weaknesses have alike been material to their progress.

Different men must learn different things. Each man must put himself as far as possible in the way of knowing what is known and he must make his choices. Everything back of him is his heritage to use or to leave. The school is a place of strengths and weaknesses. There are things insisted upon and there are things omitted. There are all sorts of advices, good and bad, and there are advices that will serve one and not another.

The man who goes into a school to educate himself and not to be educated will get somewhere. He should start out a master, master of such as he has, however little that may be. By being master of such as he has in the beginning it is likely he may later be master, after years of study, of much.

He should not enter the school with any preconceived idea of his destiny. In fact he should be

open and free. His aim should be to search deeply and work hard and let the outcome be what it may.

The best art the world has ever had is but the impress left by men who have thought less of making great art than of living full and completely with all their faculties in the enjoyment of full play. From these the result is inevitable.

¶THE technique of a little individuality will be a little technique, however scrupulously elaborated it may be. However long studied it still will be a little technique; the measure of the man. The greatness of art depends absolutely on the greatness of the artist's individuality and on the same source depends the power to acquire a technique sufficient for expression.

The man who is forever acquiring technique with the idea that sometime he may have something to express, will never have the technique of the thing he wishes to express.

Intellect should be used as a tool.

The technique learned without a purpose is a formula which when used, knocks the life out of any ideas to which it is applied.

¶THE great artist has cast a glow of romance over the café and Bohemia. It is not that he has spent much time there. He was always too busy with his work for that. It is because when he did go for relaxation he put his wit, his humor, his vitality and all himself into it. He made things hum, turned the sordid into romance, then dis-

appeared back to his work leaving a memory in Bohemia.

¶AGE need not destroy beauty. There are people who grow more beautiful as they grow older. If age means to them an expansion and development of character this new mental and spiritual state will have its effect on the physical. A face which in the early days was only pretty or even dull, will be transformed. The eyes will attain mysterious depths, there will be a gesture in the whole face of greater sensibility and all will appear coordinate.

About the portrait Whistler painted of his mother I have always had a great feeling of beauty. She is old. But there is something in her face and gesture that tells of the integrity of her life. There is nothing wabbly about her face as there is in the faces of those whose integrity has been uncertain. A wonderful record of woman's beauty would have been lost to the world if her son had seen fit to look for any other beauty than that which was present. There she sits, and in her poise one reads the history of a splendid personality. She is at once so gentle, so experienced, and so womanly strong.

She may have had other beauty in her youth, but it could not have surpassed this, which charms and fills us with reverence.

It is more the gesture of a feature than the feature itself which interests and pleases us.

The feature is the outside, its gesture manifests the inner life.

Beauty is an intangible thing; can not be fixed on the surface, and the wear and tear of old age on the body cannot defeat it.

Nor will a "pretty" face make it, for "pretty" faces are often dull and empty, and beauty is never dull and it fills all spaces.

¶THE lace on a woman's wrist is an entirely different thing from lace in a shop. In the shop it is a piece of workmanship, on her hand it is the accentuation of her gentleness of character and refinement.

¶PERHAPS whatever there is in my work that may be really interesting to others, and surely what is interesting to me, is the result of a sometimes successful effort to free myself from any idea that what I produce must be art or must respond in any way to any standard.

It must be old fashioned, or new fashioned or no fashion at all. It must be what it is and must have been made because it was a great pleasure to make it.

Whatever is worth while I am sure must be made this way, and the influences should be all the influences, little and big, of a lifetime.

¶DEVELOP your visual memory. Draw everything you have drawn from the model from memory as well.

Realize that a drawing is not a copy. It is a construction in very different material.

A drawing is an invention.

The technique of painting is very difficult, very interesting.

There is no end to the study of technique.

Yet more important than the lifelong study of technique is the lifelong self-education.

In fact, technique can only be used properly by those who have definite purpose in what they do, and it is only they who *invent* technique. Otherwise it is the work of parrots.

You can do anything you want to do. What is rare is this actual wanting to do a specific thing: wanting it so much that you are practically blind to all other things, that nothing else will satisfy you. When you, body and soul, wish to make a certain expression and cannot be distracted from this one desire, then you will be able to make a great use of whatever technical knowledge you have. You will have clairvoyance, you will see the uses of the technique you already have, and you will invent more.

I know I have said a lot when I say "You can do anything you want to do." But I mean it. There is reason for you to give this statement some of your best thought. You may find that this is just what is the matter with most of the people in the world; that few are really wanting what they think they want, and that most people go through their lives without ever doing one whole thing they really want to do.

An artist has got to get acquainted with himself just as much as he can. It is no easy job, for it is not a present-day habit of humanity. This is what I call self-development, self-education. No matter how fine a school you are in, you have to educate yourself.

There is nothing more entertaining than to have a frank talk with yourself. Few do it—frankly. Educating yourself is getting acquainted with yourself.

Find out what you really like if you can. Find

out what is really important to you. Then sing your song. You will have something to sing about and your whole heart will be in the singing.

When a man is full up with what he is talking about he handles such language as he has with a mastery unusual to him, and it is at such times that he learns language.

¶DON'T follow the critics too much. Art appreciation, like love, cannot be done by proxy: It is a very personal affair and is necessary to each individual.

A Sketch:

¶IT IS only some people sitting down out-of-doors. There is the sensation of comfort under the trees, the baby carriage, the bloom of flowers, the women's clothes, green trees. The man has disposed his legs along the line of greatest comfort. He won't keep them long that way but just for the moment he has the expansion of a dog in the sunlight. It is all a matter of the *sense* of these things and it is very beautiful. It is not the kind of art that is painful either in its conception or its doing. It seems to have been born of wit, and good-humored love of people and things—seems to have come forth spontaneously—a love song. It seems so easy and it seems so glad to exist.

Beside it, the bitter duty thing, made of painful hard labor, of grinding and irritating patience; the thing great only because of the agony it took in its

making, the dully labored, witless thing, the thing without love, the thing made not for itself but to win a prize, hangs ill at ease.

¶I DO not want to see how skillful you are—I am not interested in your skill. What do you get out of nature? Why do you paint this subject? What is life to you? What reasons and what principles have you found? What are your deductions? What projections have you made? What excitement, what pleasure do you get out of it? Your skill is the thing of least interest to me.

Don't be a high-key or a low-key artist. Both keys belong to you. Use the key that fits.

Form enveloping form. The over-modeling.

I can feel the sogginess of that man's footsteps as he comes along. He seems to be the spirit of dreary rain.

A sketch that is the life of the city and river.

So you are after the Japanese? Well, don't be so superficial about it. Get the principle of it, but not the mannerism.

¶NO ONE should be asked to write on any artist or art movement unless he likes the work of the artist or the effects of the movement very much, and has in his liking none of that propagandist spirit which boosts to the skies his idol and lays everything else in the dust. We have had much of this

in recent times. Nor should the "Honor List" be taken too seriously as an indication of worth.

I venture to say that Thomas Eakins will be spoken of in times to come as one of the very great men in all American art, but he died practically unknown and received only an "honor" or two.

I wonder what part in an encyclopedia of American art the truly decorative and significant work of the Indian will play. It is interesting to find that there has been going on for centuries a very remarkable art expression right here—pure art, not imitation, and related, somehow, to the more ancient art that existed beyond the Pacific.

In a great many writings and in much conversation I have noted a tendency to consider the paintings of a man who has never been abroad more American than those of a man who had been abroad. May as well say that Benjamin Franklin left his American spirit in Philadelphia when he went to Europe.

It is quite possible for a man to live all his life in California and paint as a disciple of the Barbazon school and for another to spend most of his life in the forest of Fontainbleau and show his California birth from beginning to end.

After all the error rests in the mistaken idea that the subject of a painting is the object painted.

Some men are so provincial that, put them where you will, they will *be* and *do* according to their home kind. Others will react to the outside world as the men of their nation feel. But in the great ones, of which a nation may be proud, the *race* speaks.

The greatest American, of whom the nation must be proud, will not be a "typical" American at all, but will be heir to the world instead of a part of it,

and will go to every place where he feels he may find something of the information he desires, whether it be in one province or another.

¶IT IS easier, I think, to paint a good picture than it is to paint a bad one. The difficulty is to have the will for it. A good picture is a fruit of all your great living.

There are terrible pictures that have taken time and pain to make, intricate and difficult, results of grinding patience, research, great amalgamations of material. They frighten the sensitive student for the message they carry is of the pain and boredom of their making.

¶DON'T take me as an authority. I am simply expressing a very personal point of view. Nothing final about it. You have to settle all these matters for yourself.

¶HOUSES, housetops, like human beings have wonderful character. The lives of housetops. The wear of the seasons. The country is beautiful, young, growing things. The majesty of trees. The backs of tenement houses are living documents.

Blunder ahead with your own personal view.

Make the man's feet grip the ground.

In drawing a tree there is a dominant line of growth throughout. Some times your tree must be

so specialized that an expert on trees would be fully satisfied. Other times it does not matter if it is even surely a tree.

¶YOUR pictures seem to be made up of things seen in nature plus a memory of pictures you have liked. The percentage of the latter is often too great.

Make the hill express its bulk as a hill.

Make the wagon express its carrying power.

I am not interested in color for color's sake and light for light's sake. I am interested in them as means of expression.

The eye should not be led where there is nothing to see.

A satisfactory painting of a head is almost the highest piece of composition.

¶I REGARD the salons of Paris and the big annuals as institutions detrimental to art. Art should not be segregated to a certain six weeks in the year. Art should be persistent; exhibitions should be small. Everyone enjoys Fifth Avenue, because there a series of very small exhibitions occur in the dealers' galleries. We enjoy them all, for they are not beyond our endurance and because they are divided into groups, a group in each gallery; we are thus enabled to see more and enjoy more than were they smashed together in one great hodge-podge.

And on Fifth Avenue art is persistent; we can always find something there in all seasons.

The Big Show should not be desired. All over the world art has been made into a three-ringed circus with salons. All who are familiar with modern art history know the "salon pictures" as a special and very overgrown and mongrel breed.

Letter, 1916:

¶THE question of development of the art spirit in all walks of life interests me. I mean by this, the development of individual judgment and taste, the love of work for the sake of doing things well, tendency toward simplicity and order. If anything can be done to bring the public to a greater consciousness of the relation between art and life, of the part each person plays by exercising and developing his own personal taste and judgment and not depending on outside "authority," it would be well. Moreover, if the buyers of pictures could be brought to believe that, whatever may be their interest in accredited old masters, they have, equally with the artists, their part to play in the development and the progress of art in our own time and place—that they, too, should enter the struggle for today's expression, lending a full support by purchasing the works of the strugglers and searchers of our day and risking many mistakes in their purchases, just as the artists are risking many mistakes in their efforts—it would be of public benefit.

To have art in America will not be to sit like a

pack-rat on a pile of collected art of the past. It will be rather to build our own projection on the art of the past, wherever it may be, and for this constructiveness, the artist, the man of means and the man in the street should go hand in hand. And to have art in America like this will mean a greater living, a greater humanity, a finer sense of relation through all things.

Few of our art critics are constructive. There is much little quibbling. I should like to see every encouragement for those who are fighting to open new ways, every living worker helped to do what he believes in, the best he can. The man of means should take his chance in the struggle, making mistakes in judgment along with the rest of us—a worker in the developments of his own time.

Out of it all, what is good will survive and will be known later; what is bad or negligible will pass and we shall have lived.

¶GO AND see the picture. I know you will like it. Put on a pair of false whiskers so you won't be bothered. I am thinking of a series of disguises for myself so that I can go to picture galleries and look at the pictures, and think about them.

There should be an art law prohibiting friends from recognizing each other in art galleries. If space were not so expensive I would suggest a "social" room adjoining each picture gallery where we could retire with friends, and ask and answer, "Where did you go this summer?"

¶DON'T make your picture like a picture, make it like nature. The result will be a picture just the same, but it will be a *new* picture.

¶DON'T let the painting of your background be the technique of seeping rain, nor that of tall grasses. Your background is mainly air in which is enveloped the distant curtain seen not with a direct eye. Your eyes are still looking into those of the model.

¶ORDER is perceived by the man with a creative spirit. It is achieved by the man who sincerely attempts to express himself and thus naturally follows organic law.

¶I THINK that this search for order, which is the artist's work, produces orderliness not only in mind, but in body. In my own experience I have sometimes felt all in, disturbed, not fit, but have had to start painting because of an appointment with a sitter. In an hour's work I have found myself O. K., fine, and at the end of the three or four or five hours' work have been tired, but altogether in better shape than when I started.

I have had the same experience when I have had to talk to a class of students. Often I start, very tired from other work, or distracted by little annoyances, with nothing to say and no invention in saying it, but am forced by the engagement to go on. Presently, as I make the struggle for orderly and relative ideas, the fatigue rolls away, order begets order, and a healthy state of mind and body exists. And again at the end I am tired, but in better condition than when I started. There is more than one way to rest and to recuperate, and it amuses me to say the paradox—that resting is often very fatiguing.

Of course, on the other hand, we find among artists and art students many who, instead of thinking and searching order, dash at their work in a wild splashing frenzy, without reason, without an interest in finding the way, just wanting the goal, screaming and stamping their feet to get it—not interested in the process of getting it. Such as these, practicing in disorder, wear themselves out, destroy.

To study art is to study order, relative values, to get at fundamental constructive principles. It is the great study of the inside, not the outside of nature. Such a pursuit evokes justice, simplicity, and good health.

¶BERTHE MORISOT learned a great deal from Manet, but she expressed her own, a woman's, vision.

Art is not in pictures alone. Its place is in everything, as much in one thing as another. It is up to the community as a whole, in conduct, business, government and play.

We will never have an art America until this is understood, and when this idea is really understood it will bring us about as near the millennium as we can hope to get.

¶I BELIEVE very much in the importance of a thorough study of the materials used. Their quality as to durability. An artist may not be a chemist but he can ascertain much from the books written by authorities.

I believe in the study of technique. One should know as far as possible all the *possibilities* of a medium.

I am not interested in technical stunts, in bravura. I am interested in simple expression. Not interested in painting the surface of things.

Paint must be so simply managed that it will carry understanding past the material fact.

Painting should never look as if it were done with difficulty, however difficult it may actually have been.

Motive demands specific technique.

Without motive, painting is only some sort of difficult jugglery.

The finer the motive, the more the artist sees significance in what he looks at, the more he must be precise in the choice of his terms.

Individuality and Freedom in Art*

¶IT SEEMS to me that before a man tries to express anything to the world he must recognize in himself an individual, a new one, very distinct from others. Walt Whitman did this, and that is why I think his name so often comes to me. The one great cry of Whitman was for a man to find himself, to understand the fine thing he really is if liberated. Most people, either by training or inheritance, count themselves at the start as "no good," or "second rate" or "just like anyone else," whereas in everyone there is the great mystery; every single person in the world has evidence to give of his own individuality, providing he has acquired the full power to make clear this evidence.

* From article in The Craftsman, 1909.

Twachtman was one of the men in America who could see the greatness of life about him. It chanced that he lived much in Connecticut and saw it there, but he would have found it in Spain or France or Russia, and had he gone to paint in those countries his art would have still been American. To me Twachtman is one of the giants in America. He got at the essential beauty of his environment and developed for himself a matchless technique. It is thus that art history must grow. There is no one recipe for this making of American artists, beyond affording to the men who have the gift the opportunity for supreme development and the right expression of it.

For instance, contrast the work of Twachtman and Winslow Homer. The same scene presented by these two men would be not an identical geographical spot but an absolutely different expression of personality. Twachtman saw the seas bathed in mists, the rocks softened with vapor. Winslow Homer looked straight through the vapor at the hard rock; he found in the leaden heaviness a most tremendously forceful idea. It was not the sea or the rock to either of these men, but their own individual attitude toward the beauty or the force of nature. Each man must take the material that he finds at hand, see that in it there are the big truths of life, the fundamentally big forces, and then express in his art whatever is the cause of his pleasure. It is not so much the actual place or the immediate environment; it is personal greatness and personal freedom which demands a final right art expression. A man must be master of himself and master of his word to achieve the full realization of himself as an artist.

That necessity is the mother of invention is true in art as in science.

It is a question of saying the thing that a person has to say. A man should not care whether the thing he wishes to express is art or not, whether it is a picture or not, he should only care that it is a statement of what is worthy to put into permanent expression.

In my understanding of color, there is absolutely no such thing as color for color's sake. Colors are beautiful when they are significant. Lines are beautiful when they are significant. It is what they signify that is beautiful to us, really. The color is the means of expression. The reason that a certain color in life, like the red in a young girl's cheek, is beautiful, is that it manifests youth, health; in another sense, that it manifests her sensibility.

We want inventors all through life; the only people that ever succeed in writing, painting, sculpture, manufacturing, in finance, are inventors.

¶EVERY stave in a picket fence should be drawn with wit, the wit of one who sees each stave as new evidence about the fence. The staves should not repeat each other. A new fence is rather stiff, but it does not stand long before there is a movement through it, which is the trace of its life experience. The staves become notes, and as they differ the wonder of a common picket fence is revealed.

¶ARTISTS are sometimes asked, "Why do you paint ugly and not beautiful things?" The questioner rarely hesitates in his judgment of what is beautiful and what is ugly. This with him is a foregone conclusion. Beauty he thinks is a settled fact. His conception also is that beauty rests in the subject, not in the expression. He should, therefore, pay high for Rembrandt's portrait of a gentleman, and turn with disgust from a beggar by Rembrandt. Fortunately Rembrandt is old enough not to have this happen, and the two, the gentleman and the beggar, flank each other on the walls in fine places. But the lesson has not been learned. The idea still remains, that beauty rests in the subject.

The artist wants to paint the baby as he has seen it in the naturalness of its usual clothes. The mother wants it painted in its new dress and cap. There is nothing left of the baby but a four-inch circle of a fractional face, all the rest is new clothes.

Many things pass in the course of a day.

¶IDLE philanthropy is a sort of disease.

It is all very well to form societies for the Encouragement of Deserving Young Artists, and people go at these things with a spirit of benevolence and a faith in their infallibility that is appalling. They seem to think that benevolence will do the whole thing, and do not realize that what they have undertaken is as much a matter of mind as it is of heart.

The plan is usually to pick out the deserving and presently to give prizes to the most deserving.

I ask, "How are we old fellows to know when a young fellow is deserving?" and the stare I get as an answer means, "Why, who should know if not we great old fellows?" and they say, "We will have a committee, a jury!"

Throughout the whole history of art, committees and juries, whoever composed them, have failed to pick winners. Oh yes, there are a few instances, but they are so few that they only serve as exceptions to prove the rule.

To cite one great instance. Take the history of art in France. Practically every artist who today stands a glory to French art was rejected and repudiated by the committees and juries.

So the young artists are to be noticed, and if they are deserving, we, the old fellows, are to hand down by our judgment encouraging awards to the little fledglings.

How does the young artist look at it?

If these young artists are really deserving it must be because they have already ideas and opinions which belong to them, and their generation. It is quite likely they don't want our judgment.

Are we not too anxious to have our fingers in their pie as well as in our own?

Can't we ever realize that it is not for the old to judge the young—that it is the young who must judge the old?

To award prizes is to attempt to control the course of another man's work. It is a bid to have him do what *you* will approve. It affects not only the one who wins the award, but all those who in any measure strive for it. It is an effort to stop evolution, to hold things back to the plane of your judgment. It is a check on a great adventure of human life. It is negative to the idea that youth should go

forward. It is for the coming generation to judge you, not for you to judge it. So it must happen, whether you will it or not.

If you want to be useful, if you want to be an encouragement to the deserving young artist, don't try to pick him or judge him, but become interested in his *effort* with keen willingness to accept the surprises of its outcome.

To struggle for an open forum for exhibition without the control of juries, and for greater opportunity to all for self-education, means an exercise not only of benevolence but of mind. To do this is not to be an old fellow reposing in the past and interfering with the future. It is part of the building of greater opportunity, and whoever participates in it is still alive and young, and will profit by it, for in the field he has helped to open there will grow new and wonderful things, and among them he may choose and judge in the way which is his right, that is, for himself, not for others. He may award with his personal appreciation, or pass money by purchasing, but this will be a personal affair.

I repeat, if our attempt to help young artists is to be by giving them prizes which *we* award, we demand of them that they please *us*—whether they please themselves or not. Let the work they do get its honor in being what it is.

Prizes generally go amiss. The award of prizes has the effect of setting up a false discrimination.

We must realize that *artists are not in competition with each other*.

Help the young artists—find for them means to make their financial ways easier, that they may develop and fruit their fullest—but let us not ask them to *please us* in doing it.

If we find, individually, that any of their works

please us, let us buy as far as we can, and rouse others to buy from them according to their personal choice. In doing this there will be quite enough judgment exercised. In fact if we become in this way participators in the new adventures, it is likely that our powers of judgment will broaden. I cannot conceive of myself as a buyer only of old pictures—turning my back on the adventures of today.

Finally, I say—don't force the prize game on the "deserving young artist"—leave it for the old children of our own generation to play with and let it die with them.

¶APPRECIATION of life is not easy. One says he must earn a living—but why? Why live? It seems as though a great many who do earn the living or have it given them do not get much out of it. A sort of aimless racing up and down in automobiles, an aimless satisfaction in amassing money, an aimless pursuit of "pleasure," nothing personal, all external. I have known people who have sat for years in the cafés of Bohemia, who never once tasted of that spirit which has made life in Bohemia a magnet. These people were not *in* Bohemia—they were simply present. Really bored to death although they did not know it, and poisoned too by the food and drink—being inert they were open prey to it. They and their kind, in the various ways, are in hot pursuit of something they are not fitted to attain. It takes wit, and interest and energy to be happy. The pursuit of happiness is a great activity. One must be open and alive. It is the greatest feat man has to accomplish, and spirits must flow. There must be courage. There are no easy ruts to get into which lead to happiness. A man must become in-

teresting to himself and must become actually expressive before he can be happy. I do not say that these people are devoid of the possibility of happiness, but they have not been enough interested in their real selves to have awareness of the road when they are on it. They no doubt fall into moments of supreme pleasure, which they enjoy, whether consciously or unconsciously. It is these moments which I am sure prevent them from suicide. There are, however, others who do recognize their great moments, and who go after them with all their strength.

Walt Whitman seems to have found great things in the littlest things of life.

It beats all the things that wealth can give and everything else in the world to say the things one believes, to put them into form, to pass them on to anyone who may care to take them up.

There is the hope of happiness—a hope of development, that some day we may get away from these self-imposed dogmas and establish something that will make music in the world and make us natural.

Of course, if a man were to plump suddenly into the world with the gift of telling the actual truth and acting rightly, he would not fit into our uncertain state, he would certainly be very disturbing —and most probably we would send him to jail.

We haven't arrived yet, and it is foolish to believe that we have. The world is not done. Evolution is not complete.

"My People" *

¶THE people I like to paint are "my people," whoever they may be, wherever they may exist, the people through whom dignity of life is manifest, that is, who are in some way expressing themselves naturally along the lines nature intended for them. My people may be old or young, rich or poor, I may speak their language or I may communicate with them only by gestures. But wherever I find them, the Indian at work in the white man's way, the Spanish gypsy moving back to the freedom of the hills, the little boy, quiet and reticent before the stranger, my interest is awakened and my impulse immediately is to tell about them through my own language—drawing and painting in color.

I find as I go out, from one land to another seeking "my people," that I have none of that cruel, fearful possession known as patriotism; no blind, intense devotion for an institution that has stiffened in chains of its own making. My love of mankind is individual, not national, and always I find the race expressed in the individual. And so I am "patriotic" only about what I admire, and my devotion to humanity burns up as brightly for Europe as for America; it flares up as swiftly for Mexico if I am painting the peon there; it warms toward the bull-fighter in Spain, if, in spite of its cruelty, there is that element in his art which I find beautiful; it intensifies before the Irish peasant, whose love, poetry, simplicity and humor have enriched my existence, just as completely as though each of these people were of my own country and my own hearth-

* Article in *The Craftsman*, 1915.

stone. Everywhere I see at times this beautiful expression of the dignity of life, to which I respond with a wish to preserve this beauty of humanity for my friends to enjoy.

This thing that I call *dignity* in a human being is inevitably the result of an established order in the universe. Everything that is beautiful is orderly, and there can be no order unless things are in their right relation to each other. Of this right relation throughout the world beauty is born. A musical scale, the sword motif for instance in the Ring, is order in sound; sculpture as the Greeks saw it, big, sure, infinite, is order in proportion; painting, in which the artist has the wisdom that ordained the rainbow is order in color; poetry—Whitman, Ibsen, Shelley, each is supreme order in verbal expression. It is not too much to say that art is the noting of the existence of order throughout the world, and so, order stirs imagination and inspires one to reproduce this beautiful relationship existing in the universe, as best one can. Everywhere I find that the moment order in nature is understood and freely shown, the result is nobility;—the Irish peasant has nobility of language and facial expression; the North American Indian has nobility of poise, of gesture; nearly all children have nobility of impulse. This orderliness must exist or the world could not hold together, and it is a vision of orderliness that enables the artist along any line whatsoever to capture and present through his imagination the wonder that stimulates life.

It is disorder in the mind of man that produces chaos of the kind that brings about such a war as we are today overwhelmed with. It is the failure to see the various phases of life in their ultimate relation that brings about militarism, slavery, the longing of one nation to conquer another, the willing-

ness to destroy for selfish unhuman purposes. Any right understanding of the proper relation of man to man and man to the universe would make war impossible.

The revolutionary parties that break away from old institutions, from dead organizations are always headed by men with a vision of order, with men who realize that there must be a balance in life, of so much of what is good for each man, so much to test the sinews of his soul, so much to stimulate his joy. But the war machine is invented and run by the few for the few. There is no order in the seclusion of the world's good for the minority, and the battle for this proves the complete disorganization of the minds who institute it. War is impossible without institutionalism, and institutionalism is the most destructive agent to peace or beauty. When the poet, the painter, the scientist, the inventor, the laboring man, the philosopher, see the need of working together for the welfare of the race, a beautiful order will be the result and war will be as impossible as peace is today.

Although all fundamental principles of nature are orderly, humanity needs a fine, sure freedom to express these principles. When they are expressed freely, we find grace, wisdom, joy. We only ask for each person the freedom which we accord to nature, when we attempt to hold her within our grasp. If we are cultivating fruit in an orchard, we wish that particular fruit to grow in its own way; we give it the soil it needs, the amount of moisture, the amount of care, but we do not treat the apple tree as we would the pear tree or the peach tree as we would the vineyard on the hillside. Each is allowed the freedom of its own kind and the result is the perfection of growth which can be accomplished in no other way. The time must come when the

same freedom is allowed the individual; each in his own way must develop according to nature's purpose, the body must be but the channel for the expression of purpose, interest, emotion, labor. Everywhere freedom must be the sign of reason.

We are living in a strange civilization. Our minds and souls are so overlaid with fear, with artificiality, that often we do not even recognize beauty. It is this fear, this lack of direct vision of truth that brings about all the disaster the world holds, and how little opportunity we give any people for casting off fear, for living simply and naturally. When they do, first of all we fear them, then we condemn them. It is only if they are great enough to outlive our condemnation that we accept them.

Always we would try to tie down the great to our little nationalism; whereas every great artist is a man who has freed himself from his family, his nation, his race. Every man who has shown the world the way to beauty, to true culture, has been a rebel, a "universal" without patriotism, without home, who has found his people everywhere, a man whom all the world recognizes, accepts, whether he speaks through music, painting, words or form.

Each genius differs only from the mass in that he has found freedom for his greatness; the greatness is everywhere, in every man, in every child. What our civilization is busy doing, mainly, is smothering greatness. It is a strange anomaly; we destroy what we love and we reverence what we destroy. The genius who is great enough to cut through our restraint wins our applause; yet if we have our own way we restrain him. We build up the institution on the cornerstone of genius and then we begin to establish our rules and our laws, until we

have made all expression within the commonplace. We build up our religion upon the life of the freest men that ever lived, the men who refused all limitations, all boundaries, all race kinship, all family ties; and then we circumscribe our religion until the power that comes from the organization blinds and binds its adherents. We would circumscribe our music, we would limit the expression of our painter, we would curb our sculpture, we would have a fixed form for our poet if we could. Fortunately, however, the great, significant, splendid impulse for beauty can force its way through every boundary. Wagner can break through every musical limitation ever established, Rodin can mold his own outline of the universe, Whitman can utter truths so burning that the edge of the sonnet, roundelay, or epic is destroyed, Millet meets his peasant in the field and the Academy forgets to order his method of telling the world of this immemorial encounter.

I am always sorry for the Puritan, for he guided his life against desire and against nature. He found what he thought was comfort, for he believed the spirit's safety was in negation, but he has never given the world one minute's joy or produced one symbol of the beautiful order of nature. He sought peace in bondage and his spirit became a prisoner.

Technique is to me merely a language, and as I see life more and more clearly, growing older, I have but one intention and that is to make my language as clear and simple and sincere as is humanly possible. I believe one should study ways and means all the while to express one's idea of life more clearly. The language of color must of necessity vary. There are great things in the world to paint, night, day, brilliant moments, sunrise, a people in the joy of freedom; and there are sad times,

half-tones in the expression of humanity, so there
must be an infinite variety in one's language. *But
language can be of no value for its own sake,* it is
so only as it expresses the infinite moods and
growth of humanity. An artist must first of all re-
spond to his subject, he must be filled with emotion
toward that subject and then he must make his
technique so sincere, so translucent that it may be
forgotten, the value of the subject shining through
it. To my mind a fanciful, eccentric technique only
hides the matter to be presented, and for that rea-
son is not only out of place, but dangerous, wrong.

All my life I have refused to be for or against
parties, for or against nations, for or against people.
I never seek novelty or the eccentric; I do not go
from land to land to contrast civilizations. I seek
only, wherever I go, for symbols of greatness, and
as I have already said, they may be found in the
eyes of a child, in the movement of a gladiator, in
the heart of a gypsy, in twilight in Ireland or in
moonrise over the deserts. To hold the spirit of
greatness is in my mind what the world was created
for. The human body is beautiful as this spirit
shines through, and art is great as it translates and
embodies this spirit.

Since my return from the Southwest, where I
saw many great things in a variety of human forms
—the little Chinese-American girl, who has found
coquetry in new freedom; the peon, a symbol of a
destroyed civilization in Mexico, and the Indian
who works as one in slavery and dreams as a man
in still places—I have been reproached with not
adding to my study of these people the background
of their lives. This has astonished me because all
their lives are in their expressions, in their eyes,
their movements, or they are not worth translating
into art. I was not interested in these people to

sentimentalize over them, to mourn over the fact
that we have destroyed the Indian, that we are
changing the shy Chinese girl into a soubrette, that
our progress through Mexico leaves a demoralized
race like the peons. This is not what I am on the
outlook for. I am looking at each individual with
the eager hope of finding there something of the
dignity of life, the humor, the humanity, the kind-
ness, something of the order that will rescue the
race and the nation. That is what I have wanted to
talk about and nothing else. The landscape, the
houses, the workshop of these people are not neces-
sary. I do not wish to explain these people, I do not
wish to preach through them, I only want to find
whatever of the *great spirit* there is in the South-
west. If I can hold it on my canvas I am satisfied,
for after all, every race, every individual in the race
must develop as nature intended or become extinct.
These things belong to the power of the ages. I
am only seeking to capture what I have discovered
in a few of the people. Every nation in the world,
in spite of itself, produces the occasional individual
that does express in some sense this beauty, with
enough freedom for natural growth. It is this ele-
ment in people which is the essence of life, which
springs out away from the institution, which is the
reformation upon which the institution is founded,
which laughs at all boundaries and which in every
generation is the beginning, the birth of new great-
ness, which holds in solution all genius, all true
progress, all significant beauty.

It seems to me that this very truth accounts for
the death of religions. The institutionalized religion
doubts humanity, whereas truth itself rests upon
faith in humanity. The minute we shut people up
we are proving our distrust in them; if we believe
in them we give them freedom, and through free-

dom they accomplish, and nothing else matters in the world. We harness up the horse, we destroy his very race instincts, and when we want a thrill for our souls we watch the flight of the eagle. This has been true from the beginning of time. It is better that every thought should be uttered freely, fearlessly, than that any great thought should be denied utterance for fear of evil. It is only through complete independence that all goodness can be spoken, that all purity can be found. Even indecency is bred of restriction not of freedom, for how can the spirit which controls the ethical side of life be trusted except through the poise that is gained by exercise? When we think honestly, we never desire individuals bound hand and foot, and the ethical side of man's nature we cannot picture as overwhelmed and smothered with regulations if we are to have a permanent human goodness; for restrictions hide vice, and freedom alone bears morality.

I wonder when, as a nation, we shall ever learn the difference between freedom and looseness, between restriction and destruction,—so far we certainly have not. When people have the courage to think honestly, they will live honestly, and only through transparent honesty of life will a new civilization be born. The people who think and live sincerely will bear children who have a vision of the truth, children living freely and beautifully. We must have health everywhere if we are to overcome such civilizations as we see falling to pieces today, not only health of body, but health of mind. Humanity today is diseased, it is proving itself diseased in murder, fire, hideous atrocity.

The more health we have in life the fewer laws we will have, for health makes for happiness and laws for the destruction of both. If as little children, we were enabled to find life so simple, so trans-

parent that all the beautiful order of it were re-
vealed to us, if we knew the rhythm of Wagner,
the outline of Pericles, if color were all about us
beautifully related, we should acquire this health
and have the vision to translate our lives into the
most perfect art of any age or generation.

I sometimes wonder what my own work would
have been if I could as a child have heard Wagner's
music, played by great musicians. I am sure the
rhythm of it would have influenced my own work
for all time. If in addition to this great universal
rhythm, I could have been surrounded by such art
as Michelangelo's frescoes in the Sistine Chapel,
where he paints neither religion nor paganism, but
that third estate which Ibsen suggests "is greater
than what we know"; if these things had been my
environment, I feel that a greater freedom of under-
standing and sympathy would have come to me.
Freedom is indeed the great sign which should be
written on the brow of all childhood.

There are other things I should like to speak of
which have been important to me as a painter. In
addition to a sense of freedom, a sure belief that
only the very essence of the universe was worth
capturing and holding, perhaps one of the most val-
uable things for the painter to study is economy,
which is necessary in every phase of life, almost the
most valuable asset a man can possess. But in
painting especially, a man should learn to *select
from all experience,* not only from his own but from
that of all ages, essential beauty. He should learn
through wisdom to gather for his work only the
vital and express that with the keenest delight and
emotion. The art that has lasted through all ages
has been culled in this way from often what seemed
meagre opportunity. Beethoven must have cap-
tured his Ninth Symphony only through the surest

understanding of what was essential to hold and translate to the world. He was not listening carelessly or recklessly to the melody which is held on the edge of the infinite for the man with spiritual ears; rather he was eager, intense, sure, wise and economical as he gathered beauty and distilled it into that splendid harmony which must forever hold the world captive. And so all great music, great prose, everything beautiful must depend upon the sure, free measure with which it is garnered and put into language for the people, for each lovely thing has its intrinsic value and belongs in its own position for the world to study, understand and thrive upon.

In various ways the free people of the world will find and translate the beauty that exists for them; the musician most often in the hidden space of the world, the sculptor closer to nature, feeling her forms, needing her inspiration; the poet from the simple people in remote countries; the painter it seems to me, mainly from all kinds and conditions of people, from humanity in the making, in the living. Each man must seek for himself the people who hold the essential beauty, and each man must eventually say to himself as I do, "these are my people and all that I have I owe to them."

¶THERE is the new movement. There always has been the new movement and there always will be the new movement. It is strange that a thing which comes as regularly as clockwork should always be a surprise.

In new movements the pendulum takes a great swing, charlatans crowd in, innocent apes follow, the masters make their successes and they make

their mistakes as all pioneers must do. It is necessary to pierce to the core to get at the value of a movement and not be confused by its sensational exterior.

¶HERE is the model with light on his face, a white collar, a brown coat, black tie, black hair, gray background.

I have named enough things to make a great picture.

Get the most expressive design out of these, each one treated as a simple mass.

See how much beauty in shape can be got out of the association of these notes: flesh, collar, coat, tie, hair, background.

They must all fit into the area of the canvas.

They must act and react on each other as the notes in music act and react on each other.

These six notes may, through their contrasts of shape, of color, of texture, produce powerful emotion.

To work this way is to work as a designer.

All good drawing or painting is compositional.

Better see what you can do on your canvas with these simple notes and for the time being let all details go.

It is useless to keep on adding things to a canvas.

Some painters put thousands of big and little features into a face, colors and more colors.

All day long they keep adding more and more.

They are like whales in a sea with their mouths wide open swallowing everything that comes along.

Much can be done with little.

¶MANY times in the work of the class I see things which are equal to the greatest. Flashes of truth and a technique so simple and comprehensive that nothing could be better.

Flashes come before a steady flame and flashes come only to die out.

Your work is intensely interesting to me. I come always to the class with expectancy.

If one could only know better when he has touched near the truth.

We are troubled by having two selves, the inner and the outer. The outer one is rather dull and lets great things go by.

To a Teacher:

¶IF I were you I would prefer a short and courageous career in art teaching to one that would be prolonged by hedgings. What does it matter if by standing for the thing you really believe in, fighting for it, giving to others the reasons you have used in your own conviction, making no weak concessions, you fail. Such failure is success. You keep your likeness, anyhow. Besides, you can depend on it, there are everywhere some people who will recognize your wisdom, truth and courage, and you will be well repaid by having won the appreciation of such people, even if you come back, as a result, out of a job and strapped. Many people would denounce what I have said as sentimental or even wild fanaticism. But don't be fooled. The diplomatic hedger is all about us. You and I have seen many of them grow up and develop their game. Some of them have bank accounts, and are very

respectable and safe citizens, but we are well aware of the price paid and know it is far too dear. There are two classes of human beings. One has ideas, which it believes in fully, perhaps, but modifies to bring about "success." The other class has ideas which it believes in and must carry out absolutely; success or no success. The first class has a tremendous majority, and they are all slaves. The second class are the only free people in the world. Some are kept under the grind of poverty. Some are sent to jail, but they are still the only free class. But the latter class does not always get ground under the heel, nor sent to jail. People are not always fools. There are those who only want "to be shown," want to know, and there must be someone who has the courage to show them. These are the words of the old teacher before you again—get mad at me if you like—but it's the same as I used to say when I was teacher and you were pupil, and it was such ideas, in which you then saw truth and value, that made you come to hear me. And it is because there are many people who are not fools and only want "to be shown," that in spite of the conventions of institutions, there has always been a place open for me, although there has never been a time that failure has not been predicted.

¶YOU go into a great cathedral and the impression may be deep upon you. Must you define what you have felt? If you can you are a poet—an artist. There are cathedrals which have measures of great and many meanings.

¶THE principles manifest in a Beethoven symphony are those of orderly growth.

A government could be constructed on the principle of a Beethoven symphony.

The principle of growth is important to your student who wishes to prepare himself before entering the art school. He should take such studies as lead to this knowledge.

An unrestricted study of sociology should interest him, for he must be intensely humane.

And in mathematics he should go just as far as he can, for proportion is his means of expression.

Ability to copy lines, shapes, tones, amounts to little.

Ability to correlate lines, shapes, tones, is the rare and necessary quality of the artist.

All good art is composition.

A portrait that is not a composition is not a portrait.

The painter deals with areas. He should *know* areas.

A line is not good because it is like a line.

A line is good because of its power related to other lines, which are powers.

Every line, area, tone, value, texture, in fact every effect produced in any way, including even the pressure of the brush, should be considered as a compositional or constructive element.

The substructure must be understood.

Any deviation in "finish" from the principle of the substructure is weakness and death to the thing as a work of art.

It is clear to see how a thorough knowledge of geometry would be valuable to the artist whose ideas are to be expressed in apparently magical proportions.

It would be well for the artist to get his training in mathematics early so that his use of such knowledge will be "instinctive" later on. He should know

while studying mathematics the great value the study is to give in his later work.

I am not proposing a "scientifically hampered" artist, but one who is unhampered by ignorance, who understands well the means he employs.

As to study for those in the industrial arts, I should say that the same principles as above mentioned should apply, for art is art, whether on a canvas, in stone, on a book cover, an advertisement or a piece of furniture.

In the class-study the current methods of hand and eye and very little head or heart procedure should be given up. There are thousands of art students in every big city. Art schools and art students. The schools have thousands, but they turn out few artists, and most that do turn out well are school renegades. The methods have not been the best.

Lines and forms should be regarded by the student from the very beginning as compositional factors, as measures.

The exterior of the model is not the model.

Any boy or girl sees more than the exterior. It is their nature to do so.

The methods of the art school of today bring them back to the surface so that they see the model in the terms of the surface and not in the terms of reality, and so their drawings and the art they produce may be but the negligible skill and trick, which have vogue for a while, and then die.

Lines and forms are not fixed things. They compose differently to different sensibilities, and to the same observer they change their endings and beginnings (although the model has not moved) because the individual cannot see always the same. He is sometimes his greater, sometimes his lesser self.

The student, from the beginning, should evoke

his greater self, realize that his work is a matter of construction (and a different construction from that generally conceived in the art school).

The difference between *light* and artist's *pigments* should be studied. They should not be confounded.

He should note the similarities which exist in color and music.

Intervals of color across the spectrum.

Intervals of color towards neutralization by mixing of complements.

Intervals in the mixing of colors with white and the constructive power which rests in the opposition of warm colors to cold colors.

I am not interested in art as a means of making a living, but I am interested in art as a means of living a life. It is the most important of all studies, and all studies are tributary to it.

I hope to see the heads of educational institutions give up the idea that their art teaching should be such as will prepare the student to earn the greatest amount of money. Art is certainly not a pursuit for anyone who wants to make money. There are ever so many other better ways.

In the past every step of human progress has been directed by art and science. These two are inseparable, and cannot exist in their pure sense, the one without the other. Theirs has been the effort to apprehend from nature the principles by which we must live if we are to extricate ourselves from the uncertainties and misunderstandings in which we now find ourselves.

It is for this reason that art study should not be directed towards a commercial end. Educational institutions should assist the student and the public to a better understanding of the meaning of the

word "art" and the need of study and individual development.

Letter of Criticism:

¶ADVICE about your paintings is difficult. As I said to you before, I cannot interest myself in whether they will pass juries or not. More paintings have been spoiled during the process of their making, through such considerations, than the judgments of juries are worth.

The object of painting a picture is not to make a picture—however unreasonable this may sound. The picture, if a picture results, is a *by-product* and may be useful, valuable, interesting as a sign of what has past. The object, which is back of every true work of art, is *the attainment of a state of being,* a state of high functioning, a more than ordinary moment of existence. In such moments activity is inevitable, and whether this activity is with brush, pen, chisel, or tongue, its result is but a by-product of the state, a trace, the footprint of the state.

These results, however crude, become dear to the artist who made them because they are records of states of being which he has enjoyed and which he would regain. They are likewise interesting to others because they are to some extent readable and reveal the possibilities of greater existence.

The picture is a by-product of such states as it is in the nature of man to desire. The object therefore is the state. We may even be negligible of the by-product, for it will be, inevitably, the likeness of its origin, however crude.

It is for this reason that we find at times works by children, or by savages, little acquainted with the possibilities of the materials they have left their impress on, and scant of tools to work with, filled with such qualities as to cause us to hail them as great works of art.

The need of activity, or expression, which the state evokes in most individuals is the cause of technical research. We make our *discoveries* of technique while in the state because then we are clear sighted. But at all times we are engaged in research. Our object is to be ready.

If a certain kind of activity, such as painting, becomes the habitual mode of expression it may follow that taking up the painting materials and beginning work with them will act suggestively and so presently evoke a flight into the higher state.

There are artists who find themselves always at the easel saying that they want to be there, tools in hand; in the saddle urging on the great departure.

Contemplative appreciation of a *trace*; a picture, hearing music, observing a graceful gesture, may cause the spirit to flame up. We care for and treasure the traces of states of greater living, fuller functioning, because we want to live also, and they inspire to living. That is the value of "a work of art." The traces are inevitable. The living is the thing.

The reason so many artists have lived to great age and have been so young at great age is that to such extent they have lived living, whereas most people live dying.

The *states* of which I have spoken are healthy states, they are natural—not supernatural. In them the mind and body, all the man, is in a state of order, perfect for functioning. Each time he attains the state he gains not only the greater life of the

moment but an effect on mind and body which is lasting.

I have spoken of activity being inevitable as a result of such states, and the ancient Hindoo might be cited, sitting in contemplative inactivity, as refutal of this, but it is well to note that the only ground we have to believe in the loftiness of his contemplation has been through his words or his acts, however seldom these have taken place. The activity need not be violent or continuous.

The Hindoo's state of contemplation is many times referred to as supreme or pure because of near total negation of material interests. Wherever we have had knowledge of the quality of his contemplation he has touched material things. He has left the *trace* which we may read. Purity is in the state, in being in the state, because the state is true living. Things touched while in this state are transformed into a likeness of the state. The stone of the ancient Greeks was so transformed.

The Hindoo denied the world and died of this denial. The Greek acknowledged the world and commanded it, made stone and the many things of life subservient to his state. The world won from him in the end, but his step was a stage gained in man's struggle to live in full function. What we have that is great in old India is of those periods where man was so well in the state that he had no fear of material and made of it a vehicle of expression. His object was not to make Art. His object was to live. He did not fear what he touched as a result of the activity created by his state. In having his state and with free rein to the activity engendered by it, the inevitable happened—the by-product—art—the trace of his being.

In all times, as in our times, the domination of

the world has stood the enemy of the artist—the one who would live. The demand to pass juries, to make the acceptable, the salable, fighting off the wolf from the door, obtaining of medals for the weight they have in waging the social war; all these things, certain and terrible in their exactions, have held the slave with his eye on the by-product, and the by-product has suffered, for the by-product cannot produce itself.

Things being as they are, the life of an artist is a battle wherein great economy must be exercised. The kind of economy which will result in moments of the purest freedom in spite of the world's exactions.

If one is a painter this purest freedom must exist at the time of painting. This is as much as to say that a painter may give up his hope of making his living as a painter but must make it some other way. This is generally true, although some do, by a freak of appreciation, make enough while going their way to live sufficiently well. Perhaps this happens, but I am not sure but that there is some curtailing of the purity of the freedom.

I was once asked by a young artist whether he could hope to make any money out of his work if he continued in his particular style of painting. He happened to be a man of considerable talent and had great enthusiasm in his work. But I knew there was no public enthusiasm for such work. I remembered he had told me that before he got really into art he had made a living by designing labels for cans, tomato cans and the like. I advised him to make tomato-can labels and live well that he might be free to paint as he liked. It happened also that

eventually people did buy his early pictures, although he was as far from pleasing by what he was doing at this time as ever before. He now lived on the sale of his old pictures and was as free to paint his new ones as he had been in the days of tomato cans.

What is past in this letter is the most important part of my advice to you in regard to your work. What follows probably will be more technical.

A fault I find is a lack of solidity. By solidity I mean the employment of bulk as a factor of expression. Forms interacting with forms. The weight and density of the sea. The bulk and hard resistance of rock. The cavern of the sky. A blouse with a body in it. A head with a back to it. Bulk is only one of the factors of expression, but it is a mighty force. Putting form against form, color against color, line against line, movement against movement, texture against texture and showing their interaction, showing through them the force which binds them, is the way of good painting and drawing. It's a question of the life within.

How can solidity be obtained? What is the recipe? It is a matter of conception. If in your *state* you have the sense of it, in your work you will have the will for it. Whoever cares most for the body which the blouse screens from the eyes will paint the body in painting the blouse, for in the *state* one sees through. In like fashion the wrinkles and folds will become signs of movement, not only of a blouse but of the life one senses in the individual.

Very technically speaking, thicker paint, a fearlessness in painting over and not being afraid of

spoiling in so doing, may be conducive to a development of more solidity, just as a larger brush will sometimes induce a broader treatment. There is some consideration of the nature of the materials you use in these statements, and there is the value of suggestion in them. But whatever dodge you try, what you will succeed in suggesting is only what you have actually *conceived*.

Of the three beach pictures, I like most in them the emotional quality. Like also the lilt of the gulls and the rhythm of movement in the gulls collectively. Solidity as I have described it would add much to the work. I may say that the compositions are rather the expected. In this regard I will refer to that rare quality of the unexpected in Chinese paintings. Also will remark that solidity does not require thickness of paint. A Chinese painting is almost invariably solid. A Sung drawing, though it may be but lines, very solid. The artist sensed form highly—got in his lines what he sensed because nothing else would satisfy him.

In the calm beach; red rock a good note, sea a bit attenuated, horizon line monotonous, ordinary, not richly expressive of what it means. This line is so important in the composition that it must be strong in interest. There must not be weakness of foreground. The eye is expected to pass over it because it must *feel* to be there, solid, and not attenuated.

Foregrounds being generally out of interest are hard to do. But they must be sufficient. The small canvas—feeling that it is wind-swept, good. But here meagre foreground. Three textures—sky, sea, sand. We consider red, yellow and blue-green a good chord in color if they are well differentiated. Sea, sky, sand are a good chord of textures if well differentiated.

The head. A background is a certain color, but see a head before it and the background color changes. A head makes its own background. Movements in background must grow out of head. We come to see only what relates. In your backgrounds I see paint-brush strokes, not forms related to head. Study massing of heads by masters. Dignity of each mass in relation with others. Every shape on a Velasquez head is a grand thing and every shape pays a compliment to the other shapes, an organization of great units. Note how few changes of direction in great drawing. Economy. When change occurs, it counts. Where is the dominant light? See how a master would mass the hair. Note that your sterno-mastoid sags, has not the grand gesture of youth and delicacy.

Notwithstanding all these criticisms you have heart for the work. You love the things. You have a heart feeling for the girl, and a respect. Forget about the exhibitions and the juries. Think less of the success of the by-product and you will have more success with it. Keep living. And that means keep on painting.

¶IT IS not easy to know what you like.
Most people fool themselves their entire lives through about this.

Self-acquaintance is a rare condition.

There are men who, at the bottom of the ladder, battle to rise; they study, struggle, keep their wits alive and eventually get up to a place where they are received as an equal among respectable intellectuals. Here they find warmth and comfort for their

pride, and here the struggle ends, and a death of many years commences. They could have gone on living.

¶PAINT like a fiend when the idea possesses you.

¶THE tramp sits on the edge of the curb. He is all huddled up. His body is thick. His underlip hangs. His eyes look fierce. I feel the coarseness of his clothes against his bare legs. He is not beautiful, but he could well be the motive for a great and beautiful work of art. The subject can be as it may, beautiful or ugly. The beauty of a work of art is in the work itself.

¶USE the ability you already have, and use it, and use it, and make it develop itself.

Don't just pay your tuition and drift along with the current of the school. Don't just fall in with the procession.

Many receive a criticism and think it is fine; think they got their money's worth; think well of the teacher for it, and then go on with their work just the same as before. That is the reason much of the wisdom of Plato is still locked up in the pages of Plato.

Make compositions. Use the knowledge you acquire in the life class at once.

Like to do your work as much as a dog likes to gnaw a bone and go at it with equal interest and exclusion of everything else.

It isn't so much that you say the truth as that you say an important truth.

¶GESTURE and music are alike in that they have powers of extension beyond known measurements.

In looking at a great piece of sculpture—the Sphinx, we may be impressed by a sense of time. The sculptor seems to have dealt in great measures, not the ordinary ones. I believe that some such impression as this is received by most of those who contemplate the Sphinx, that it certainly does convey something outside its material self, something in very great measure. There is a peculiar feeling of awe in its presence.

In viewing the Greek sculptures there is a similar sense. The measures in the modeling are not casual external measures, but seem to be such as to convey a sense of the life within. External measures have been used therefore by the artist in their analogous sense—not in their material sense.

This may explain the great difference in impression we receive from works of different periods in art history and also the differences we feel in one artist's work from another in spite of the fact that they may be equals in matters of skill.

In some works, marvelous though they may be, the spirit of the observer seems to be caged within the measures employed, and in other works, more marvelous, the spirit seems to be liberated into a field of other and greater measures.

In the first type of work we find ourselves caught and held in fascinating intricacies. In the second we find cause to take departure and enter into a condition of new and yet very personal states of consciousness. One catches us and shows us its marvels. The other is incentive to a personal voyage of discovery. The first type can eventually be exhausted. The second can remain as a perpetual incentive to new flights.

The men of action in the world have fixed their interests in different ways at different times, and at the same times men have taken different roads. The marvels of external beauty for one and the marvels of the internal life for the other, and in painting and sculpture the means of expression is in either case external appearances. But such different uses must they make of external appearances! It is a finding of *signs*.

We realize that there is no one way of seeing a thing no matter how simple that thing may be. Its planes, values, colors, all its characteristics are, as it were, shuffled before each new-comer arrives, and it is up to him to arrange them according to his understanding.

Once when I was a young student I heard another student spoken of as "one who saw color beautifully." I was very much impressed by this. So one has not only to see color but he must see it beautifully, meaningly, constructively!—as a factor in the making of something, a concept, something in his consciousness, something that is not exactly that thing before him which the school has said he should copy. This thing of seeing things. All kinds of seeing. Dead seeing. Live seeing. Things that are mere surfaces. Things that are filled with the wondrous. Yes, color must be seen beautifully, that is, meaningfully, and used as a constructive agent,

borrowed from nature, not copied, and used to build, used only for its building power, lest it will not be beautiful.

It is very hard to see this aspect, our aspect, of the thing before us. It is very hard because it is the simplest thing we do. If you could catch yourself while on some ramble in the woods and know the source of your happiness, and continuing the same kind of seeing, proceed to paint, the work you would do would be eventually a revelation to you. Eventually, I say, for at first it would shock you, so different would it be from that convention which has enslaved you. It would be your original output. The easiest thing is the hardest. It is harder to be simple than it is to be complex. Schools of new vision rise and fall. The type of that man who said he couldn't see shadows purple but hoped soon to do so, is yet our average type.

We are not yet developed to the plane where there are many who would pit their own originality against the fashion of the day.

It is, however, to the artist or to the scientist— there are times when the distinction disappears— that we look for that freedom which will return us to simple understanding.

Our future freedom rests in the hands of those whose likeness will be in their dissimilarity, and who will not be ashamed of their own originality, whatever the fashion may happen to be.

¶TO ANSWER, to the best of one's ability, the questions of a child is fine teaching. This is as beneficial to the teacher as it is to the child. If the question finds the teacher unprepared he is stimulated to research on the point in question.

Many of these questions though apparently trivial

are fundamental, related to the beginning of a life. The teacher participates in the study and becomes a student along with the child.

We are all different; we are to do different things and see different life. Education is a self-product, a matter of asking questions and getting the best answers we can get.

We read a book, a novel, any book, we are interested in it to the degree we find in it answers to our questions.

When the teacher is continually author both of the question and its answer, it is not as likely the answer will sink deep and get into service, as it will if the question is asked by the child.

Both methods properly used have their value, but one is much better than the other.

The special knowledge needed by one may not be much needed by another.

¶I AM particularly glad to hear that you have been painting from memory. I am quite certain your best work will come from dealing with the memories which have stuck after what is unessential to you in experiences has dropped away. Of course in many of your pictures, even painted in the presence of the subject, this thing did happen.

I know one beautiful street scene you sent to the exhibition that I have always felt was done in a trance of memories undisturbed by the material presences (that is if you did do it out of doors and with the street before you).

Especially in painting brilliant sunlight, working outdoors is difficult, for it takes a long time to get eyes accustomed to the difference between light and pigment so that anything like a translation can be made.

In fact I think most pictures of the Southwest are to a great extent false because the painters get blinded into whiteness, make pale pictures where the real color of New Mexico is deep and strong.

Anyhow, all work that is worth while has got to be memory work.

Even with a model before you in the quiet light of a studio there must come a time when you have what you want to know from the model, when the model had better be sitting behind you than before, and unless such a time as this does come, it is not likely the work will get below the surface.

From a Letter:

¶THERE is great beauty in your penmanship. The flow of it. It is just such apparently unimportant tendencies toward expression of something that runs deep in one, which make drawing beautiful or otherwise.

It seems to have been Rembrandt's very spirit which pushed the inked stick around for him, while many another appears to have been moved by intellect alone.

One of the attractions of Renoir is that at times his paint seems to have a flow, one color into and through another. One thinks of the elegance of mind that was back of the line. We seem to know the very spirit of Giotto. And the form of Manet! A beautiful dignity always in Velasquez!

It would be easy to divide artists into two classes: those who grow so much within themselves as to master technique by the force of their need, and

those who are mastered by technique and become stylists.

¶I CAN think of no greater happiness than to be clear-sighted and know the miracle when it happens. And I can think of no more real life than the adventurous one of living and liking and exclaiming the things of one's own time.

Letter of Criticism:

¶I SEE in the sketches a very personal outlook, an interest in the beautiful design of nature, a decided sensitiveness to the orchestration of color, good sense of form and the compositional possibilities of form.

All this I see so that the principal response I have to make is "go on." Going on will mean a continual attack with ever the will to get the fullest conclusion, to make every work as complete as possible. By "complete" I do not mean any conventional finish, but I do mean a complete statement of just what you feel most important to say about the subject.

A work of art is not a copy of things. It is inspired by nature but must not be a copying of the surface. Therefore what is commonly called "finish" may not be finish at all.

You have to make your statement of what is essential to you—an innate reality, not a surface reality. You handle surface appearances as compositional factors to express a reality that is beyond

superficial appearances. You choose things seen and use them to phrase your statement.

When I opened the package and set out the five panels, I had a decided satisfaction in them. The sense of beauty was refreshing. No. 3 caught me first.

No. 4 seems not to have the fine areas, weights, measures, variety, balance of the one thing against another as in No. 3, where the measures are excellent, giving those qualities called distance and atmosphere.

I find the white house a bit big for the other forms of the composition, big to be so empty. The incidents of door, windows, fence, roof and chimney do not seem sufficient to take away from the baldness of this large and prominent area of the house.

With an area so large and prominent, which *attracts* so much, there should be more interest to warrant the attraction. This interest might be produced in many ways. Variation in color, in light and dark, etc. The green tree to right is to me the finest incident in the composition. This has life. One does not *stop* in seeing it. There is an engaging variation.

In sound there may be monotony—one note prolonged to infinity.

There may be variety.

Variety may be a devilish jangle.

Variety may be such as to produce a popular air.

Variety may be such as Beethoven employed.

Good composition in painting is equally a fine employment of measures.

Compare your painting of the *things* of No. 4 with those of No. 3.

Does not each thing look more precious in No. 3?

Compare white house with white house, window with window, incidental stave, stick or other interruption with each other. You will find them all functioning, alive, interesting in No. 3. It is only in that tree in No. 4 that one feels an equal life. The why of this is that there is coördination in No. 3. The *things* are parts of a whole. Each thing benefits the whole, its neighbor, all its neighbors, and is receiving benefit from all of them. This is the principle of order. Each thing is more than itself alone.

In the great compositions of sound, the notes have a power beyond what we might have hoped for them. They enrich their surroundings and are enriched by their rich surroundings.

In the efforts to accomplish composition there are many rules and schemes established, some of them good and some of them bad. But one thing I am certain of, and that is that intense comprehension and intense desire to express one whole thing is necessary. Without a positive purpose, means effect only an exercise in means.

You can't know too much about composition. That is; the areas you have to fill, their possibilities, but you must, above all, preserve your intense interest in life. You must have the will to say a very definite thing. Then, the more you know your means the better.

I put a different meaning to the words *things* and *forms*.

I once had a pupil whom I considered an artist, and he was an artist despite the fact that he never drew the model in even reasonable anatomical proportion. This was too bad, but the proportions of the *forms* in their areas on the canvas, the proportions and "steps" made in his colors, values, lines, were beautiful. He was remarkable in expressing with what might be called *form* proportions, and

not at all good in expressing with *thing* proportions.

You have surely a sense of beauty and romance in reality. You do not have to soften and sweeten nature to make it beautiful. You are plainly not of the sort who think a work of art or a thing beautiful must be a cheat. You like nature, do not feel that you have to apologize for it, and you believe in its integrity, you like integrity. You think nature is all right, that there are endless, inexhaustible pleasures, and revelation in it. You believe that it is worth while getting frankly acquainted with, and that it is worth while trying to tell about the deepest intimacies of this acquaintance, to tell in paint, or in any other way, in fact. Your work tells me this much, because perhaps I am looking for it, anxiously expecting and desiring it in all work, and because I am used to pictures. That's the reason I say "go on." I do not say "go differently." You have to go on satisfying yourself more and more in order that others less keen to see and less used to reading pictures will get the song you sing. Your only hope of satisfying others is in satisfying yourself. I speak of a great satisfaction, not a commercial satisfaction.

There are people who buy pictures because they were difficult to do, and are done. Such pictures are often only a record of pain and dull perseverance. Great works of art should look as though they were made in joy. Real joy is a tremendous activity, dull drudgery is nothing to it. The drudgery that kills is not half the work that joy is. Your education must be self-education. Self-education is an effort to free one's course so that a full growth may be attained. One need not be afraid of what this full growth may become. Give your throat a chance to sing its song. All the knowledge in the world to which you have access is yours to use. Give yourself plenty of canvas room, plenty of paint room. Don't bother

about your originality, set yourself just as free as you can and your originality will take care of *you*. It will be as much a surprise to you as to anyone else. Originality cannot be preconceived, and any effort to coddle it is to preconceive it, and thereby destroy it. Learn all you can, get all the information that is within your reach about the ways and means of paint.

The best advice I have ever given to students who have studied under me has been just this: "Educate yourself, do not let me educate you—use me, do not be used by me."

What I would say is that you should watch your work mighty well and see that it is the voice that comes from within you that speaks in your work— not an expected or controlled voice, not an outside educated voice.

In the No. 2 there is beauty of open space, an expression in the temperature. There's a good over-all state of being in that landscape, and then that fence is beautiful in its color, it progresses.

You need not know a thousand tricks performed by others, you need not have a great stock of tricks of your own making. With a great will to say a thing comes clairvoyance. The more positively you have the need of a certain expression the more power you will have to select out of chaos the term of that expression. Your sense of color I am sure of. I think you see color in beautiful order in nature. You see color in construction. Some people only see color and more color. The great thing is what happens between colors. Some eyes see how lines go over a shoulder and over a hip, can copy them and make an indisputably honest statement of them; another eye may see the relation between them, will recognize them as powers in a great scheme.

I think you can have a wonderful time. It is really a wonderful time I am wishing you. Art is, after all, only a trace—like a footprint which shows that one has walked bravely and in great happiness. Those who live in full play of their faculties become master economists, they understand the relative value of things. Freedom can only be obtained through an understanding of basic order. Basic order is underlying all life. It is not to be found in the institutions men have made. Those who have lived and grown at least to some degree in the spirit of freedom are our creative artists. They have a wonderful time. They keep the world going. They must leave their trace in some way, paint, stone, machinery, whatever. The importance of what they do is greater than anyone estimates at the time. In fact in a commercial world there are thousands of lives wasted doing things not worth doing. Human spirit is sacrificed. More and more things are produced without a will in the creation, and are consumed or "used" without a will in the consumption or the using. These things are dead. They pass, masquerading as important while they are before us, but they pass utterly. There is nothing so important as art in the world, nothing so constructive, so life-sustaining. I would like you to go to your work with a consciousness that it is more important than any other thing you might do. It may have no great commercial value, but it has an inestimable and lasting life value. People are often so affected by outside opinion that they go to their most important work half hearted or half ashamed.

"What's the use of it if you are not making money out of it?" is a too common question. To what distinction an artist's labors are raised the moment he does happen to make money out of them! Very false values. I say this and I know as

well as any the difficulties of making sufficient money and the necessity of making it in order to live and go on.

Go to your work because it is the most important living to you. Make great things—as great as you are. Work always as if you were a master, expect from yourself a masterpiece.

It's a wrong idea that a master is a finished person. Masters are very faulty, they haven't learned everything and they know it. Finished persons are very common—people who are closed up, quite satisfied that there is little or nothing more to learn. A small boy can be a master. I have met masters now and again, some in studios, others anywhere, working on a railroad, running a boat, playing a game, selling things. Masters of such as they had. They are wonderful people to meet. Have you never felt yourself "in the presence" when with a carpenter or a gardener? When they are the right kind they do not say "I am only a carpenter or a gardener, therefore not much can be expected from me." They say or they seem to say, "I am a Carpenter!" "I am a Gardener!" These are masters, what more could anyone be!

I like your work and have only to ask you to go on your own interesting way with all the courage you can muster.

¶KEEP as far as possible all your studies, all your failures, if somewhere in them appear any desirable qualities.

Such canvases are good for reference.

Later study of the work recalls the good of it.

Sometimes an old unfinished canvas will serve as a recall from lesser and unimportant wanderings.

You can learn much from others but more from yourself. In looking at an incomplete canvas some time after its doing, the whole thing becomes clear, the tangle dissolves, and you see the way to complete it and how certain faults may be avoided.

Don't be ashamed to keep your bad stuff. After all you did it. It is your history and worth studying.

Shame makes a small man give up a lot of time smearing over and covering up his rough edges.

There is a wonderful work of art by Leonardo da Vinci, one of his most interesting. It is quite unfinished, yet perhaps it is one of his most finished, gets us in deeper. No work of art is really ever finished. They only stop at good places.

Shame is one of the worst things that ever happened to us.

There is weakness in pretending to know more than you know or in stating less than you know.

¶TECHNIQUE must be solid, positive, but elastic, must not fall into formula, must adapt itself to the idea. And for each new idea there must be new invention special to the expression of that idea and no other. And the idea must be valuable, worth the effort of expression, must come of the artist's understanding of life and be a thing he greatly desires to say.

Artists must be men of wit, consciously or unconsciously philosophers, read, study, think a great deal of life, be filled with the desire to declare and specify their particular and most personal interest in its manifestations, and must invent.

Exhibitions will never attract crowds or create

any profound interest until there is in the works exposed evidence of a greater interest in the life we live.

Letter of Criticism:

¶THE most important thing I can say to you is that your work shows the artist temperament; the tendency to produce impressions of life, as you find it fascinating, through the mediums of drawing and color.

All your things suggest action, or, better still, the state of mind which is the cause of action.

You have the gift of color. Look at Japanese prints. You will see in them these gifts developed to completion. The color is benefited by the form. The form is benefited by the color. They balance. They seem sufficient. There is no haste, yet they are as fast as one could desire them to be.

They are impressions of nature, often similar to yours. But they fill and satisfy. They have the sense of full completion.

The Japanese artist had no hurry to get away from the work lest it go wrong. He faced it out, and won out.

I would not have your drawings take on the conventions, but I would have them acquire the solid integrity, the certainty, of the Japanese prints.

Your *Children with the Balloons* (No. 1) is beautiful in color, in child action. The balloons appear to have been painted through the wondering eyes of the child. The balloons are as admirable as the child saw them.

Should they have more completion? I believe that

it is not in the balloons themselves that further completion should be sought, but it should be in establishing a finer relation in all the parts of the composition to the space of the whole.

Probably it would be good to say to you: Consider the whole space of your canvas as the field of your expression. A fine adjustment must be made within its limits. Your ideas must not wander, anywhere, within the confines of the canvas, but they must fill it completely.

A space may be left bare, but that bare space must become meaningful. It is a part of the structure nevertheless.

In the picture of the *two women in the rain* (No. 2) there is the look and the feel of a shower pouring down beautifully. The lines with which you have indicated the rain appear to have an easy haphazard look. But they cannot be haphazard for they have a fine rhythm and they do make me follow you into the spirit of rain. They have the science of design in them and the science is, as it should be, beautifully covered.

The *Portly Lady* (No. 3) with the market basket has the fascinations of Renoir color, and the humor of her shows your kindly spirit. This may be said of practically all your figures.

Courage to go on developing this ability to see in nature the thing which charms you, and to express just that as fully and completely as you can. Just that. Nothing else. Not to do as any other artist does. Nor to be afraid that you may do as any other artist does.

Do not require of your work the finish that anyone may demand of you, but insist on the finish which you demand.

When the thing suits you it is right. Your greatest masterpiece may be even more slight than any

of these things you have shown. Even more sketchy. But the order in the slight material you will use will be so positive, so certain and all comprehending that the fullest sense of your idea will be conveyed and it will be complete.

The most beautiful art is the art which is freest from the demands of convention, which has a law to itself, which as technique is a creation of a special need.

The demand we so often hear for finish is not for finish, but is for the expected.

Judging a Manet from the point of view of Bouguereau the Manet has not been finished. Judging a Bouguereau from the point of view of Manet the Bouguereau has not been begun.

I have just placed six more of your pictures before me. One need not bother you talking of color. You need but to command your medium and your sense and pleasure in color will do the rest. With an actual command of the medium, which you must work for, you will make beautiful things. In No. 4 the white is exquisite. But the seated figure is an ogre from lack of sustained intention.

No. 5. Beautiful in color and gesture and space relation of the figures.

No. 6. Again the beautiful relation of figures. They are in charming sympathy with each other.

No. 7. Interesting for the strident action and color.

No. 8. An excellent thing. Except that the table rests uneasily on its legs this canvas has the quality of relationship within its confines that gives to the whole a real integrity. Its spaces organize and one space illuminates the other. It has that largeness which we admire in the lithographs of Daumier.

No. 9. Altar boys. The *allegro* and the pomp. Such an excellent boy to our side of the priest.

What fine work you can do in this vein when your grip is stronger, when you can go the step of greater assurance. It will do well for you to look at Daumier's lithographs. His fancy is free. His statement is assured.

In the color of your No. 10 one imagines the voices in the air.

No. 11. A beautiful background.

No. 12. Charming color. Had you more security in your idea of the figures, which would have made you draw them hardly different, yet with more positiveness, this would be a splendid composition.

No. 13. Again the color, air, space, gesture of woman's head. Too bad she has such short fat legs; and that the ground is not substantial. By substantial I do not mean heavier, darker, nor this nor that, but simply had you considered it more as ground on which a woman walks, your feeling would have dictated the means of its substantiality.

Your drawings also show the artist in you. You are interested. You have art. What you say is as though it came from you. It is a personal interest of your own and it interests me.

You have a big *line*. It often gets cramped, but the big line is there and it can grow.

Daumier and the Japanese prints can be a good influence on you because you need not do like them.

I have just noticed the backs of two little girls walking away. But there are so many I might notice. A woman in red with another at her side. Little children walking parade. Children at a door. Fat party in cab. Groups of people. Foot bath. Sweepers. Fashions. People drooping in the rain. Women and children. And so forth, and so forth. All interesting matters of wit.

My best use to you is that I appreciate these

things. And my present appeal to you is to go on telling us what you like, giving us your delight in it all. It is the way the best artists have made themselves.

In going over these slight works of yours I have had a great pleasure. They might have been much heavier without having as much weight and I might not have had any pleasure at all.

Letter of Criticism:

¶IT IS the conception which dictates the form and the color. The world and life are common, every day, and almost empty to a great many people, but there are those who see that the world and life are mysteriously wonderful.

There is a latent possibility of specific and penetrating vision in each individual. The thing is to develop this possibility. The artists who count develop their vision, and the results, since each one is different from the other, are surprising and important.

I would call your attention to the reproductions of those children's heads done by Renoir. They are easily obtainable and they are very beautiful, even without the Renoir color. To have done such work Renoir must have been charged with a high estimate and a great reverence for the child, an unsentimental but a just appreciation of the wonder before him; and he must have been so charged at the very moment of the execution, for thus his hand was guided to a magic that makes his interpretation so wonderful.

In suggesting the works of masters, I do not mean that pictures like their pictures should be made, or that motives like their motives should be repeated. But I point rather to the principles which underlie their work. The principles of developed judgment, power of essay, power of intense feeling, intense respect.

Rembrandt's beggars are wonders of life. He did not pass them on to us saying simply, "They are vulgar fellows."

Besides this principle of motives, there is the principle of construction. The construction with paint on flat canvas of colors and forms, for the expression of ideas. The mastery of these mediums, understanding of limitations and possibilities within the borders of the canvas, and with the materials used.

And these two; the motive and the means must be so brought together, so enacted at the same time, that their action is as one.

It will not do to have your fine thought yesterday, and paint your picture today.

I advise the study of the works of the masters. Titian is a good one, for he understood organization, as his works demonstrate, and he happens to be available in many reproductions. Observe his compositions of figures and his portraits of men and women. See how much use he makes of balances and rhythms. Study these things well. Look for the way the pictures are laced and bound together by their lines, how they flow in currents which control your sight and your interest. See the masses of light so held in size in spite of detail, and the masses of dark, all of such weights and such measures that there is fullness, sufficiency.

Good painting is a result of effort to obtain order, and the order must go to all the sides of the canvas. Thus serene dignity, static repose, vitality, action, variety, and the various states of life can be suggested.

The exclusion of the trivial must be effected.

I am not considering so much either the merits or demerits of your present work. I am trying to say things that will be useful to you just as though I were saying them to myself—for they would, and I hope will, be useful to me.

¶IN THE faces painted by Greco we get something of what was real—what happened in Greco. Novels are sometimes more historical than histories.

We read books. They make us think. It matters very little whether we agree with the books or not.

Ibsen clearly identifies his characters. These characters, however, are merely his materials. It is not *Hedda Gabler* he introduces to us. It is a state of life and questions as to the future of the race.

Today we do not know how much we owe to Shakespeare. His work is no longer confined in his writings. All literature has been influenced by him. Life is permeated with the thoughts of Plato, with the thoughts of all great artists who have lived. If you are to make great art it will be because you have become a deep thinker.

¶NATURE is sometimes seen through very obscure evidences.

¶IT IS a big job to know oneself, no one can entirely accomplish it yet—but to try is to act in line of evolution. Men will come to know more of themselves, and act more like themselves, but this will be by dint of effort along the line of humble self-acknowledgment. Today man stands in his own way. He puts a criterion in the way of his own revelation and development. He would be better than he is and because man judges poorly he fails to become as good as he might be. He should take his restraining hands off himself, should defy fashion and let himself be. The only men who are interesting to themselves and to others are those who have been willing to meet themselves squarely. The works of the masters are what they are because they are evidences from men who dared to be like themselves. It cost most of them dearly, but it was worth while. They were interesting to themselves, and now they are interesting to us.

Letter from New Mexico:

¶HERE in the pueblos of New Mexico the Indians still make beautiful pottery and rugs, works which are mysterious and at the same time revealing of some great life principle which the old race had. Although some hands lead, the whole pueblo seems responsible for the work and stands for their communal greatness. It represents them, reveals a certain spirituality we would like to comprehend, explains to a degree that distinction which we recognize in their bearing.

Materially they are a crushed out race, but even

in the remnant there is a bright spark of spiritual life which we others with all our goods and material protections can envy.

They have art as a part of each one's life. The whole pueblo manifests itself in a piece of pottery. With us, so far, the artist works alone. Our neighbor who does not paint does not feel himself an artist. We allot to some the gift of genius; to all the rest, practical business.

Undoubtedly in the ancient Indian race, genius was the possession of all; the reality of their lives. The superior ones among them made the greater manifestations, but each manifested, lived and expressed his life according to his strength; was a spiritual existence, a genius, an artist to his fullest extent. Apart from that, they raised crops, covered themselves, attended to the material according to their understanding, and wandered of course afar into that dark life outside the artist life, into war and strife, and all the fruits of material greed—like ourselves.

Behind them they have left some records of both existences, but we cherish most those which tell of a certain spiritual well-being, the warm heart in love with life and working with a love of work which is the song of their well-being.

In America, or in any country, greatness in art will not be attained by the possession of canvases in palatial museums, by the purchase and bodily owning of art. The greatness can only come by the art spirit entering into the very life of the people, not as a thing apart, but as the greatest essential of life to each one. It is to make every life productive of light—a spiritual influence. It is to enter government and the whole material existence as the essential influence, and it alone will keep government

straight, end wars and strife; do away with material greed.

When America is an art country, there will not be three or five or seven arts, but there will be the thousands of arts—or the one art, the art of life manifesting itself in every work of man, be it painting or whatever. We will then have to give in kind for what we get. And every man will be a true enrichment to the other.

Any step toward such an end is a step toward human happiness, a sane and wholesome existence. Much will come of the effort. There will be failures as well as successes, but if the strong desire exists both conditions will serve as experience in progress.

¶GESTURE, the most ancient form of expression—of communication between living creatures.

A language we have almost lost.

Its infinite possibilities of expression.

To recapture gesture as a means of expression would mean not only added powers of communication but would mean also a greater health and strength.

¶IN GREAT cities public art galleries are generally put in out-of-the-way places—remote from most of the people. A visit requires an elaborate effort and more time in going and coming than people can spare.

Having an idea of the educational influence of

art, I would like to see many small well-organized art galleries scattered over a city, furnishing easy access to each community—whatever that community might happen to be, rich, poor, business or residential.

In the same spirit I favor the Little Theatre movement, and I would like to see places in every neighborhood for good music by the best of musicians, so that their precious influence might be spread over all the community. This of course could not be done so long as the only will comes from the box office.

As to the art galleries, what I am thinking of particularly is rotary exhibitions of the best works owned by the great central museum. In this way a series of very fine collections would be kept in motion going *to* the people.

Anyone can see the pleasure and the benefit these exhibitions would give, how they would be frequented in spare hours by those who rarely have more than an hour's freedom at any one time.

The existence of these small neighborhood galleries would in no way deflect from the importance or the usefulness of the big museum—in fact they would be a great help.

¶IF YOU have the idea that an artist is not a decidedly practical person, get over it.

Don't think that Frans Hals was drunk when he painted his vital pictures. Let the romancing historians think so, but just look at one of his heads and realize what cool generalship and positive, immediate decision were necessary to place those solid forms in action and to render so much completion with such simple strokes. Wonderful judgment in the conception and execution of these works. A

great order in them. The whole thing an invention.
No copying. He must have had a fine working
mind and he must have used it as its master. I'll bet
his tools were the best, and everything in the right
condition, and the right place, for immediate use.

One man, all distinguished bearing, another fat
and soft, with a ribald joke on his lip, one made of
iron, and by his side a dandy.

Frans Hals liked them all for what they were and
he gave his best to each one.

Every bit of Frans Hals' painting is sheer inven-
tion. Examine the structure in the strokes which
make the heads. They are parts of mighty buildings.
Look at a mere tassel on a boot or a sword hilt, you
will find it a marvelous composition.

Frans Hals was a man of wonderful judgment.
He saw life and people in his own peculiar way and
he was a supreme master of the tools in his hands.

¶I BELIEVE that keeping one's faculties in
full exercise is the secret of good health and longev-
ity. It made Titian a young man at nearly a hun-
dred.

Perhaps mental inactivity is the most fatiguing
thing in the world. It is a common thing for busi-
nessmen to die soon after they retire. That is, if
they do not take up some new enterprise in life.

There are cases of actual rejuvenation as a result
of new enterprise more interesting than that which
preceded.

¶CRITICAL judgment of a picture is often
given without a moment's hesitation. I have seen
a whole gallery of pictures condemned with a

sweep of the eye. I remember hearing a promi-
nent artist on entering a gallery declare "My eight-
year-old child could do better than this." The sub-
ject of the charge was a collection of modern pic-
tures with which the artist was not familiar. There
were pictures by Matisse, Cézanne and others.
Works of highly intelligent men; great students
along a different line. The works, whatever any-
one might think of them, were the results of years
of study. The "critical judgment" of them was ac-
complished in a sweep of the eye.

All kinds of critics, professional, artist, student
and lay critics are prone to bring with them their
preconceived ideas. Many of them are outraged if
they do not find what they expect. Such people
want peace—they want no new sensations, and they
want nothing that is hard to get.

The critical spirit which is yet to develop will
invite difficulties, will wish to be disturbed into
revaluations. New works will inspire to further
energy. I have seen a picture judged, acknowledged
as good, and bought by a man without turning a
hair. He bought it really because it did not give him
a kick. It was a further proof that what he already
knew was sufficient. He bought it to dam the stream
of his own development.

¶THERE is an idea in America that people
can be told how to appreciate pictures. Whereas
the appreciation of art is a very personal and special
response to creative work. And it must be a part of
the province of the artist so to present his work as
to help create this response.

¶THE grip of a line.
Note how a line takes hold.

It hooks the vital parts together.

It binds the composition.

Look well at the model and look well at the drawings of masters and you will see why I speak of the *hook* of a line, which grips.

See the drawings of Rembrandt, the Chinese and the Japanese masters.

¶THERE is a portrait in the Louvre which has a great abrasion on the face, but somehow the abrasion does not spoil the work. It is there but it does not count.

The picture is the work of Tintoretto—a great master. His organization of forms is so powerful that it carries through the obliterated place.

¶WHEN you make figures in composition you may discover that you do not know the figure. Students work in schools making life studies for years, win the prizes for life studies and find in the end that they know practically nothing of the human figure. They have acquired the ability to copy. It is the common defect of modern art study. Too many students do not know *why* they draw.

If you are studying art and not making compositions, my advice is to begin immediately. You study from the model mainly to get experience. Your composition is the expression of your interests and in making your compositions you apply what you learn when working from the model. Your object in painting from the model is not to become a painter of school studies, but to become a painter of

whatever you have to express with figures, portraits, landscapes, street scenes, anything, in fact, that interests you.

Letter of Criticism:

¶DRAWING, disconcerted, going at random, now after one idea, now after another. Good drawing comes of a concerted movement, the selection of certain things, and the specifying of them with an end in view. To the expression of this end all the parts of the canvas must work. Features or parts of features, or accessories, all must be treated as factors in a general movement. However interesting they may be in themselves, in a painting they are parts of a sequence more important than themselves.

Throughout the whole canvas you should think of the effect of the big masses of color in their relation to each other. In a good canvas these big masses work together, have constructive effect on one another, just as in music. In well composed music you can't get away from the motive.

A hundred artists might work with you from that same subject, *The Girl and the Goldfish,* and assuming them all to be good artists, each one of them because of his motive would render the nose, the neck, the fish, all the parts, all the colors and all the values in different ways, some eliminating where others accentuate, and all the pictures, although different, would look like the model, all of them beautiful because the factors of each picture are selected and assembled with relation to their constructive value.

Now to deal with the work from another viewpoint and give you further criticism I will say that my impression of your two paintings made me feel that in doing them you were trying to fit yourself into a kind of work, done to your admiration by another artist, but quite outside *your* power of concept. I think your only salvation is in finding yourself, and you will never find yourself unless you quit preconceiving what you will be when you have found yourself. What, after all, are your greatest, deepest, and all-possessing interests? Most people seem to think they are great enough to know beforehand, and what generally results is that they imprison themselves in some sort of *Girl and Goldfish* subject, which, as I say, they may admire from the hand of another but for which they have no personal vocation. Those who are so imprisoned work like prisoners. You can see where the heart is out of it. Pictures tell the story of actual impulse in the artist—or the lack of it.

What you need is to free yourself from your own preconceived ideas about yourself. It will take a revolution to do it, and many times you will think yourself on the road only to find that the old habit has possessed you again with a new preconception. But if you can at least to a degree free yourself, take your head off your heart and give the latter a chance, something may come of it. The results will not be what you expect, but they will be like *you* and will be the best that can come from you. There will be a lot more pleasure in the doing.

Now these are only my opinions, I do not say they are final, nor do I say they are right, but they are my opinions. You have asked for them, and at any rate they are kinder to *you* than they are harsh to the two pictures.

¶YOU are often told that your painting is "very good—as far as it goes—but you should carry it further." You proceed to "carry it further," and find yourself carrying it backward. The trouble is most likely that you have added things to it where what was needed was a coördination of what had already been set down.

¶SOME people study hard for a time, then they "graduate" and sink back into the little they have learned.

There are many kinds of study. Those whose study is of the real and rare kind get the habit. They can't throw it off. It's too good. They go on studying all their lives, and they have wonderful lives.

¶IT IS not desirable to devote all your time to an appreciation of art. Art should drive you forth. It should be an incentive to life. The greatest value of art to the appreciator is in that it stimulates to personal activity.

¶WHEN you have made a sketch, close your box—walk away—then open your box. Maybe you will see that you have deflected from your original idea. What you have painted is not what seized you in the beginning—a vital impulse has been lost—go back and go after that first seizing idea—and refuse to be mastered by material things.

¶IT IS a mistake to think that spirituality is seen only through a mist.

¶THERE are some painters who deal with the play of light as the most graceful thing that exists.

¶WHAT does a man see when he goes to the Indian Dance? What are all these impressions? I have gone to many, had a perfectly delightful time, and then later hearing others talking of what they had seen, have found that from their point of view I had missed everything of importance. I have gone again and have struggled to see the "right" things. In doing so I have felt quite educational, but I have not had any happiness. The effort has prevented me from seeing what are *my* things in the dance. But what does a man see when he sees his own things? A few have found out—somewhat.

If a picture is not of these self-seen things, then it must be a mighty interesting accounting of externals. It must be strong in its kind. It would be a big job really to paint the Snake Dance. I have never seen it, but of course with my knowledge of other Indian dances, I have a ground to base imagination on. I know that I would see a vast country, an immense sky, great space. In this great space there would be the mesa, the pueblo, the little crowd of spectators, and then the dancers with rattlesnakes in their mouths. Something happening way off there, a little speck on the face of the earth. But how would I see it? Would it not be a reversal of all these proportions; the smallest become the largest. I can believe that the tiny little snakes would so enlarge upon me that I would be filled with an overpowering sense of their writhing strength, their quick and slow movements, strike and poison. They would dominate the sky and the

mountains, which would have to take shapes according to them. It would be the Snake Dance filling the universe.

Isadora Duncan dances and fills the universe. She exceeds all ordinary measure.

The difficulty for us is to know what, or how we see material things, when we are seeing beyond material things. If we could only know what we see, and paint what we see!

¶I AM glad to hear that you propose to take the bit in your teeth and buck for freedom. There is little use in painting—in living in fact—unless you let yourself grow your natural course.

You will have a wonderful time. Others (those who wish to dictate) will not be satisfied perhaps—but they are never satisfied anyway—and you will give them better than they know. At any rate what you will give will be news from *your* country. The big men have been rare simply because most men heed dictators.

Nobody wanted Walt Whitman, but Walt Whitman wanted himself, and it is well for us that he did.

Of course it is not easy to go one's road. Because of our education we continually get off our track, but the fight is a good one and there is joy in it if there is any success at all. After all, the goal is not making art. It is living a life. Those who live their lives will leave the stuff that is really art. Art is a result. It is the trace of those who have led their lives. It is interesting to us because we read the struggle and the degree of success the man made in his struggle to live. The great question is: "What is worth while?" The majority of people have failed

to ask themselves seriously enough, and have failed
to try seriously enough to answer this question.

Life is being wasted. The human family is not
having half the fun that is its due, not making the
beautiful things it would make, and each one is not
as good news to the other as he might be, just be-
cause we are educated off our natural track. We
need another form of education.

The great revolution in the world which is to
equalize opportunity, bring peace and freedom,
must be a spiritual revolution. A new *will* must
come. This *will* is a very personal thing in each
one.

Our education has led away from the realization
that the mystery of nature is in each man. When
we are wiser we will not assume to mould ourselves,
but will make our ignorance stand aside—hands off
—and we will watch our own development. We
will learn from ourselves. This habit of conducting
nature is a bad one.

If those who work in both pastels and oils could
get a bit of the quality of the one into the other a
good thing would happen. For instance, here is a
pastel all gay and pale in its pastel lightness and
there an oil deep in oily sogginess. The pastel
would benefit by a deeper note and a textural unity
of surface and the oil might come up out of the
gloom into which you have let it sink. It is not dark
because you willed it so. It is not lighter or more
luminous simply because you did not will strong
enough to have it so. In too many cases pastel stays
pale because it wants to be pale. Oil becomes dark
and muddy because it is easy for it to sink into
depths, and the artist is victim, not master.

Letter of Criticism:

¶GENERAL effect—far the best works I have seen of yours. Throughout there is a strong individual view of things. Individual enough to make them the unexpected, and therefore not likely to meet the formulated expectations of average "picture lovers." The readers of the various books on "How to Appreciate Pictures" will not have learned how to appreciate yours, therefore pioneer-like you will have a rough road to travel with your public. Where others are clever and precise you are not. Where you are clever and precise, others are not. You have not interested yourself in these subjects in the expected ways. You have disregarded what you should have been conventionally expected to regard; have neglected, slighted, slurred, done poorly where you would be expected to do your best, and have done well with insistence, with interest, where others neglect.

For the critics of their times, Manet, Corot, Millet, took interest in the wrong side of things. They did not do the expected, but were pioneers—followed their very individual whims, told their publics what they wanted their publics to hear, not what their publics already knew and wanted to be told over again.

In all your pictures the eyes are remarkable no matter what may be my criticisms—technical, anatomical or otherwise. They are remarkable expressions of human sensitiveness. In the usual phraseology it might be said "They arrest," "They haunt." They are inscrutable, and yet they seem to invite one in. The six figures standing here before me look

with their serious questioning eyes. They seem to ask me if there are not some deep sensations of life forgotten in this hurly-burly business of New York City.

You have study before you that will help you with this feeling you have about the "look of people." You will gain by adding to your knowledge of the anatomy of an eye. You can learn much from cool study of a living eye. Examine it closely and record in your mind just what and where are its parts.

You want to know an eye, nose, mouth, skull, the muscles. The sources of information are many, first the living feature itself, examined, studied. Then books on anatomy, photographs from life, reproductions from the works of great masters, then again the living feature itself.

The muscles are functioning always in life They show sometimes prominently—easy to see. An arm in its strength is not difficult because there the actions of the muscles are obvious. In other places it is hard to see the muscles, hard to see the action. One who knows what is under the skin will understand the slightest change on the surface. He is able to separate the important from the unimportant in all these evidences. He knows the nature of the thing. He sees the slightest sign that has meaning, and is not deceived by accidents.

If you actually know the human body you can draw most sensitive actions through clothes. You see the signs of life in the body through the clothes, and the wrinkles and folds of drapery become living things. You seize of them what is essential and discard the rest. Without knowledge and sense of the body, wrinkles and folds remain wrinkles and folds.

There are thousands, however, who have drawn from the nude model for years, and passed quite

well according to school standards, but who, never-
theless, do not know the human body.

There are thousands who paint the features of
the face and yet could not pass a childish examina-
tion in facial anatomy. This probably explains a
good deal of the lifelessness existing in portraiture.

The tendency of your color is straight, healthy,
honest. I know you have only to go on in order to
develop a most expressive color.

In your picture called *Grain* I admire very much
the rare independence in your vision of the sky.

The Brown-Eyed Girl with the Cat—Some frank
notes in the cat's head and good closed-eye charac-
ter. Handsome in blue ribbon and the girl's pigtails.
Not quite enough "whole note" to the dress. There
is a feeling for and a cherishing of the dress, but
the underlying or mass color is not sufficient. You
began painting variations before you established the
mass. Not so in the hair, excellent; and the face
excellent. I admire this. A fine piece of painting, a
frank rendering of character. I believe this is a good
likeness. It is certainly a distinct type.

When you are painting a background, don't fol-
low, unless there is a good reason to do so, the com-
mon habit of thinning the paint. Don't try to spread
too little paint over too great a surface. Mix if any-
thing more than is needed. Put it on so that it will
have the appearance of sufficiency. Repaint a back-
ground as many times as each new condition of the
painting in the head or body calls for a change in
the background. The reason for many a feeble,
false or inefficient background is lack of energy to
do the labor of it. Paint the background in such
a way as to appear to pass back of the head, not
simply up to it.

To return to the *Little Girl and Cat*, get a more

beautiful relation in the proportions of the body, arms, legs and chair, more significantly appreciated. That leg is painfully brittle and thin. Your brush stroke is too often the same in figure, chair and background. In using everywhere this same stroke it becomes meaningless and it robs each part of character, texture, perspective and distance.

The Man, austere, grave, wonderfully fine eyes, but undoubtedly exaggerated in their forms. Look again. It is excellent over-characterization, nevertheless. Arms stiff and scrawny. Don't believe they were so. Good chair. It holds him.

You are not yet a master of the medium, not yet in command, but fine of mind, serious, austere, showing that you are made of good stuff, should work. You will never become a popular painter. You are too much of an individual for that. Yours is a harder task, and one that will have fewer encouragers, but the popular painter is not in for as good a time as you are.

¶NEVER change the course of a line until you have to.

Never change the plane of a form until you have to.

Never change the tone of a color or from one color to another until you have to.

If you follow these injunctions intelligently you will practice that great economy which is necessary to expression in your medium.

Every change must count, and count strong. There must be no quibbling. You have the observer of your work under control. Through the changes you lead him straight or crooked into your meaning. If you have digressed into triviality he must digress with you. Where you hesitate or are uncertain, he

hesitates and is uncertain. If you are a quibbler and a flounderer, and not direct in your purpose, he turns his back on your work unless he is, himself, like you, happier in floundering.

Because the medium we use is very limited, we must exercise a great economy in its use.

No line or form or color must change until you are compelled by the necessity of the structure you are making to change it.

The need for change must be great. You only make the change because you must respond to an absolute demand.

You have reserved your forces but now you must expend them positively and effectively. A new course, full of meaning is to be taken, and by it the observer is to be carried deeper into your meaning. You have taken a positive step to force his understanding of your motive.

Some painters flutter all about their subjects, others are straight drivers to the essence of things.

A house has many windows, but a ray of light catches on one. It becomes the window which declares all windows. It is a builder and a vitalizer. It links with all the other structures—is one of the big factors in making the whole.

Your questions are, "What is essential?" and "How shall the greatest economy be practiced?"

Water runs down hill concisely. There is no quibbling about it. It does not have to run up hill in order to be entertaining. Man has always followed its course with fascination. The soul of man may reveal its mysteries through direct expression, simple speech, simple gesture, simple painting, just as the soul of the brook is expressed in full simplicity and economy.

One of the curses of art is "Art." This filling up

of things with "decoration," with by-play, to make them "beautiful."

When art has attained its place, surfaces will be infinitely less broken. There will then be millions less of *things,* less words, less gesture, less of everything. But each word and each gesture and everything will count in a fuller value.

When we have attained a sense of the relative value of things, we will need fewer things. We will not change a line or form or color until we *have* to—and when we do make a change, a wealth of meaning will then fill the world from this new gesture.

The most furnished rooms may have very little in them. The mere proportions of a room act on our sensibilities much more than is declared by our present consciousness. Man suffers, but it is in very little that he knows why he suffers. He is happy and he is equally ignorant. As he comes to know better the significance of *change* he can be less hurt and he can move more swiftly to his natural environment.

It is not the barrenness of an empty room, or an empty life that we seek, we would get rid of clutter, and thus get room for fullness.

On a face one accent rightly valued in all its powers is worth a thousand little forms. The little forms subtract more than they add. The right accent achieves.

Humanity may be divided into two distinct families. They are as different as opposites in their course of life. They do but confound each other in their effort to believe themselves alike. One family may be called the digressors—those who live with the billions of things, the billions of ideas which clutter up the surface of life.

The members of the other group tend toward a simplicity of sight, are conscious of a main current, are related to the past, see into the future, are not of the time present, but extend forward and back.

Be game—take a chance—don't hide behind veils and veils of discretion. The spirit of youth should be in the young. Don't try to be ponderous. Youth has clear eyes. Let your colors be as seen with clear eyes. Go forward with what you have to say, expressing things as you see them. You are new evidence, fresh and young. Your work, the spirit of youth, you are the progress of human evolution. If age dulls you it will be time enough then to be ponderous and heavy—or quit.

It takes a tremendous amount of courage to be young, to continue growing—not to settle and accept.

The most beautiful life possible, wherein there is no sordidness, is only attainable by effort. To be free, to be happy and fruitful, can only be attained through sacrifice of many common but overestimated things.

¶ON THE steps of the Prado I met a well-known French painter who was there like myself studying the Spanish masters. It was in 1900 and the great exhibition of Goya's work had just opened. He said "Have you seen the Goyas! A wonderful genius! What a pity he couldn't draw!" Goya drew well enough to make this man think he was a genius, anyhow.

¶MANET did not do the expected. He was a pioneer. He followed his individual whim. Told the public what he wanted it to know, not the time-

worn things the public already knew and thought it wanted to hear again. The public was very much offended.

¶WE HAVE Great Periods. Periods when we freshen, become disposed toward health and happiness, move forward into hopeful philosophy. Then comes the stamp of personal whim.

Technique becomes a tool, not an objective. We are interested and we have expressions we must make. All things are appreciated with an abundance of humor. There is an association with nature. Something happens between us and the flowers in a garden, a communication of gayety, a rhythm in the grass understood—something charming in a day's wash hung on the line—a song running through it all. Associations with nature. It's a state to be in and a state to paint in.

¶THERE is a past, present and future in the fall of a dress. Don't arrange it.

In the old days of long skirts the models used to wonder why I made them walk from the end of the room to the place where I would have them pose. They were to continue walking until I spoke, and then they were to stop and turn as though to hear what I had to say. It was not always a success, but eventually it would happen right, and the fall of the drapery would express the gesture of movement, the arrest and the possible next gesture. There would be a past, present and future, and there would be unity and rhythm in the dress.

¶CONTINUITY. You draw this leg as though it were *near* the body—so near that separa-

tion is not visible, yet you do not make me feel that the two are one. The leg must go right into and all through the body.

You can learn to make a good map of the model, but it will remain only a map unless you *intend* to make it more.

Map making is difficult, and in some cases useful, but our business is more important, infinitely more difficult and ever so much more interesting.

I do not say, however, but that a simply made map might serve you as something to underlay a drawing. But map making and drawing should not be confounded.

¶WE HAVE our choice of living in the past or the future—the present being but for an instant —not that of course, in fact. In the future there is the reality. The past is the history of our failure in attaining it.

¶SUPERFICIALLY there is negligence, but deep down in people there is love and craving for the beautiful. There are many who go through their whole lives without ever knowing when they have liked or what they have liked.

¶KEEP up the work. Try to reduce everything you see to the utmost simplicity. That is, let nothing but the things which are of the utmost importance to you have any place.

The more simply you see, the more simply you will render. People see too much, scatteringly.

A landscape has got to mean a great deal to anyone before it can be painted in any worth-while

way. It is harder to *see* a landscape than to paint it. This is true because there are lots of clever people who can paint *anything*, but, lacking the seeing power, paint nothing worth while.

The technique used to express a dull idea is of the nature of the idea, and however skilled it may be it is still dull. The technique of a fine idea is likewise born of the idea, and is like its parent. Seeing is not such an easy thing as it is supposed to be.

Letter to the Class:*

¶IT IS important that you reach out for all information regarding the materials you use. You must know your tools. You must have the best, and they must be in perfect arrangement for service. Painting requires great judgment and skill. In the effort to capture and record in paint one's sensations, there must be no handicap with the materials. It is only now and again that the best masters succeed, even though they have a highly developed technique.

It is characteristic of the masters who have the ability to now and again succeed, that they profoundly study the means and ways of their expression. They insist on good tools, and they develop a remarkable order in their preparation for work, and this order continues throughout their performance.

To be negligent, to be above such mean things as the materials one handles, to be a sort of genius in a dream, is a common misconception of an artist's

* Art Students League, 1915.

state. On the contrary his whole success in self-expression depends on order, or balance, which, in fact, is not only the means to the end, but the work itself is great in measure as it stands as a manifestation of order and balance. Such works give us our vision of freedom. For freedom can only be obtained through order—through a just sense of the relative value of things.

The technique of painting begins with the simplest mechanical issues and extends through to the heights of science.

You should begin with the simplest issues. See that your palette is a good tool, sizable for what you have to do. See that it is well set with clean pigment, ordered to the greatest convenience for your work. Be watchful of your need and enjoy the steady development of your craftsmanship. See to the size, quality and condition of your brushes, they are to be handled for a difficult operation. See to your medium. Are the cups right in size for your brushes? Are they securely attached in place most convenient for the service? Have you the rag and have you the other facilities for cleaning your brushes as you work? It is surprising how these and many more equally simple and equally important questions can seldom be answered in a favorable way.

A barber has an apparatus that is surprising, and all in such remarkable order. His intention is but to shave and cut hair with the least amount of discomfort to the sitter. An artist proposes to make a work of art, and while his work requires infinite skill, he is generally far behind the barber in the arrangement of the most ordinary necessities. Why should this be so? Why should a studio be a boudoir, a dream of oriental splendor to have tea in, a junk

shop, a dirty place, and rarely a good convenient workshop for the kind of thought and the kind of work that the making of a good picture demands?

Why should a palette be a crust of dirty, dust collecting, dried up paint in which little inadequate squeezes of fresh paint become confounded? Why shouldn't the whole thing be cleaned up every day, with ways devised for the saving overnight of the good paint that remains from the day's work? The reason for all these things is that one does as one's neighbor does, and as your neighbor is no more of a pioneer or inventor than you are yourself, you do not move out of your uncomfortable position until a new neighbor comes along and shoves you out of it—if such is possible, which it may not be, for many get ossified in matters of technique, and while they are not comfortable they are still immovable.

The thing to do is for each individual to wake up, to discover himself as a human being, with needs of his own. To look about, learn from all sources, look within, and find if he can invent for himself a vehicle for his self-expression. He has a world of precedents to begin on, some within his sight, and more can be found. Let him move about a bit; investigate the needs of his own case.

To have ideas one must have imagination.

To express ideas one must have science.

All this is to urge you to investigate, to read, to think. You will understand what the word *technique* refers to. You will wake up to the fact that the only education that counts is self-education. There are the facilities of the school, its advices,

there are books, strengths and weaknesses of those about you. All these things are good materials to the one who will use them constructively.

¶WHEN I read about artists and their works I am not as a rule interested in what is said about their works, but am keen to know of the personalities of the artists themselves. If I want to know about a picture I go to see it or I get a reproduction. I find it is usually not at all like the writer's description. Pictures explain themselves. They are their own describers.

Sometimes it does happen that the writer, in his effort to describe a picture, reveals himself; and if his philosophy is interesting it is worth hearing him, even if he has insisted on explaining a thing which is already self-explained.

When children are taken to a museum they are too often talked out of their personal appreciations.

A friend of mine took his two boys to the circus. It was their first circus. He was worried and discouraged because his boys did not get the thing. He kept saying to them "Look! Look!" but they were always looking the wrong way. It was pretty tough to find that his boys were not real boys. That night he left the table to read his paper. The boys remained with their mother, and from the next room he heard them tell what they had seen at the circus, and their account settled the matter. His boys were real boys! They had seen all and several times more than he had.

Letter of Criticism:

¶AS TO your "method" of work try something different. Take a change from your little fragmentary life-studies on a 5-by-9 paper. Cast about a bit.

My advice to you is to venture, meet some other difficulties, be a real student.

Real students go out of beaten paths, whether beaten by themselves or by others, and have adventure with the unknown.

There are few *students* in the schools. They are rare anywhere. And yet it is only the *student* who dares to take a chance, who has a real good time in life.

But remember that I say it is even possible for you to follow your old method and have the adventures and come out all right. It's altogether what you are able to get out of it.

Be sure that your decisions are really made by yourself. Decisions made by yourself may be of a nature very unexpected. In other words, very few people know what they want, very few people know what they think. Many think and do not know it and many think they are thinking and are not thinking.

Self-education is no easy proposition.

Men either get to know what they want, and go after it, or some other persons tell them what they want and drive them after it.

I can't tell you what you want to do, can't lay any plans for your doing it. You must surprise me. I am not interested in your being the kind of regular fellow who tells me what I know before. The

case is in your own hands. Get as much acquainted with yourself as you can. Question yourself. After a while you may get some answers. They will surprise and shock you, but they will interest you. Maybe you will get so that you will begin to do things for yourself. It will be very fine when you can begin to serve yourself.

After all, your "method" of work is nothing. Why be tied to any method? You will say that when you step out of your rut you don't do as well. But what does that matter? It may come better later. Anyway, don't be a slave to a "method," to a 5-by-9 piece of paper. Don't let anyone drive you away from your method and your 5-by-9 piece of paper. Don't be a slave either way. Ask yourself.

There is no school that will exactly fit you. There is no advice made just for your case. The air is full of advice. Every school is waiting, whether it is willing or not, for you to make it your school.

I do not know if this answer to your questions will be satisfactory to you, but it's the most useful I can give.

Do not let the fact that things are not made for you, that conditions are not as they should be, stop you. Go on anyway. Everything depends on those who go on anyway.

Letter Concerning Prizes and Medals:

¶THE pernicious influence of prize and medal giving in art is so great that it should be stopped.

You can give prizes justly for long-distance

jumps, because you can measure jumps with a foot-rule.

No way has been devised for measuring the value of a work of art. History proves that juries in art have been generally wrong. With few exceptions the greatest artists have been repudiated by the art juries in all countries and at all times. For a single example I will say that very few if any prizes or medals were awarded to the artists who are now in their old age, or after their death, the glory of France.

In fact most of them did not get past the jury of admission.

It's not that the juries do not mean well, or at least think they mean well, but it is simply that art cannot be measured.

The reason for the survival of the award system is purely commercial.

I suggest that you use the money to buy pictures; that you let this action carry with it the satisfaction which your approval of the artist may mean; that you choose the pictures you buy, yourselves, making your own mistakes, learning the lessons which you will learn from your own mistakes; and that you hang up the pictures you buy in your permanent collection to represent your judgment.

Every community should have its own will, and have the courage of it. Should develop its own power of judgment. Mistakes must be risked.

There are collectors who do not do much or anything for themselves in the field of art. They do not select their own pictures, but they pay another man to make what mistakes are to be made, and this man has a wonderful and improving time doing it.

Perhaps you will see by what I say, that I am

more interested in the artistic development of a community than I am in adding titles to artists' names.

Nothing can help the artist more than such actual participation as I suggest.

I should like every community to have a will of its own; to be distinctly like itself; to make its own mistakes; to make its own discoveries; to choose its own pictures, hang them up, and then take them down again when they no longer like them, and replace them with such others as they have come to like.

To visit such a community would be interesting, would shock or please, would shake us up a bit, and cause revaluation.

There would be some things in that place which one could not find in any other place. We might like or we might not like it, but the place would have its effect on us. It would not be negative.

An artist must educate himself, he cannot be educated, he must test things out as they apply to himself; his life is one long investigation of things and his own reaction to them. If he is to be interesting to us it is because he renders a very personal account. If a community is to be interesting to outsiders or have any sort of an existence, any sort of a good time, it must do likewise.

When a community starts afresh in matters of art, it takes on a big job. Not an outside job, but an inside job, and one that can be most enjoyable and most profitable.

The greatest honor you can do an artist is to buy his picture and hang it up in your gallery.

¶ALL art that is worth while is a record of intense life, and each individual artist's work is a

record of his special effort, search and findings, in language especially chosen by himself and devised best to express him, and the significance of his work can only be understood by careful study; no crack-judgment, looking for the expected, will do, nor can we be informed by the best critics, for appreciation is individual, differs with each individual and is an act of creation based on the picture which is an organization, not a mirror of the artist's vision; but the essential principle of it, and therefore of basic value to the creative impulse in the spectator.

All interesting developments in art have at first puzzled the public, and the best appreciators have had to suspend judgment during the period necessary for full consideration.

I value the effect of new notes on myself. I believe in constant revaluation.

To appreciate and get a great deal from a work of art does not mean to find the expected in it, nor does it mean, necessarily to accept or follow it wholly, in part, or at all. Every work is one man's vision, an outside experience, useful to us in our own constructions. The wisdom and the mistakes of the past are ours to build on, and the picture painted yesterday, now hanging on the wall, is already of the past and is a part of our heritage.

I regard the battlers for ideas and the builders of new roads with enthusiasm and reverence. Their works (the record of their struggles and findings) are things to watch and to cherish. This is the way I feel about the works of serious men whether they be of the past or of today.

I am not interested in any one school or movement, nor do I care for art as art. I am interested in life. The most we can desire of men is that they be masters of such as they have, and then we should be highly satisfied with them, and regard them as

neither less nor greater than any. Place them as themselves.

I claim for each one free speech, free hearing. I am interested in the *open forum*, open for every man to come with his word and for every man to come to hear the evidence, unticketed, unprejudiced by jury or critic.

¶IF YOU want to be a historical painter, let your history be of your own time, of what you can get to know personally—of manners and customs within your own experience.

John Leech was a comic artist on *Punch*, and while no one would care much to look over the Royal Academy catalogues of his time, the pages in *Punch* by John Leech hold our interest to this day. Leech is known as a "comic" artist, but his pictures went deep into life, and the choice of his expression, was noble. He is one of the greatest artists England has had, and because he was so interested in life as he found it his works have a great historical value.

Rembrandt did not go out of his own sphere to make his religious subjects—he applied the ideas to the materials of his own life. That is one of the reasons his work is so lasting in our interest.

If you must paint a "Good Samaritan" do not paint the old story, in the old form, but let your subject be the recurrence of the spirit of the good Samaritan as it presents itself to you in your own environment. These great moments didn't happen just once—they still continue to happen.

Perhaps some of you will recall seeing a picture painted by John Sloan of the backs of the old Twenty-fourth Street houses with the boys on the roof startling the pigeons into flight. It is a human

document of the lives of the people living in those houses. You feel the incidents in the windows, the incidents in the construction of the houses, the incidents in the wear and tear on them; in fact, the life of that neighborhood is all shown in the little line of houses, yellow and red houses, warm in the sunlight. And the quality of the sunlight is that of a caress; the houses, the atmosphere are steeped in its warmth. That canvas will carry into future time the feel and the way of life as it happened and as it was seen and understood by the artist.

Sometimes in looking at the people of an old Chinese painting I have felt how close in human kinship these ancients were to me. In all other forms of record they appear remote. The artist, who is not a materialist, sees more than the incident. He puts in his work, whether consciously or not, a record of sensibilities, and his work bridges time and space, bringing us together.

There are the beautiful drawings William Glackens has done of the children in Washington Square, and his streets on the East Side with their surge of life. In being great works of art they are none the less documents of life. Even the prints of these, clipped from the magazine in which they were published, are now treasured, mainly, of course, by artists (for artists do know something about art) and are shown to friends with a great pride in their possession.

Ever since the beginning there have been artists who have found in the simple life about them the wonderful and the beautiful, and through the fact of this inspiration have sensed the way to make the combinations of form and color we know as art.

¶GENIUS is not a possession of the limited few, but exists in some degree in everyone. Where there is natural growth, a full and free play of faculties, genius will manifest itself. The disposition to preconceive one's degree of genius, or the quality of it, is a mistake, for this preconception is a limitation.

The results of individual development cannot be foreseen, nor can these results be estimated by one in whom such development has not as yet taken place.

It is useless to study technique in advance of having a motive. Instead of establishing a vast stock of technical tricks, it would be far wiser to develop creative power by constant search for means particular to a motive already in mind, by studying and developing just that technique which you feel the immediate need of, and which alone will serve you for the idea or the emotion which has moved you to expression. You will not only develop your power to see the means, but you will acquire power to organize the means to a purpose. In this form of study there will be no less familiarization with what is generally found in all technical study. You will acquire a habit and ability to select and correlate. You will become a master and organizer of means, and you will understand the value of means as no mere *collector* of means ever can.

I have known many men who have read everything, have what is called a perfect education, and who while knowing everything know little of the essential qualities, or the possibilities, through organization, of anything. Such as these while appearing learned through familiarity with learning make no constructions of their own, for the genius in them is still dormant.

¶TO BE an artist is to construct, and to whatever degree one shows the genius for construction in work of any sort, he is that much an artist.

The *artist* life is therefore the desirable life, and it is possible to all.

Letter of Criticism:

¶BOTH yours received and the last understood in all its loneliness. You have a hard proposition, but I believe if you fight it through it will be all the better.

Of course you can't expect to go out and paint masterpieces every day, and you can't expect to equal steadily what you have already done.

Since I returned to New York I have done a good deal of work, but it has been discouraging because nothing yet has happened to put me beyond my rank and file of work; nothing that I will care to pick up and show and show again, as I do some things. Like some of those I did last summer.

But you have got to think there alone, and work to keep yourself company, and thinking and working is what counts. In the cities, in the studios, there is usually too little time to think matters through. Most things are skimmed, and people often believe they are doing quite a good deal themselves when they are only being jostled by others.

Up there, whatever will be interesting will be your ideas, and whatever will be done will be your work. But a man is human. Well, you are going to

Boston to a genial friend for a few days. Have a good time!

Coming down from the school with L—— the other afternoon we got talking of how free we were to work and think in dead old Haarlem; how it seems, eliminate and shirk as you will, there is no time here to do one's work. Trouble, friends, business, distances to travel, a million things great and small, no time to be long enough on any one idea.

Last summer was a good one. Looking back on what it forced on us; a dead place to work in, with that bunch of children, and you, your landscape, occasional flights for mild change to Amsterdam. And then after the long season of dead Haarlem and work, the solid bunch of simple amusement in Paris.

It looks to me as though you might break your long quiets by letting loose occasionally. But you are up against it and it is up to you.

You have gone there to find yourself. What you have started, this thing of becoming an artist, a real one, almost every man fails at. Few have the courage or stamina to go through the parts one has to go through alone in more ways than one.

I don't believe in being *in*human. I should feel sorry for the man who would not cry for company and for sympathy. The human creature must have these things, and when you can't stand it you will have to dig out and get your belly full—and then go back.

If you go through this winter you will come out a strong man and you will be well acquainted with yourself.

It's hard. I shiver with the cold. It is easy maybe to sit here and write this, seated by a steam radiator. But I know what it is to be in the cold and alone in

both ways. I have lived, a little younger than you, where there was equal cold and more exposure. I have known ever since what it is to be in the cold and alone, and sometimes desperately so, because I have believed what I believe and have stood by my believing.

You go on. The country is full of men who are working in the cold, or worse—too much heat—just to get enough to purchase a day's miserable existence. You are working for your character, and your pay is to last you all your life.

I admire you for your start and I like to see men do these things so much that I shall be shouting with joy when I see you win out.

Of course I do not believe in the place you have chosen more than another place. If you should think a warmer or a more populated place would be better don't consider stubbornness a virtue.

To work, mind and body, and to be alone enough to concentrate is the thing. I think you will like it there, though mind you, you have only been there a short time. You are not yet used to the weather. You can't jump from comfort into the conditions of such life. And then the snow is to come. Get ready for the wonder of it, and paint like a fiend while the ideas possess you.

I write so much because I admire you for the stand you have taken and I want to shout with joy because a man has taken the bit in his teeth.

As I said before, we can't hope always to succeed. But by fighting for it, out of the whole crop of a season's work there are surely some things that look like one's simple healthy view of life. If you paint two or three hundred canvases this winter and a dozen of them are really good and say your say of yourself, time and place, you can be happy.

Purposes of an Art School:

¶THAT of interest in the work. Development of a strong personal art in America through stimulating in students a more profound study of life, the purpose of art, a real understanding of *Construction, Proportion, Drawing*—stimulating activity, mental and physical, moral courage, invention in expression to fit the idea to be expressed; the study, therefore, of specific technique, not stock technique. Impressing the importance of the *Idea*, that it must have weight, value, be well worth putting forth and in such permanent medium. The development, therefore, of individuality, search for the just means of expressing same simply and fully. The development, therefore, of artists of mind, philosophy, sympathy, courage, invention. Taking their work as a matter of vital importance to the world, considering their technique as a medium of utterance of their most personal philosophy of life, their view of the subject—one that must be important and worthy of their powers of seeing and understanding. Drawing that is solid, constructive, fundamental, inventive, specific, adapted to the special needs of the idea to be expressed; such drawing as can come only from one who has a decided and special purpose, profound understanding, a realization of the importance of his word, and the evidence he has to give.

A school where individuality of thought and individuality of expression is encouraged. A school and instruction which offers itself to the student to be used by him in the building of himself up into a force that will be of a stimulating value to the

world. That he may *use* the school, its facilities, its instruction, that he may know that the school and the instructors are back of him, interested, watching, encouraging, as ready to learn from him as to teach him, anxious for his evidence, recognizing in him a man—another or a new force, giving him the use of its knowledge and experience, only demanding from him that he work both mind and body to the limit of his endurance to find in himself whatever there is of value, to find his truest thoughts and find a means, the simplest, straightest, the most fit means to make record of them. To be the deepest thinker, the kindest appreciator, the clearest and simplest, frankest creator he can be today, for by so doing he is the master of such as he has today, and that he is master today is the only dependable evidence that he will be master tomorrow; that he has dignity, worth, integrity, courage in his thought and action today proves that he is today a student such as is worthy of the name in its fullest meaning.

Letter:*

¶I HAVE no sympathy with the belief that art is the restricted province of those who paint, sculpt, make music and verse. I hope we will come to an understanding that the material used is only incidental, that there is artist in every man; and that to him the possibility of development and of expression and the happiness of creation is as much a right and as much a duty to himself, as to any of those who work in the especially ticketed ways.

* *Pleiades Club Yearbook,* 1918.

There is much talk of the "growth of art" in America, but the proof offered deals too often with the increase in purchases. I'm sure it often happens that the purchaser believes he has done his art bit for himself and for the public, when he has bought. Being a struggling artist myself, far be it from me to say he should not buy! But buying is not enough. We may build many imitation Greek temples and we may buy them full of pictures, but there is something more—in fact the one thing more which really counts before we can be an art nation—we must get rid of this outside feeling of looking in on art. We must get on the inside and press out.

Art is simply a result of expression during right feeling. It's a result of a grip on the fundamentals of nature, the spirit of life, the constructive force, the secret of growth, a real understanding of the relative importance of things, order, balance. Any material will do. After all, the object is not to *make art*, but to be in the wonderful state which makes art inevitable.

In every human being there is the artist, and whatever his activity, he has an equal chance with any to express the result of his growth and his contact with life. I don't believe any real artist cares whether what he does is "art" or not. Who, after all, knows what is art? Were not our very intelligent fathers admirers of Bouguereau, and was not Bouguereau covered with all the honors by which we make our firsts, and were they not ready to commit Cézanne to a madhouse? Now look at them!

I think the real artists are too busy with just being and growing and acting (on canvas or however) like themselves to worry about the end. The end will be what it will be. The object is intense living, fulfillment; the great happiness in creation. People sometimes phrase about the joy of work. It

is only in creative work that joy may be found.

To create we must get down to bedrock. You cannot construct unless you get at the principles of construction. The principles of construction are applicable to any work. If you get away from these principles, your structure will fall down when it is put to the test. Governments have fallen because their ideas of order were not based on natural principles.

Sentiment, money, violence were not the agents in the creation of that master work of art, the flying machine. The Wright brothers had a wonderful *will* to comprehend natural law. Billions of dollars could not buy, blind faith could not persuade, violence could not compel the flying machine. It came with the expenditure of comparatively little money, no sentimentality, and came easily, because they went to the right source.

We will be happy if we can get around to the idea that art is not an outside and extra thing; that it is a natural outcome of a state of being; that the state of being is the important thing; that a man can be a carpenter and be a great man. There is a book about a fisherman written by Jeanette Lee, called "Happy Island"—a very simple little book, but it is worth reading apropos, for that fisherman was a great man and had in him the secret of a great nation. I think a great nation must be a happy one.

I remember a great picture—it is no larger than my two hands—it represents seven pears, and evokes everything—cathedrals, beautiful ladies. Such was the spirit of the artist that for me he projected universal essentials of beauty. In his seven pears he evidently found a constructive principle and expressed it.

The great thing lies in the little things as well

as in the big. If I were to try to review the art of the past year it would be to estimate how far we have gone in this idea. But I will not try to review the art of the past year—it can't be done—it is too near to us. We have been terribly busy with it, and it is not yet through with us. Our past is our mystery. It is the tangle we have made of our hopes when we have come up to them. The future alone is clear.

¶NO NATION as yet is the home of art. Art is an outsider, a gypsy over the face of the earth.

¶THE only sensible way to regard the art life is that it is a privilege you are willing to pay for.

¶SELDOM has the great art or great science of the world been paid for at the time of creation. It has been given, and in general has been cruelly received. You may cite honors and attentions and even money paid, but I would have you note that these were paid a long time after the creator had gone through his struggles.

¶BREADTH is useless unless it effects expression. Sometimes an almost imperceptible note plays a great part in the making of a picture. It is not necessarily the obvious thing which counts strongest. The great moments of a day are sometimes such as hardly reach our consciousness, yet such moments may have made all the beauty and the success of the day. The almost imperceptible

note may be the most powerful constructive agent in a whole work.

A red flower placed in a window may expand its influence over all the area of your sight.

¶A MAN possessed of an idea, working like fury to hold his grip on it and to fix it on canvas may not stop to see just how he is doing the work; nor may he consider what might be any outsider's opinion of it. He must hold his grip on the meaning he has caught from nature, and he cannot grope for ways of expression. His need is immediate. The idea is fleeting. He must have technique—but he can now use only what he actually knows. At other times he has studied technique, tried this and that, experimented, and hunted for the right phrase. But now he is not in the hour of research. He is in the hour of expression. The only thing he has in mind is the idea. As to the elegance of his expression, he cannot think of it. It is the idea, and the idea alone which possesses him, and because it must be expressed, because he has need to express it, he makes a great draft on his memory, on all his store of knowledge and past experience, and all these he regulates into service.

If later we find that there was an elegance in his expression, that there was brilliant technique, still he was not aware of it at the time of its accomplishment. It is only the sign of the success of his effort to recapture all his knowledge and make it work for him at a time of great need. He was not conscious of his gracefulness, for it was only a result of the high state of order to which he had raised himself.

A young girl may come into a room and with her thoroughly unconscious gesture bring animation

and a sense of youth, health and good will. It is a fine technique which she employs, for all in the room receive her message and she imparts without loss somewhat of her youth and spirit to each one present. Her technique is handled as only a master could handle it; that is, without thinking of it. In the activities of play she has made her body supple and it readily responds to her emotion. Through gesture she has a language that is so much her own that it is spontaneous. She is young, she is healthy, and she looks on the world with a wonderful good will and there is a need within her to transform all environment to her own likeness. Her whole body, her look, her color, her voice, all about her is in service and is unconsciously ordered to express and spread the influence of the song that is in her.

If, on the other hand, she is one of those terrible creatures who must walk and talk with the airs of their betters, who must in some way pretend to be that which they are not, we may see a very skilled technique, one filled with a thousand clever tricks, but it is a self-conscious technique—one which is an end in itself. We often meet men who wear a mask of great profundity who would be bored to death in being profound.

A scientist is not a scientist in order to be a scientist. He is what he is because he wants to know about life. The scientist wants to know life—therefore the marvels of mathematics.

The young girl wants to live in the happiness of her state—therefore her buoyant gesture.

The artist wishes to declare the significances he finds in nature—therefore the painter's technique.

There can be no delight in considering a technique that is without motive.

The simplest form is perhaps that of the juggler. Whether he catches the balls in his hands or not,

the balls go up into the air, perform perfectly natural curves and fall according to the laws of nature. Whether he catches them or not what the balls do is equally beautiful. But the motive is to catch the balls, and the marvel is in the manifestation and the achievement of the motive.

A line, or a form, or a color, therefore cannot be meaningful in itself. It must have motive, and to have motive it must be related to other lines, forms and colors. It must have sequence and an end must be attained. If the end is a simple one the sequences will be equally simple. If the end is the revelation of a profound mystery of nature the sequences must be equal to it, for the revelation is written in every part of the construction.

If the technique of a master is marvelous, if it appears that he has turned paint into magic—rendered the life, the look, and all about an eye in a stroke or two—it is not that he has a bag of tricks. It is that with a mighty power of seeing the particular eye and an absolute need to express it, he uses judgment and he taps all his store of experience: the eye is not made in a stroke or two because he wants to make it in a stroke or two. He does not care how many or how few strokes it takes. The eye is what he wants.

Later he may himself marvel at the simplicity of its rendering, and other days; in the days of research, he may set himself the task of doing an eye in a stroke or two and work hard at it. It is likely that in such conscious effort he will not come anywhere near equaling the aforesaid eye, but what he will do and what he will think in this experience will sink into him and will become part of that store which must open up when again he is in the state of great need.

¶I COUNT on seeing your new work when you come to town, and I count on finding in it the likeness of the man I know. The techniques which are beautiful are the inventions of those who have the will to make intimate human records.

¶BE A warhorse for work, and enjoy even the struggle against defeat. Keep painting, it's the best thing in the world to do. Learn that there are different views and that it is up to you to make your own judgments. See the value in compositional work and don't be a life-class hack. Don't believe that sitting in an art school and patiently patting paint on canvases will eventually make you an artist. There is more than that. If a new movement in art comes along be awake to it, study it, but don't *belong* to it. Have a personal humor about things. You will never know your calibre until you have tried yourself. Avoid idle industry. Always leave out the padding. Be venturesome. Try new things that appeal to you. Examine others. Have a pioneer spirit. Prevent your drawing from being common. Put life into it. The way to do this is to see the model, see that the model is great, wonderful—a human creature there before you in the tragedy and comedy of life—then draw. Avoid mannerisms, your own and other people's. Preserve your originality by painting what is before you as you see it, for things have a special look to you. Make your pictures of big pieces rather than small ones. Through the big pieces the statement can be made frankly and fully. Get the easy naturalness of nature. Nature is full of surprises. They happen equally in great and small events, and are inevitable

results. They are parts of a sequence. Make your picture as full of surprises and as easy as nature. Don't ever stock your head so full of "learning" that there will be no room left for personal thinking. Develop your power of seeing through the effort and pleasure of seeing. Develop the power to express through the effort and pleasure of expression.

Ways of Study:

¶THE school is not a place where students are fitted into the groove of rule and regulation, but where personality and originality of vision are encouraged, and inventive genius in the search for specific expression is stimulated.

The real study of technique is not the acquirement of a vast stock of pat phrases, but rather the avoidance of such, and the creation of a phrase special to the idea. To accomplish this, one must first have the idea and then active inventive wit to make the specifying phrase. This places the *idea* prior to the technique as a cause for the latter, contrary to the academic idea, which is the reverse.

I am saying this with reference to the "hard grind" and "grammar" ideas. Hard grind! I was in art schools for three years before I really began the struggle with mind and body to do something with my faculties other than the sheer mechanical process of eye and steady hand assisted by several judgment-saving tools such as plumbline and stick with notches in it.

I know the "hard grind" and the "grammar"

study both here and in Paris, and while I was in it I was regarded as typical, for I was anxious, and I worked all day and all evening.

From my own experience I know that "mindless drudgery" would be a better name than "hard grind," and that "idle industry" would be equally descriptive of such work.

There are at present, all over the world, art students sitting meekly at their work copying external appearances in whatever is the fashion of the school in which they work, copying lines and tints of models of which they have no idea, no understanding, for which they have no respect, no enthusiasm, putting off to some future day that sensitive appreciation, that grasping of significance, that announcing of a special evidence of their own about the matter, simply "hard grinding!" Maybe the name is not so bad. Like a mill stone! Learning technique! Technique of what? For the expression of what? Studying construction? Construction of what? What a deception!

Those meek students, plodding away, afraid to use their intelligence lest they make mistakes, have a faith that after so much virtuous humble tint and line copying, years of it, the gift of imagination, the power to say things the world is in need of hearing for profit or pleasure and the special management of the medium, will be handed to them as a diploma is handed to a graduate.

The man who becomes a master starts out by being master of such as he has, and the man who is master at any time of such as he has is at that time straining every faculty. What he learns then from his experience is fundamental, constructive, to the point. His wits are being used and are being formed into the habit of usage.

He is working on his direct road. His "grind" is hard. His brain as well as his body is taxed to the limit, but his "hard grind" is not a dull grind. For he is grinding something. He is studying grammar because he needs it, and needing it he studies with greater wit, and knows it when he finds it.

This "going slow," this "hard grind," this study of "grammar" as understood in Julian's Academy and in the academies that have sprung from Julian's is too easy. There is not in it the "hard grind" that makes a man find himself and invent special language for his personal expression.

I am for drawing and for construction, for continued and complete study, acquirement of firm foundation. But the drawing I am interested in is the drawing that draws something, the construction which constructs. And the idea to be expressed must be at least worthy of the means.

¶I FIND nature "as is" a very wonderful romance and no man-made concoctions have ever beaten it either in romance or sweetness.

Everything depends on *the attitude of the artist toward his subject*. It is the one great essential.

It is on this attitude of the artist toward his subject that the real quality of the picture, its significance, and the nature and distinction of its technique depends.

If your attitude is negligent, if you are not awake to the possibilities you will not see them. Nature does not reveal herself to the negligent.

As a matter of fact the most ordinary model is in reality a fascinating mysterious manifestation of life and is worthy of the greatest gifts anyone may have of appreciation and expression.

It was the attitude of Velasquez toward his model that got for him the look which so distinguishes his portraits.

The people he painted were conscious of the humanity and the respect of the man before them. They knew that he could pierce masks and that he could appreciate realities with unbounded sympathy. They undoubtedly enjoyed posing for him, and while he painted they looked at him—responded to his look—were frank with him, and revealed without pomp or negation their full dignity as human beings.

So, his king becomes a man for whom you have sympathy, pity and respect.

In that studio the king and Velasquez met and in the portrait that was painted we see eyes and gesture which tell of an unusual contract. To Velasquez he responded, and he was safe to take his true position—that of a man, not good, not bad, not great, but conscious of the futility of pomp; touched with sadness, possessed of a certain innate dignity, and craving above all things just that kind of human sympathy and respect which Velasquez, with love and without fear, was capable of giving.

Philip IV sat for many portraits to Velasquez, and it was probable that he did so because the contact meant for him his greatest moments.

There is something in environment which affects all men, causes them to live for a time in a surprising fullness, or, on the other hand, causes them to close up.

By a compelling impulse a man goes for a day in the woods. Just why the impulse came to break his usual habit he does not know clearly, rather wonders at it, but there is some vague thought of freedom. He plunges into the rough parts of the wood,

climbs under and over. He runs wild. He tears his clothes—but it does not matter. The business of his progress is met with enthusiastic energy and time passes as in a dream. And concurrent with his action there is thought of a surprising fluid character. His attitude toward the life he has just stepped out of has wholly changed. Intricacies untangle. He sees people in new values. Bitter feelings have disappeared. He is over and above all petty grudges, envies or fears. Something has happened. The spirit of the wood has possessed him. He has got into rhythm. Surely he is no longer in his usual plane of life. It is a day of clear seeing.

Later, days later, in his office he cannot recall just what it was that passed—just what that ecstasy of the wood really meant, but he has a memory that he had seen into his life, and had seen it from a different angle and in a way that simplified many matters.

When the dwarfs posed for Velasquez they were no longer laughing stock for the court, and we see in their portraits a look of wisdom, human pathos and a balancing courage. Velasquez knew them as fellowmen with hearts and minds and strange experiences. He knew them as capable of sensitive approach. Even in the madman it is the glimmer of human sensibility, a groping of a puzzled heart, that makes the great moving force of the picture.

Where others saw a pompous king, a funny clown, a misshapen body to laugh at, Velasquez saw deep into life and love, and there was response in kind for his look.

If you paint children you must have no patronizing attitude toward them. Whoever approaches a child without humility, without wonderment and without infinite respect, misses in his judgment of

what is before him, and loses an opportunity for a
marvelous response. Children are greater than the
grown man. All grown men have more experience,
but only a very few retain the greatness that was
theirs before the system of compromises began in
their lives. I have never respected any man more
than I have some children. In the faces of children
I have seen a look of wisdom and of kindness ex-
pressed with such ease and such certainty that I
knew it was the expression of a whole race. Later,
that child would grow into being a man or woman
and fall, as most of us do, into the business of little
detail with only now and then a glimmering re-
membrance of a lost power. A rare few remain
simple and hold on through life to their universal
kinship, wade through all detail and can still look
out on the painter with the simplicity of a child
and the wisdom of the race plus an individual ex-
perience. These, however, are rare, but the poten-
tiality exists in practically all children. We will not
see much of any of this unless the quality of our
attitude is equal to it. The sky will be a dull thing
to the dull appreciator, it will be marvelous to the
eye of a Constable. Still-life will be dead, inert, to
the eye that does not start it in motion. To a
Cézanne all its parts will live, they will interact and
sense each other.

All nature has powers of response. We have al-
ways been conscious of it. Our idea that things are
dead or inert is a convention.

I am not particular how you take this, scientifi-
cally or otherwise, my simple motive is to make such
suggestions as will bring strongly to mind the
thought that the student in the school or the artist
in the studio must be in a highly sensitive and
receptive mood, that negligence is not a character-

istic of the artist, that he must not bind himself
with preconceived ideas, must keep himself free in
the attitude of attention, for he can never be greater
than the thing before him—which is nature, what-
ever else it is, and nature contains all mysteries.

NOTES TAKEN BY M. R. FROM ROBERT HENRI'S CRITICISMS AND CLASS TALKS

¶ART is the giving by each man of his evidence to the world. Those who wish to give, love to give, discover the pleasure of giving. Those who give are tremendously strong.

Be always looking for the thing you like and not afraid of overstating it. We want the simple vision of one who sees and enjoys. Suppose all people try to declare the things they like.

Terrible to have an artist put into his portrait what he does not like in the sitter. If we could only learn to see while we are painting as we see when we enjoy things.

It won't do to blunt and dull your sensitiveness. Study to appreciate.

What we need is more sense of the wonder of life and less of this business of making a picture.

Your painting is the marking of your progression into nature, a sensation of something you see way beyond the two pretty colors over there. Don't stop to paint the material, but push on to give the spirit. We do not enjoy or admire the material in life, for we hate a miser or a *merely* businessman. So why should we draw like a miser? Rather, we should work like a person who sees beyond the material. When we look at anything, we see beyond the objects we draw. We should draw with this spiritual sight. Thus the measure of a painting is the conception of the artist. The value of a work of art depends on the flight the observer takes from it.

A sign makes us see no end of things. Painting is to a great extent a thing of signs. Of the many forms on the model there are very few that the greatest artist need employ.

The cause of revolutions in art is, that, at times, feeling drops out of the work and it must fight to get back in again.

Those who express even a little of themselves never become old-fashioned.

The only true modern movement is a frank expression of self.

The artist should have a powerful will. He should be powerfully possessed by one idea. He should be intoxicated with the idea of the thing he wants to express. If his will is not strong he will see all kinds of unessential things. A picture should be the expression of the will of the painter.

We have very little idea and sight of big things, but a splendid idea of little ones. This is the reason the war could occur. Such evil growths as its cause would otherwise have been foreseen. People have not looked largely at life, mainly because our education drowns us in detail. We don't see the why of it all. Even the superficial thing is important if you can see way beyond it. This is true of painting. Much can be said with a few elements if you can see each in its place.

There is a joy in the pursuit of anything.

Life is finding yourself. It is a spirit development.

Drawing:

¶A DRAWING should be a verdict on the model. Don't confuse a drawing with a map.

Lines are results, do not draw them for themselves.

Your drawing should be an expression of your spiritual sight.

You should draw not a line, but an inspired line.

Yours should be the drawing of strong intentions.

Every line should be the universe to you.

Every line should carry a thousand pounds.

A line expresses *your* pride, fear and hope.

A line that has come from a line. Lines give birth to lines.

Drawing is not following a line on the model, it is drawing your sense of the thing.

Reality is obtained not by imitation, but by producing the sense of nature.

Has your drawing the meaning you saw in the model at first?

Make a drawing flow, stopping sometimes, and going on.

Yours should be the drawing of the human spirit through the human form.

You will never draw the sense of a thing unless you are feeling it at the time you work.

Search for the simple constructive forces, like the lines of a suspension bridge.

Get the few main lines and see what lines they call out.

Some lines are as though they would like to run off the canvas.

Keep a bad drawing until by study you have found out why it is bad.

Work for continuity of line. Strength is gained through culmination.

Have a motive in breaking a plane. Have purpose in the places where lines stop.

Keep thinking of rhythm of line and of forms. Colors should have rhythmic effect.

Count on big line to express your ideas.

Find and lose.

Find the big shape of the head. All the small bumps are but variations under control of the big shape. This is constructive drawing.

The act of receiving is as difficult a feat and as creative as the act of giving. Therefore help the observer by making your painting simple. Straight lines and clear angles have definiteness of character. If you use them, the observer knows when he is being led in a new direction, while a wabbly line confuses him. It is surprising how much variety or how many changes exist within a line, that is, without destroying it. Work for the holding of a line. If all points are painted with the same valuation only monotony will result. You should drive the observer on to a conclusion.

There is always a commanding and simple line around each head. Learn to have a love for the big simple note.

¶IF PAINTING is painting, it is drawing. You do not stop drawing when you begin to paint, for painting *is* drawing.

A study from the nude should be a study to comprehend the human body. When away from model draw from memory. Draw also opposite or very different views from what you had in the class.

If you think of a school drawing while you work, your drawing will look like one.

Originality can be halted but not stamped out or taken away.

Let yourself free to be what you will be.

Clerk mathematician. Creative mathematician.

¶IF YOU do not act on a suggestion at first, you grow dull to its message.

Be yourself today, don't wait till tomorrow. He who is master of what he has today will be master of what he has tomorrow. Many things we know are true that we have never made a part of us. An artist is a master at the start, if he is ever going to be one. Masters are people who use what they have.

Don't demonstrate measure but demonstrate the results you may get from the employment of measure. There is geometry in all good expression.

In a canvas there are two orders working together, the dynamic and static.

Things are at interesting intervals away from you, as well as across the canvas.

Look for echoes. Sometimes the same shape or direction will echo through the picture.

A curve does not exist in its full power until contrasted with a straight line.

Good to oppose straight line to action side of figure.

In making the variations within a curve do not destroy the main movement of the curve.

It is mathematics that gives the imposing architectural structure.

It is through change that we get the laws of nature.

In this group get the beautiful relationship which exists between these two children, that is, the rhythm of their life.

¶THE model is not to be copied, but to be realized. The painting is the result of the effect of

the model on the artist. It is not the model we need but the vision. Thus when a great artist, as Isadora Duncan, affects us, that is when we realize her, we are great as well as she. Thus the observer can be great as he looks at a picture; that is, to the extent to which he sees it as wonderful. The greatness of the picture as it hangs on the wall is up to the observer.

In your model are the essential materials out of which to make a good composition. Enough is there to make a Manet, had he seen it; or a Whistler, had he seen it; but the idiot if he saw it would make a copy. He would put each line as he saw it, for he does not see correlation. Those who interpret the model do not use the measures of photography or of sheer skill.

The Greeks did far less on a piece of work than Bouguereau. Still we do not feel that there is anything more to be done on a Greek statue. What is needed is a wonderful judgment in the handling of your materials.

There has never been a painting that was more beautiful than nature. The model does not unfold herself to you, you must rise to her. She should be the inspiration for your painting. No man has ever over-appreciated a human being.

Get the distinction of the model.

In painting some people we select mass rather than action, they are more like a static pond than a running brook.

A good model is one whose lines have meaning.

Sometimes the sparkle on a button may be vital to the whole composition.

Look for the spirit line that runs through everything.

Let your painting show the vibration of breathing.

Take the pose of the model, yourself, then you can feel the pull of the muscles. Make the legs as though they ran right through the body.

Defend your sight of the model.

Think, are the energies of the model in your painting?

Demand of the model all your greatest ideas. See the dignity of the model, see the man in him.

What you see is not what is over there, but what you are capable of seeing. It is a creation of your own mind, not the model. The model is dependent on your idea of her. Your canvas should be a thing created under the influence of her.

Draw constructively from the model. Art is a manifestation of the constructive power. Construction is the bearing or relation of one note on another, each note in its relation to each and every other note.

The model is one thing, like one gesture. Each part does not exist until all parts are. Each part is a step in a progression. There is a power that things have when organized. Finish is only good when it plays a part in the whole, but it is, too often, only an attempt to cover up faults.

Energy, vitality and unity are the essential things about man. The strength of a wild horse lies in its unity.

Think of a mother's love for her child while you paint that subject, that is, think of the idea you want to give while you are painting.

I must win my way in with a child. He lives in a world he has made, and in it there is no tying down to literal facts. Paint with respect for him. You can't buy him. He is the great possibility, the independent individual. The child lives in his world. It is nothing to you, but it is just as big as yours.

To a child all the different colors are a romance, and romance is all that is true.

The tremendous activity of a boy sitting still.

There have been periods when the world has thought much of human beings, we knew more about them then than we do now.

¶IT IS not the way you put paint on, but what you ask of it that counts.

Your style is the way you talk in paint.

That little covering up is what is generally called finish.

The thing that makes the artist is a gigantic individual development.

Is your painting in accord with the big scheme in nature? Anyone who desires to make a thing in large, simple terms is in a healthy state.

¶SELF-EDUCATION, only, produces expression of self.

Don't ask for a criticism until you are sure you can't give it yourself. Then you will be in a fine state to receive it.

You cannot impose education on anyone.

Few people ever mention that they have studied under themselves. Their attitude in school is, "Here I am, a student, a ball of putty, roll me." Nobody in the land is free, for they are all asking, "What do people expect of me?"

If I could see and really understand the essence of the life that is right around me I could with even such technique as I now command make masterpieces.

By my teaching I hope to inspire you to personal activity and to present your vision.

I am interested in the size of your intention. It is better to overstate the important than to understate it.

¶IN YOUR painting think of the neck, head and body as having a liking for each other. There is a love of the hand for the head. No cold lack of sympathy between the parts of a human being, but a beautiful fellowship exists. The parts are joyous in their play together, and an absolute confidence exists between them. There should be the same loving harmony between the face, the drapery, ornaments, and in the very air which surrounds, for in your portrait all these things have become part of the person.

THE HEAD.

Regard the head as a gesture.

Think—how does the head come out of the body?

Some people's features are strongly cut.

Look upon the head as a Greek bust. It may help you to see the beauties of the head before you.

Sometimes the features shape the face, other times they are contained within the face. The features of a Chinese rarely destroy the dominance of the face.

If you wish, concentrate on a single feature (as, build all toward one eye), make all lines lead toward that eye.

Interest generally begins with the eyes, with the mouth or the gesture of the nose.

Often the rise of the forehead is as though it were a surprise. A beautiful nobility of light up there.

Better have eyebrows too long and mouth too big than the opposite.

Get a large and simple appreciation of the head.

Make the head a solid in a swim of atmosphere.

Keep your masses distinct, do not merge them to softness. But note also that decided things are on the verge of crudeness and may go over.

Never use a highlight unless you have to. Use it only when it will be of great service. The same is true of reflected lights, and even of half-tones.

In painting a flower aim for its strength. Strength in delicacy.

¶FIVE minutes' consideration of the model is more important than hours of haphazard work.

If you get stuck with your painting, make a sketch of the model in another medium. It will give you a fresh eye.

HAIR and beard. The hair is wonderful in its gamut from materialism to idealism, from detail to bigness.

It is so free and still so certain.

In hair there should be places of silence. These are of great value.

You may use her hair, in contrast, to *make* the cool distinction of her face. The beauty of one is necessary to the other. The hair helps to make the face, the face helps to make the hair.

The line on the head between the hair and the face is often a great opportunity for expression in a picture.

Ask yourself, what is your concept of the hair. How get its activity?

Let the hair flow amply over the head. It goes back into richness.

First see that it gives the shape of the head, then get its own gesture.

Notice the way the hair dresses the head, how it reaches out and possesses the background.

Black hair may be painted over a warm—sienna —undertone, and at its edge against the flesh there is often a stronger red. Paint this red to be felt— not seen.

There is very little white paint about white hair.

There is a wonderful fancifulness in the old man's long gray hair.

Look for the occurrence of beautiful measures in the hair. Things are beautiful because they are related. The beauty lies in relationships.

Have elasticity in the hair.

The skull should be firm under the hair.

Often the hair produces the idea of action, will.

A white beard is nearer the color of the face than one would think. Sometimes it is but a few accents that make the difference.

ALL FACES have a direction of their own, some point in, some point out. Concert the lines to express them.

A passage of gesture over the face.

Drive for the activity of mind through the features.

There may be many colors and shapes in a forehead, but it should look like one thing, a forehead. This is simplicity.

See the clock! Its great, big, blond, full face is not spoiled by the hands, as the face of your paint-

ing is by the features. Handle the majesty of the human face without destroying it with the features.

AN EYE is an expression.

Think of the eyelid and the lip together. They are different features but they concert to express the same emotion.

The eye of a young person is clear cut, of an old person indefinite.

Generally there is a richer color around the eye.

Remember the shadow from the upper lid on the eyeball.

The light in the corner of the eye, near the nose, helps to model the socket.

The white of an eye deceives almost everyone. It is much less white than you think it, nor is it so cold. It is nearer the color of the flesh. Often a slight variation makes it.

The eyebrows are important. They have great meaning. They are never without important action, and they may have a multiplicity of gestures.

The eyebrows should be the master constructors of the forehead.

Be certain of them, their place, direction, length, beginning, variation and end. Then draw with this understanding.

What use will you make of the eyebrow?

Remember the importance of the cheekbone.

Feel the sweep back under the eyebrow.

Feel sense of quick movement.

THE direction of the nose may decide the way the hair shall go.

The painting of a nose is the painting of an expression.

Think of the nose as dominating and giving direction. It is like a chieftain advancing.

Work for the shape of the end of the nose. Do not forget its whole shape in attention to the details of the nostrils.

You need not elaborate both sides of the nose. In all cases one side dominates the other. If the two sides are made equally important the observer does not know which to look at and jumps from one to the other satisfied with neither.

Paint the nostrils as just going to expand.

Square the nose, angularize.

The end of the nose is not light, only the highlight on it is bright.

The neck is often very expressive of the character of the person.

Get the mellowness and glow of the neck. You must sensitize paint and color.

Paint the neck, not only the shadow on the neck.

The neck rises from the action of the body.

There is imagination in the neck. The forms should have life and action.

The body projects the neck and the neck projects the head. The neck holds the head. Vital force articulates the picture.

A pair of lips is not enough to make a mouth. The chin must be active, not soft, mushy, or mixed up in shadow.

The lips are a culmination. It takes all the lower part of the face to make a mouth.

A GESTURE that embraces space.

Every picture should have one big controlling gesture.

Things should all be moving toward the expression of a great idea.

Certain animals have developed into a grandeur of gesture.

In painting a group of three women do not let interest in the individuals spoil the dominant gesture of the whole group.

Better to give the gesture than the outline of the arm.

Jump, and all becomes the spirit of that jump.

We watch dancing because there we can see the essential. We find in it the significant, wonderful line. It takes a mighty little to do a lot.

THE BACKGROUND has as much to do with the likeness as anything else. It should be evoked by the figure. It is the sensation of all space around the girl. The background should be sensitive to the head, and the chair seem to strengthen itself to hold the body.

This drawing is good because the woman grips the chair, she has weight. The legs of the chair support her, they meet the floor. There is a sense of touch. The artist should not copy the chair but be filled with the thought of its function. If only a small part shows, never paint this small part as a bit of a chair, but transform it, that is, paint it in its relation to the head. There should be something of the model all the way through. Paint her fan in its relation to her head.

Paint even the rungs of the model's chair so a poem could be written about them.

Remember that your model is not *against* space but in it. What is real to us and what we enjoy is the space, not the walls of a room.

A background is that thing sensed around and back of the model.

A background is good in color and form when it

is so certainly there that you do not think of it.

A poor background is sometimes thin, purely theatrical, a mere drop curtain. It could be taken away.

The face should radiate its activity and color out into the background.

Don't let the background smother the figure.

When you paint the background don't look back of the model to see it.

The space this woman occupies is very handsome. Realize the dignity of space.

Some people need a big space back of them. Some heads call for a big space, some others for a small one.

Be interested in the containing power of the wall.

Sometimes it is easier to draw the spaces left around the model than actually to draw the model. Study the Greek compositions done in relief on the Parthenon to get the value of this.

Silk conducts the eye rapidly.

Some colors seem slow, others represent speed.

A purple thing may be painted without mixing the constituents, red and blue, but these colors, red and blue, may be so applied as to create a purple sensation in the eye and at the same time give a richer modeling than possible with the flat purple. The red forward and the blue receding.

The importance of the garment as a garment is negligible in the presence of life.

Furniture and clothes are the escape of the bad artist.

Eradicate no end of lines and values, so that the clothes become sensations of clothes with big gestures in them. In life we eradicate much to see beauty.

Everything on the canvas, hair, coat, background and chair should help express your idea of the man's character.

¶FIGHT with yourself when you paint, not with the model. A student is one who struggles with himself, struggles for order.

¶MAKE the forms of a garment so that a trip through its hills and dales will be delightful.

When you start a painting, think: why is the model interesting, why strong? How shall I use this necktie, his hair, these things, to express him?

How does this tie make for energy, accent or character?

Paint not the material but the spirit of the necktie, that is, its relation to life, thought, breathing of the model.

Tie (here bright orange). Think of an engine coming—cumulative effect.

A necktie is like a cork floating down a river, it is itself last.

To make body exist under the dress, make the lines in the man's shirt continue those in the neck. Think of the man while you draw his clothes.

The shoulder straps of that dress draw the shape of the upper part of her body.

The beads of a chain had better not be counted. Think of it as a series of influences. The chain around a woman's neck is a live thing.

In the line of the collar over the shoulders give the graciousness of the young woman.

Paint the hat as a complement to the head.

Give *her* quality to the dress, as gentle as she is.

The way a bit of white looks on an old woman. It is different from the way it looks on anybody else.

Give the cuffs and muff the energy of the hand.

Something of savagery and untamed life is indicated by the jewel in the ear.

The flesh pulsates. In reality it is never very brilliant, still it has the effect of being the most brilliant thing you see. You can't quite touch it as you can the earring.

A drag in a dress suggests a past action. Good with long skirt to have model walk and thus trace the action. All, instead of being limp, should be carrying out the theme. Clothes should have not limpness but the beauty of activity. Great things should be happening, currents should be running through.

Think, what have you to *say* about that red dress and white collar?

Remember that the *angle of light* should catch down the whole figure. It is deflected in its course by the accidents of form, but it is continuous.

Avoid monotony among the lights.

The white of a collar may be an excellent compositional note in the color of a canvas, and it should be an aid to solidity.

Think of the coat as a great opposition to the head.

Better paint the gesture of the hand than the hand.

The belt around the waist should be an expression of the living, breathing body.

The wrinkles of a child's dress are full of the history of the day. The little child spoils the clean dress and *makes* it. The clothes have become part of the child.

The necklaces on a papoose are the signs of the bountiful in the savage.

Paint that over there as though the shawl itself were alive. Put a certain expression in the shawl. Try to give the sensation of the activity of her shoulders, the life of her. The shawl should tell of its excursion around her neck and over her shoulders.

Paint her clothes, laughing, brave.

¶FORCE a sense of life and sense of volume. Don't look the shadows out of the face. If you look at any shadow long enough, it tends to grow light. Therefore keep your eye focused on the lights or on the expression, never on the shadows or background. Better have shadows black and simple than weak.

Nothing should be negative or trying to get away, brush strokes irresolute, words you did not mean.

Positiveness makes for good art. Don't work flatly, softly, roundly and negatively.

All concession is lying.

You will never get form till you *want* it. And wanting to want it is not wanting it.

There are forms that can only be seen when you are near a canvas, others only appear when you are far away. To paint is to know how to put nothing on a canvas, and have it look like something when you stand back.

¶THINK of solidity as you work.

Think of values as giving form, not as spots of light and dark.

Do not ask, "Where is?" but "Where do I *need* the light to make the beard, etc.?"

Dark and light to produce form not dark because there is dark and light on the model.

Be sure not to model the knuckles and small incidents so carefully that you forget the general big planes. This fault causes lack of solidity.

Hardness and thinness of edge makes for flatness.

Draw for solid as well as plane geometrical forms.

Be careful to go not nearly around, but rather, all the way around the head.

Lack of solidity is sometimes due to little lights all over.

Angle of light, find and trace.

Nothing would be more horrible to you than the elimination of form in real life.

Put parts nearer to you or further away, as you work. Reach way back to the background and then forward until it envelops the figure. Use forceful projection.

When painting a laughing head the idea of continued motion should be impressed on the observer. The picture should only start the observer, should make him think he sees more than is on the canvas. To do this, the painter takes all the factors of the canvas and sets them in motion. He must create a rhythm of movement through all.

A laughing head should be organic; that is, all related. An organism has order.

Idea of face all bound together and tight as a clasped hand, idea of pressure. A laughing mouth is stretched, the chin projects, nose and upper lip shortened, the nostrils spread, and eyes squeezed with ends lifted. The spirit of laughter lights up a room. It spreads out over the whole canvas. The body should be laughing as well as the face. The laughter should pass from the beginning of the hair to the ends of it. In the picture of a laughing boy, the laughter should be continued in the hair, carry-

ing out the lines of the features, and a chatter should be in the background. The whole canvas should be like a laughing person coming into a room.

After laughter one should feel full, not empty as one feels after fireworks.

A ripple runs around and picks up the chin. When he laughs a whole new set of forms begin.

¶LEARN giving and receiving in giving.

¶THAT which is worth while in a landscape is the expression of human emotion in it.

The sympathetic painting of a still-life has more humanity in it than a head, unsympathetically painted.

¶I WOULD rather see a wonderful little child than the Grand Canyon.

Paint mountains as they are when they look wonderful to you, when they seem to move and have a life of their own. Try to discover what it is you see when they look so wonderful. The thrilling glimpse from a train window may dissolve into mere materialism when you go back and coldly look at the subject. Mountains are great living things under the sky. Sometimes a mountain lies there in the atmosphere. The atmosphere comes down and envelops it.

Grasp the big things outdoors. The immense power of the sea, the rock standing there. We do not think of rock, but of resistance.

The romance of snow-filled atmosphere and the grimness of a house.

Render the waterfall not merely as a waterfall, but use the waterfall as an expression of life.

The old house sits down. At first a new house is an interloper, after a while the landscape takes it in. The houses become all of a family, related, and all the neighborhood grows old together. People's houses get to look like them. There is more in a house than the materials it is made of. Humanize the houses.

Get one form that looks like the tree rather than little pickings at the branches. Give the tree its gesture. Some trees are heavy, ample and full.

In a tree there is a spirit of life, a spirit of growth and a spirit of holding its head up.

Get the music that exists in the play of light over the houses in the landscape.

A mountain seen in the haze of distance must nevertheless look a solid heavy mountain.

Evening has a powerful light.

Be sensitive to just a common stick leaning against the wall.

The very sense of love was in the approach of part to part.

This is extremely beautiful, it is like a thought.

In his pictures there is the supreme line.

Everybody who has any respect for painting feels scared when he starts a new canvas.

A person who has never been afraid has no imagination.

There are "colorist" pictures which have color as agents of construction, and there are others which riot like a ribbon counter.

¶BRILLIANCY is going toward color, not toward white.

Cumulation is stronger than contrast. Cumulative color.

Yellow makes things come forward, purple makes them go back. Model with oppositions of cold and warm side of palette.

Black is a very difficult color. Don't get an overbalance of it.

Black or gray, when opposed to warm colors tend to look cool and opposite. That is, with purple they tend to look yellow, but when with yellow the black or gray seem purple.

Study the effect of juxtapositions of pure colors with neutrals.

Vitalizing of color, by having it play within its note a warm, a medium and a cool vibration, is very good and you may develop it to advantage in all your color. This is easily overdone, and sometimes becomes an obvious mannerism.

Work for simplicity of color.

Don't see the colors too much by themselves.

There is a golden mean in color, a spectral relation.

People who have sense of color have sense of texture. Color may be expressed through texture.

There are fashions of painting, such as painting dark, painting light, and using a hundred colors to the square inch.

At times you may produce the effect of a change of color by only a change of texture.

A color mysteriously true.

Color is only beautiful when it means something. It is never good of itself. It must be the expression of some life value.

Color represents the deeper strain in human life.

There can be no fine color without good form.

Form should carry you along by its beautiful

measures. Think of form as an agent. Also there are measures of color as they advance and as they recede.

There are many colors and they are all moving, moving.
Color should flow over the face.
Color and warmth are coming into our lives.

A big simple space is often a good complement to activity.

¶A VERY dark picture is likely to look well in a white frame. See the dark pictures in Petit Trianon, Versailles, set into panels of white rooms. A very light picture may look well in a black frame. Gold in good tone is generally safe, but every picture has its best setting.

The frame should be an agreeable complement to the picture. A picture made with dull colors should not be in a dull frame; most certainly not if there is also a similar tone in the frame to that of the picture. When a wall is beautifully complementary to the picture in color and texture only a very slight border is necessary as a frame to stop the picture. The border and the wall combine to make the setting.

When we have acquired good taste most of the frames now made will go to the furnace.

A picture has its definite areas, they should not wander out into the frame. The frame should show that the picture has stopped at its edges.

¶DO WHATEVER you do intensely.
The artist is the man who leaves the crowd and

goes pioneering. With him there is an idea which is his life.

The signature on a picture should be modest, should be readable and simple and should enter into, not interrupt, the composition.

¶THE strong make-up of the human body is beauty and refinement. The human body is terrific. Beauty is a terrific thing, as great as structure. Very few life-studies are strong enough to live.

If you work from memory, you are most likely to put in your real feeling.

The nude is exquisite, the most beautiful thing in all the world.

Don't let your figure look as though it had been ironed.

Feel the energy of the man. The shoulders have thickness.

Description of a nude. See the welling of one color into another, the mellowness and glow, the fire. She is gracious, organic. There is a wonderful melting of red in the flesh of her body.

A gleam of light plays over the body of the model. The painting of the gleam depends more on change of color than on white.

Paint the look of the body, the sensitiveness, the full, tight leg. Her head is a delicate rose color seen in shade.

Purple over there is the *sensation* of purple rather than the color purple. Don't think of them as paints, but get the quality of light.

Give the sensation of motion by distinctly showing in your work which parts of the body are movable and which not. Study to know which are which. Remember that the head of man is a solid structure. It refuses to be twisted and cannot be

bent up. The neck is a more loosely jointed thing. Then come the fixed structural bones of the chest. The waist again is movable and pliable, but is followed by the structural and bony place at the hips, then to the knee. The whole body consists of flexible parts, inflexible parts. It is at the flexible places named that the bend or twist actually occurs, but one is made to feel the continuity of movement throughout.

Study muscles so that you know the nature of what you use. Where each comes from, and goes to, and its part of the action in hand.

Anatomy is a tool like good brushes.

Caught by facts, caught by facts of anatomy.

When in trouble drawing a nude, look for the straight line. It may straighten you out.

A hand is more important as a hand than it is as a series of fingers. You can't see all the fingers of a hand at once.

The overlay and interplay of muscles is like the running of a brook.

Feel the grip of the muscles on the heel.

Study that seeming magical effect of one line on another.

A human body in a work of art may have normal color and normal shape. The Greeks did it, they did not distort.

¶A GREAT painter will know a great deal about how he did it, but still he will say, "How did I do it?"

The real artist's work is a surprise to himself.

The big painter is one who has something to say. He thus does not paint men, landscape or furniture, but an idea.

There is a spirit of youth in the way these flowers are painted. They are presented as youth sees growing things, strong, courageous and sympathetic.

In looking at the work of another, try to enter into his vision.

First look for the beauties in a painting. If I see anything beautiful in my own work, that is what I am interested in.

¶PRETEND you are dancing or singing a picture.

A worker or painter should enjoy his work, else the observer will not enjoy it. It is not good to wear lace that was a drudgery to someone to make. The lace, as well as the picture, should be made in joy.

His works are full of the beauty of his enthusiastic interest in life.

All real works of art look as though they were done in joy.

¶LOW art is just telling things; as, There is the night. High art gives the feel of the night. The latter is nearer reality although the former is a copy. A painter should be interested not in the incident but in the essence of his subject.

Here is an emotional landscape. It is like something thought, something remembered.

Reveal the spirit you have about the thing, not the materials you are going to paint. Reality does not exist in material things. Rather paint the flying spirit of the bird than its feathers.

¶THE coming into the presence of a piece of art you truly love causes a tremendous revolution to occur in you.

WHISTLER. In this painting by Whistler we get the sensation of the silence of velvet. From this there is a change to its contrast—harder and more visible materials. We are held a moment and are deflected to areas where we seem to pass through air. We come to the figure. Every step we have taken in our approach is a preparation for the ecstasy of human flesh.

The *White Girl* looks like the finest nature of Whistler. It shows the heart and vision of Whistler. The hands are not finished because he knew he could not do them in the same spirit he had while painting the rest, and he could not descend to common manufacture. The frailty and delicacy of her dress are opposed to the solidity and strength of her. It is a fantasy, it is a spiritual expression. We do not have to stop and examine each part. Notice the sensation of the melting of the arm into the dress.

Whistler's sensitive nature influences every touch of his brush.

REMBRANDT. His drawing is made with the might of an age of study.

His lines are filled with a great man's sense of life. Every touch on the canvas is laden with his interpretation of life. His drawing gives the essence of his character. His greatness lies in his intense feeling for his subjects.

Each line of his drawing was the inevitable thing.

The greatness lies in the way he managed the lines to suit his state of mind.

Rembrandt was comfortably on earth.

Each line comes from within the model. It is as though the brush stroke had come out of the life-

blood of the model. The deeper you penetrate below the surface, the better you will see the surface.

The drawings of Rembrandt are full of color. In them he tells us not only what he was able to do with paint, but what he would like to have done.

EL GRECO. His work is an illustration of what a composition should be, that is, he puts together forces and makes of these forces a great unit. Continuity is carried through the canvas with a positive control, a coördination. His work overlays and interplays like a brook. The rising movement in it is like a flame, and he makes much of the movement of light.

Every touch you put down is part of a construction. All that is not related to the basic idea is destructive to the canvas. The laws of composition should be those of growth. The work should have the spirit of growth in it. The artist must put in the force and power he sees in nature. He must see such elements as will build. Begin the flush on her face from the corner of the canvas. That is composition. Then a strength will go through the canvas. A good composition is thus an expression of will. Get the idea of progression. The artist uses the *principle* of nature. Growth equals beauty. All structure is built up by variety. That is, variety is one of the factors in construction.

Take care that your compositions are an expression of your individuality. See things not as they are, but as you see them.

The lines of the model are factors of composition. Lines change as you are your greater or smaller self. You are using the line for a deeper impression. Try to

see the terms of the reality, and not the terms of the surface. A child sees the reality beyond surface or fact, but later in an art school he is taught to see the lines on the surface. Get over this thing of copying the surface. You must not see your subject, but through it.

We should not need to have a picture full of things. The Japanese can appreciate a simple proportion, but we are bred on excitement and thus do not appreciate a Japanese house. Most of our life in New York is directly opposed to their principle of simplicity.

Good composition is like a suspension bridge, each line adds strength and takes none away. Thus a work of art is finished from the beginning, as Whistler has said. If there are only ten lines, then they are the ten lines which comprehend the most. Composition is the freedom of a thing to be its greatest best by being in its right place in the organization. It is a just sense of the relation of things.

Making lines run into each other is not composition. There must be motive for the connection.

Get the art of controlling the observer, that is composition.

Be sure you are composing to express yourself, not composing to compose.

The observer should be carried through a canvas, each part should be tied up with another part.

Do not let space in a canvas seem empty of purpose.

Decoration is not the flattening out of objects, it is construction.

CÉZANNE. He had a great vision and it was beyond him. In his effort to give his idea, he car-

related things never before correlated. Therefore he was a great artist.

His work shows part of a universal existence.

Some sculpture is warm, some forever cold.

All through the works of Goya there are Chinese characteristics.

ARCHAIC WORK. It is constructed mainly with over-values. Reveals the inner life.

COROT. The quality of mind that makes you paint as you do is what counts. In this Corot was great. His color and form identify the nobility of his nature.

MANET. Notice the meaning of every change.

WINSLOW HOMER. Had such a sense of proportion that his work would hold a businessman straight.

He gives the integrity of the oncoming wave.

The big strong thing can only be the result of big strong seeing.

TITIAN. What majesty in a Titian! He was one of the greatest masters of composition. His work has large and beautiful masses and lines which move in correlation.

DRAWINGS. Study Daumier's drawings.

Rodin gives us all the greatness he could find in the model.

The Japanese weigh their proportions.

HOGARTH. The head of fish girl. It is like the wind that blows.

The old masters were not so nervous as we are, that is why they could hold on better to the big masses.

The real people make the vision of youth come true.

VELASQUEZ. Everybody he painted had dignity, from a clown to a king. In the Infanta Margarita he united the look of a child with that of a queen. He drew greatness out of his models. Velasquez was a man in love with humanity. He had the utmost respect for the king, the beggar and the dwarf.

He must have felt and willed all that he did.

He did not have to deviate from nature for he could see the beautiful in nature.

He painted with easy large movements, and his work has great finish combined with great looseness. His forms make beautiful rhythm.

A silver light runs through his work. There is a violet note in the Spanish face.

His foreheads. Gave much human sensitiveness to them. Put there a certain thickness and knotted force. Built architecturally. An energy in the fore-

head. Did not neglect the shape of the crown even if covered by hair. He models the skull by the shape of the hair and eyebrows.

Certain of his pictures have climax in the eyes. He was interested in the vital life of an eye. Made it simple. Depth of eyes. Uplift of eyebrows. The cheek as though described with fine phrases. A whole series of events that gives you the romance of the hair. Divides it at interesting intervals.

He gives the great movements of form, and the movements of color as they surge one against another.

¶FEEL the dignity of a child. Do not feel superior to him, for you are not.

¶A WORK of art is the trace of a magnificent struggle.

The paintings of such masters as Titian, Velasquez and Whistler are like great documents hurled down. Each is a great decision. They are records of the thought and struggle of an artist. The picture stands as a record of how much and how little the artist knew, as rough as he was and as capable as he was. The mistakes left in a drawing are the record of the artist's struggle.

¶IN GREAT art there is no beginning and end in point of time. All time is comprehended.

Index

INDEX

Icon Editions